Fierce Love

Music Leads a Lost Child Home

— ADRIAN SNELL —

WITH LEON VAN STEENSEL

Sacristy Press
PO Box 612, Durham, DH1 9HT

www.sacristy.co.uk

First published in 2020 by Sacristy Press, Durham
Paperback edition published in 2021 by Sacristy Press, Durham

Sacristy Limited, registered in England & Wales, number 7565667

British Library Cataloguing-in-Publication Data
A catalogue record for the book is available from the British Library

Hardback ISBN 978-1-78959-118-7
Paperback ISBN 978-1-78959-119-4

Contents

Acknowledgements .iv
Preface .vi

Part 1: The Lost Child . 1
Part 2: Refuge . 19
Part 3: Lost Children . 79
Part 4: Music Therapy . 151
Part 5: Forgiveness . 183

Conclusion . 201
Discography . 203
Photo Credits . 205
Notes . 206

Acknowledgements

Adrian Snell

I feel I should acknowledge every person referred to in this book since, without them, there would not be a story at all. However, I will focus on the three people who have been directly involved in the creative process.

It was Leon who approached me three years ago with the idea of writing a book. I have to say I needed some convincing, feeling genuinely uncertain as to whether there would be enough general interest in reading my story beyond what is already contained in the song lyrics and music that span almost my whole lifetime.

But . . . I was to be humbled and encouraged by the number of friends and colleagues who seemed immediately interested and enthusiastic about his suggestion.

So, first, I would like to acknowledge and thank Leon, from the heart, for believing in this book and for the extraordinary commitment he has made over these last three years in bringing it to completion.

Secondly, I wish to mention Judy Bloomfield. As well as being a friend and my sister-in-law, she is also a gifted and diligent proofreader. She manages to combine her linguistic skills with genuine joy and excitement over the texts she is reading.

My third acknowledgement is the most personal one: to my wife, Sue. Of course, she has read every word, made suggestions and corrections (in particular regarding dates and places that I easily and regularly misremember) and also challenged me as to whether certain content is either appropriate or likely to be of interest even to the most committed reader.

But much more importantly, for the last forty-two years she has been the rock upon which I have been able to rely, come back to, feel safe, and by whom I am held, during all the many moments when my path has

led me to difficult, sometimes painful places. Without her love, support, encouragement and, often, forgiveness I am certain I would not have had the motivation to do this, let alone sustain a musical career for this many years.

And so, this is where, perhaps unusually, an acknowledgement will become a dedication: I dedicate *Fierce Love* to my wife, Susan, with love and immense gratitude.

Leon van Steensel

Thank you:

- to Adrian and Sue Snell, for your candour, attention to detail and patience;
- to Judy Bloomfield, for tireless editing and improving upon the manuscript;
- to my parents, for enduring countless hours of typewriter noise and encouraging me to pursue my dreams and interests;
- and above all to my wife Jolanda: I love you more than words could manage to describe. Here's to sharing coffee and stealing glances.

Preface

Language and words surely rank among the most beautiful aspects of God's creation. I have used words in a variety of ways throughout my life, seeking to convey emotions and messages, especially in songs. The words my parents used to instil their love and wisdom in me have stood the test of time. The words I read in the Old and New Testaments have resonated in my heart, providing me with an eternal context for the peaks and valleys of life. For me, it is the language of music that has done much of the talking over the years. It has become more than expressions and interpretations of moments, thoughts, sentiments or theology. As life swirls and sways along sometimes unexpected paths, the songs and albums have become like signposts on a journey, communicating what I have found hard to put into words while living it.

More recently, I have witnessed the redemptive nature of music in new and unexpected ways. And people close to me challenged me with an intriguing prospect: to write a book that could not only serve as a telling of my story, but that could hopefully share some insights along the way. Putting words to the many experiences—as a child, a father, an artist and in all of this as a person of faith, seemed like a daunting task. But the key turned out to be what words like "journey", "story", "love" and "forgiveness" have come to mean for me. I do believe these words can rightly apply to the chapters that lie ahead. Why? Because with every one of us, through place and circumstance of birth and upbringing, relationships, parenthood, as well as cultural, social, environmental, political and religious influences, our narrative is formed. These are the things that shape our lives and determine the person we become, and the thousands of daily events and experiences form the canvas for the ordinary and extraordinary stories we live and then tell. Our lives are often a smaller representation of a bigger story. And all our stories are worth telling.

Words matter. Without them, we are impelled to seek out other ways to speak the language of our hearts. I hope that in reading this, you will find the words that speak to yours.

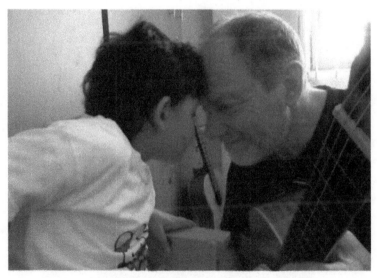

A music therapy session in Korçë, Albania
(photo: Marleen Van de Voorde).

The Lost Child

There is a quote fixed to the door of my music therapy room by one of the greatest composers of all time, Ludwig van Beethoven: "Music is a higher revelation than all wisdom and philosophy".[1] It is quite some statement—bold in its directness and insightful in its meaning. Wisdom, philosophy and music all share exactly this: revelation. Each field seeks to explore and present something that was once hidden, obscured by our own limited perception of the world around us. The quote moved me for a number of reasons, not least in its validation of the communicative power of music. When we come into this world we set out on a journey of exploration where experience, wisdom, philosophy and music inform us along the way, revealing truth that exceeds the trivial.

I have always loved the imagery of being on a journey: the metaphor of travelling down a long and winding road that leads to an enrichment of how we look at the human condition. We often think of a journey as a clear path with a known point of origin and a specific destination. In reality, we invariably lose track of the path quickly through a wide variety of circumstances. Perhaps a child is forced to grow up without the comforting guidance of his or her parents; perhaps he or she faces physical or psychological challenges that lead to a place of isolation; perhaps a child is led astray early on in life, driven by desires, disappointments or unfulfilled dreams. Not everyone has the luxury of a person or persons in their life that act as a lighthouse, an anchor. While parents normally do their best to set rules and boundaries out of love, a child can become lost when ignoring those boundaries, sometimes even perceiving them as some type of punishment. The biblical account of the people of Israel, freed from slavery and set on a journey towards their promised home, wandering through the desert, is so much more than a historical

recollection. It is the story of a Father who seeks to guide his children, providing rules and boundaries along the way; guidelines given solely for the purpose of enabling them to live life full and well. There are numerous instances in this story where the people, the children too, rebelled and became lost as a result.

When I use the word "lost", I am well aware that this figure of speech will be interpreted very differently, depending on our unique circumstances. To me, the image of a lost child is deeply rooted in the absence of revelation, a place where the path forward is obscured from view and there seems to be no one around able or willing to guide you towards it. The simplistic explanation is a lack of positive upbringing and tuition. But a person can have received all the guidance and signposts one could hope for yet, unable or unwilling to see them, still find themselves lost. Throughout my life I have come across many children who were "lost" in some capacity. Their stories and circumstances resonated deeply with me. Without a doubt because, although the circumstances are very different, I recognize the root of their condition. We share in the feeling of helplessness that comes with lacking revelation. Since becoming a music therapist, my life has increasingly revolved around providing children with beacons and a voice in the hope that we can walk together towards the place that can truly be called home.

But I feel that, in order to explain why I took this path and followed these signposts in my life, I should share the journey from the beginning.

1

"Snell, you just live in a world of your own!"

The moment my classmate turned around and made this remark is deeply etched on my memory. I cannot quite remember what had led to this point, but the rather impatiently delivered line did ring true. This boy had—perhaps unbeknown to him—made an observation that simply captured my youth and my relationship to the world around me. I did live in a world of my own, but it was no ordinary childish seclusion, nor a trait of absent-mindedness. There was an ever-present feeling of unease, and

even anxiety, in my dealings with life as it was in those early years. By all accounts I would be far more content if allowed to sit and play by myself in a corner during group activities at nursery school. Birthday parties were occasions to just get through, to survive, ideally without having to engage with the other children. While I did have a small number of genuine friends with whom I could truly relax, in general I was perceived as "the odd one out".

From the outside looking in, this unease must have seemed unwarranted. I was born in Northwood, a town on the outskirts of London, the second of three children, to loving parents in a middle-class family. My parents made sure we were lacking in neither means nor love. My father, Stuart Snell, was a man of great empathy. He had been in business (successfully so) and had spent time as a District Commissioner in Kenya before returning to the UK in the early 1950s. He, too, had a tendency to deal with experiences internally. When someone asked him how he was doing, he would typically answer without hesitating: "struggling". It seemed uncharacteristic for a deeply committed Christian, as he was, to say this outright, but my father had his own troubled family history that undoubtedly affected his response. There had been deep religious strife between family members, leaving its mark on him, and his views were influenced above all by compassion and sympathy for the disenfranchised. He was not someone who was easy to get to know intimately, but my mother Margaret had managed to do so. She was an immensely loving and caring person, providing a balance in our household where her kindness and practicality complemented my father's more introverted personality. I was very attached to my mother who seemed to have an instinctive understanding of my sense of unease with the world, even though I even though I rarely felt either able or willing to put it into words. Margaret was also a profoundly committed Christian, but this did not result in a particularly strict religious approach to bringing up her three children. My older sister, Julia, myself and my younger brother Christopher were taught and shown, through simple daily life, what it meant to live as a family believing in, and guided by, a God who loved each of us unconditionally and wanted us, his children, to thrive.

However, both my father's and my mother's sides of the family had experienced serious friction where faith was concerned. Apart from the inevitable scars this left on both, it had made my parents decide not to let faith become a matter of allegiance or tradition in our household. The trappings of religious strife were carefully avoided in our home and my parents lived their faith with open hearts and clear devotion to their children and each other. This meant that for all three of us, belief and trust in God and the teachings of the Bible were as natural as breathing, scientific facts or the daily news. It was an indelible part of me from the very beginning. As was music.

Both my parents loved music. And both could play instruments: Mum the piano and Dad piano and violin. Home was actively presented as a place of musical discovery and expression. Although my father had briefly had violin and piano lessons, he had ultimately learned how to play without the help of a teacher. I could easily relate to this approach to music-making—"playing by ear" as we described it. I was about three years old when I started to discover the piano. I loved the experience of being by myself, exploring all the sounds I could make, dabbling in playing and joyful experimentation. At the piano I could once again lose myself in my own little world, but this world was one of excitement and musical discovery. I could not have been further from the unease and anxiety that so often crept into my other world. When I touched a key there was a sense of a note not just echoing outward from the instrument but rather speaking directly to me. It did more than merely pique my interest—it got my undivided attention. It quickly became obvious to my parents that I had a natural talent for playing the piano. It was equally clear that I would require lessons to truly nurture this, even though that would mean the daunting and regular challenge of facing and interacting with a teacher. I persevered, spurred on by my parents, who were very supportive of my music-making. They were relieved to see me immersed in constructive creativity and through that developing a sense of self-worth. Whatever the motivation, the lessons paid off. By the time I was six years old I had composed my very first original piece to the delight of my parents. But this moment also had significance—the creation of something tangible, something I could share with others, that had come into being without the need for interaction with others, or the

involvement of anyone else! While other children would play outside with their friends, I was happy to spend my time in our living room, sitting at the piano, playing the hours away.

In many ways, my early memories of childhood development are rooted in the sensory world. Exploring the sonic and tactile properties of anything that caught my attention was as natural to me as learning to walk. As a five-year-old I was opening up to the rich sound palette of everyday appliances and objects. I tapped pots and pans, hit furniture and rustled paper. The different noises they made were music to my ears. I was fascinated by the way so many things could produce such a sonic kaleidoscope. It was a journey of discovery I could happily immerse myself in. But there was also an involuntary, perhaps darker side to this. There was the ever-present feeling of anxiety that I could not trace back to its roots, and during my trips to and from school everything around me would tend to feel amplified. Sounds, conversations, approaching bikes, animals or something as common as a summer's breeze would overpower my senses while I struggled to make sense of it all. Whatever I encountered on the way that—to my mind—required my undivided attention, would receive just that.

Whether it was through a deep sense of empathy or something else I cannot fully explain, from time to time I would arrive home from school with a dead bird that I had found by the roadside, intent on giving it a proper burial. My long-suffering parents went along with this strange ritual by allowing me my own little burial ground in the back garden. Taking it a step further, I remember a failed attempt to cremate one of the deceased animals in a small wooden box! To an ordinary observer it might have appeared comic and weird in equal measure. But for me, it came from a deep sense of doing what felt right and necessary at that precise time.

Some of my early eccentricities needed more diplomatic handling. I did not quite understand what the problem was when my mother appeared aghast at the rather sizeable collection of stationery I had gathered from my classroom and brought home at the end of one particular school day. My somewhat black-and-white interpretation of circumstances and events suggested to me that if pupils had left pencils, paper and rubbers on their desks, they were obviously unwanted and therefore

could rightfully become mine. So, accordingly, I helpfully cleared the desks, placed the unwanted items in a large paper bag and took them home. My mother tried to explain, with great sensitivity, the flaw in my logic. I was persuaded to return them to my teacher the following day, and I remember her generous explanation to the class that Adrian had "helpfully collected all the untidy bits of stationery to keep them safe", and they would now be redistributed to their rightful owners. I listened with a typically childish mixture of indifference and indignation.

My feelings of anxiety and unease were frequently amplified by the frustrations around feeling misunderstood, or simply not understood at all, by grown-ups and peers. It was a taxing way to spend my days. Many years later my mother would paint the picture of young Adrian, arriving home from school, walking through the back door, closing it behind me and just staying there, back pushed hard against the wooden panels, just taking deep breaths until emitting a huge sigh of relief. I had made it to my sanctuary. I had made it home.

I explored various ways of trying to ease this rather stressful way of living and being. An anxious person seeks all possible ways of taking control of their environment, carefully planning a way through the next event, negotiating each step before embarking on the next mission. I found one solution particularly helpful, comforting and long lasting. Meet John, King of the World! John was an imaginary character that I had invented for myself. He was, in effect, my alter ego. I considered him an adventurer, a warrior, a bringer of justice and generally good things or, quite frankly, anything I needed him to be. He was, of course, invincible. And this was far more than just typical childish fun. To me, John was necessary. I escaped into the character. I had bestowed the title "King of the World" on my imaginary friend as a reference to the fact that he was able to do anything and make life better because of it. It was not uncommon for me to lock myself in the bathroom and spend long periods of time allowing my imagination to transform it into a battleground, the scene of an adventure or a dangerous mission. John, King of the World would be waiting there, ready to lead his armies, save the world and return home to the admiration and adulation of his many followers . . . John, King of the World (JKOTW), enabled me to close the door on unwanted people, shut them out, but I would not be alone.

Although I struggled to find my way in the public realms of nursery and primary school and secluded myself accordingly, I was not totally devoid of significant relationships with my peers. I was the second of three children, and my relationships with Julia and Christopher could be described as sharply contrasting. Julia was definitely the *older sister* to me in that wherever possible she took charge. From her perspective, this was no doubt driven by a sense of responsibility of care for her younger brothers. Julia was kind, caring and fun and quite simply easy to be around. My relationship with Christopher was another story entirely. It is not uncommon for brothers to be at odds with each other, but our relationship was particularly strained from an early age. Part of this was likely due to Chris's competitive nature clashing with my black-and-white view of the world around me. It would only take the slightest provocation, clearly at times calculated on his side, to elicit a really negative response from me. My early childhood memories of us together are dominated by squabbles and a constant sense of injustice. Because Christopher was the younger brother by two years, I felt he often unfairly got the benefit of the doubt when my parents broke up another clash. Riding along in the back of the car, our poor sister would often be asked by her exasperated parents to position herself between us in order to keep us either from making provocative facial expressions, or from actually thumping each other. It is hard to explain what exactly was at the root of all this, but the reality was that we simply would not allow each other space to breathe. But being the older brother, I was usually the one to be blamed or punished first, regardless of my emotional pleas about the truth of the situation. It added to my general feeling of not being understood and meant that I placed even more value on other relationships, inside or outside the confines of family, few and far between as they were.

On one particular occasion Christopher and I had taken the croquet set outside for a game, but it quickly degenerated into arguments. After a few altercations our mother came out of the house to separate us. She told us off and, in her own way, drew a line in the sand. Quite literally, in this case. She proceeded to indicate an imaginary line that divided the garden and instructed us both to play on our own side of it. When she went back into the house it did not take long for one of us to provoke the other and cross the line. Things escalated quickly and ended with

my brother throwing a croquet ball at me. I retaliated by hitting him on the back with a croquet mallet . . . just as both our parents arrived on the scene. I was sent to my room. I was furious, not so much at Christopher for his part in the ongoing war between brothers but at the injustice of it all. My parents probably expected me to be the responsible one, but that message was lost on me as I sat fuming in my room, thinking of dozens of similar incidents. This process quickly led to an inevitable conclusion. Full of indignation, I decided there and then that I had just had enough. I got out my little brown briefcase and stuffed it with my teddy bear, my Bible, a torch and a toothbrush. I was in a hurry to leave so that would have to do. I sneaked out of the house and proceeded to march down the street, still in indignant fashion, and away from the terrible injustice I felt I could not live with any longer.

It took about twenty minutes for me to calm myself enough to come to my senses. For a start, where would I find food? It was nearly time for tea—what would I eat at teatime, and where would I eat it? Reluctantly, I dragged myself home and, quietly again, crept up to my room. The whole episode had not gone unnoticed by Mum. She gently knocked on my bedroom door, let herself in and quietly helped me unpack my few belongings. My anger melted away largely due to her silent act of love. Sobbing, I started to talk it over with her, a rare event when it came to these incidents.

As supportive as my mother could be, my father had a tendency to weigh up all sides of an argument, sometimes just to make sure all sides were explored. It suited his inclusive personality, but I found this approach very hard to accept as a young boy. My world was far more black-and-white, right or wrong. A devil's-advocate approach to an argument would probably have been lost on me as it would have only served to heighten my sense of injustice. But whenever I was in any sort of crisis, in the end I still had two safe places to retreat to: the piano, or JKOTW!

When I was ten years old our family moved to Canterbury. My father had recently been appointed Assistant Warden at St Augustine's Theological College. St Augustine's specialized in training men and women for ministry in the Anglican Church worldwide. I was curious. Our family was entering a new phase of life where our home would be

open to countless guests from, quite literally, all over the world. So, the Snell family made their home near the river in this historic cathedral city.

Even though our home was my sanctuary, sadly there was no reduction in incidents of fraternal conflict. Clearly my parents began to have grave concerns about the negative impact this was having on the whole family. They made a difficult decision. In order to preserve the peace at home, and in keeping with the times, it was decided I would spend a number of terms at a boarding school for boys two miles away. There was a school of thought, prevalent at the time, that boys in particular would become more independent, and mature more quickly, by learning how to fit into a structured and strict system of education away from their families. It was a terrifying prospect for me. I had a built-in, even cultivated fear of relating to others and could not fathom out how I was supposed to handle a totally new environment, even if it was only two miles away from my parents. Being so close to home, and yet so removed from it, was a crushing experience. My parents obviously thought they were doing the right thing, but to me the prospect of boarding school felt like nothing short of a prison sentence. I was registered at St Edmund's for what was to be a little over a year. Boarding school was like normal school during the hours of a school day. But, when the bell signalled home time, there was no going home. No cycling out of the school gates (with or without a dead bird in my pocket) and no breathing a sigh of relief on arrival. We were educated and cared for well enough, but I did not want to be here in the first place. Lying in the dormitory on the first night, surrounded by dozens of strange boys, I cried myself to sleep under my blanket. That reality was to continue for several weeks, especially after family visits or weekend excursions home.

Although I never warmed to boarding, I was happy to discover activities that served as lifelines during this period. One was provided by the excellent music department at the school. I could spend many hours here and as well as "playing out" my feelings, could avoid interactions with the other pupils. My musical development, particularly in the area of original composition, was unquestionably intensified by the situation I found myself in. Another place of release and joyful solitude was fishing in the river that ran through the school grounds. Once I had discovered the strange, magical pull that every fisherman or -woman recognizes,

there was almost nothing I treasured more after lessons than to take a rod, go down to the water and install myself for hour upon hour of peace and quiet. Just me, the river and the riverbanks, my rod and float, my thoughts and, just occasionally, the actual landing of a fish! To me, this was heaven on earth. Not only was there was a kind of safety in its simplicity, but this multisensory experience—in particular the sound of the flowing river—also soothed whatever was boiling beneath the surface of my outward emotions. While here at boarding school I was just about coping.

When I returned home a little over a year later, I was not yet the shining example of a balanced, self-assured and independent young man boarding school was supposed to release into society. By now I was a young teenager whose fear of the unknown had been deeply engrained in my being. I was loved by my parents, but that love could not suppress a feeling of being lost, of not being understood. Even though I had a profound aversion to the whole experience of boarding, my relationship with Christopher had improved somewhat. It had allowed us both the space to grow and develop without the stresses and strains of living in the same house. Also, both Christopher and I were quite simply growing up. We were perhaps finding a little more in common as we matured into our teenage years. There was more to talk about, more to discuss, without immediately tearing into each other.

My sister Julia, in the meantime, had gradually turned into a rather rebellious adolescent. She allowed me and my brother to be more and more involved in her activities, which included the creation of our very own secret society: the "JAC Club" (i.e. Julia, Adrian and Christopher), complete with meetings where we discussed grievances (mostly against our parents), planned activities and much more besides, which obviously cannot be revealed because they were *secrets*. Happily, Julia's teenage years certainly brought the three of us closer together.

Very soon, though, it would be my sister who would play a crucial part in her brother's transition from secret composer to band member and occasional performer.

2

Becoming a teenager inevitably plunges you into impressionable adolescence. Music was already central to my life, but I was not well versed in contemporary music culture. If you were sociable, or one of the "cool kids", then music and the knowledge of current trends would be an automatic part of daily life . . . and night life! But needless to say, "cool" or "sociable" was not me. I did have a gateway to pop music close by, though. Julia was a passionate "teeny bopper" and was keen on sharing her taste in music with me. Her enthusiasm was contagious. I was around fourteen years old when she sat me down to play me the song "Terry" by singer-songwriter, Twinkle. The Beatles had only recently taken the charts by storm and shattered preconceived notions of what pop music should sound like. Twinkle was riding a wave of new music that was shaping a generation, and this particular song made a big impression on me. I loved the melody, the dramatic theme (boy breaks up with girl, speeds off on his motorbike only to crash and be killed), and I was very excited by the inclusion of the sound of an accelerating bike. In hindsight, even at this early stage, I was being encouraged to think more broadly about sound, about the fusion of musical instruments with natural or live soundscapes.

In her inclusion of me in her musical discoveries, Julia was opening my eyes and ears to a world of seemingly endless possibilities. I had already sensed that the largely classical framework for my musical education and learning to play the piano, necessary as it was, had its limitations. What my sister introduced me to represented a whole new world to explore. I started listening not only to pop music but progressive rock, blues, soul and contemporary jazz as well. My parents were generously open to it despite their own musical tastes. Their openness and tolerance led to my early teenage years being much more defined by discovery than they would have been otherwise.

My piano lessons had reached a point where it had become clear that I was at a crossroads. I loved playing and was frequently encouraged by my teachers to believe that I had the talent to keep growing in skill and style. However, improvising and composing my own music was by far what gave

me the most pleasure. To add to my piano teacher's frustration, I was not eager to invest the necessary time and effort in practising "by the book". He tried to instil in me the kind of disciplined approach to developing my playing skills that just might lead to a future as a professional pianist. This was clearly something my parents had considered, albeit briefly. The fact that this possibility was not entertained for long, I did not consider a big loss—actually quite the opposite. I was increasingly inspired and overwhelmed by completely new music, sounds and styles that came my way and which immediately triggered my desire to learn, master, and then assimilate them into my own approach to composition. When I heard music that truly moved me, my excitement and interest in what I was listening to was leading me way beyond the desire to simply play the notes of a piano skilfully. I was far more interested in developing a musical understanding of what I was hearing, and then somehow capturing and owning what I had been so inspired by. In time, all of these influences would be identifiable in my own compositions. Music was truly a gift that kept on giving. It also helped me form significant friendships within which I could share the things that gave life meaning.

One such friend was Chris Kirkness, a fellow pupil at St Edmund's secondary school, which I was now attending as a day student, much to my relief. Chris was an immensely gifted drummer. When we discovered we had broadly the same taste in music we quickly formed a bond that led to us exploring a musical collaboration. Chris loved my style of piano playing—by now clearly defined by classical, progressive rock and modern jazz influences—and was thrilled when my parents agreed that he could leave his drum kit, fully set up, in the front room of our house. We had the kind of space and room separation that he did not have at his house and, unsurprisingly, we had parents more willing to tolerate the level of noise! Just playing and improvising together, we began to discover that wonderful place where our individual interests, musical preferences and natural styles of performance came together, sometimes around a shared, favourite piece of music. One of these emerged from a television show called *Not Only . . . But Also*. This programme featured jazz pianist and comedian Dudley Moore in partnership with the extraordinarily gifted writer and comedian Peter Cooke. The show always began with the *Not Only . . .* theme music and ended with another piece, both played

by the Dudley Moore Trio. Somehow, this music, this combination of instruments, at this time, completely captivated Chris and me. Hour upon hour we practised together, determined to master, in particular, the *Not Only . . .* theme tune. I have no doubt that, during this formative time, my young musical mind and heart were being profoundly challenged and expanded, allowing a completely new way of thinking about my own approach to the piano as not just a tool for composition, "But Also" . . . for performance.

Dudley Moore's playing brought with it a sense of joy and freedom that I wanted to pursue, and as Chris and I kept on playing and practising together, something extraordinary happened. Our playing had not gone unnoticed by our peers at school. Even more importantly, it was appreciated to the point of us starting to perform in front of the other boys. In a natural way, music had now begun to bestow on me with one of its biggest gifts. It brought me out of isolation and right in front of the other pupils, feeling like I was relating to them through it. Better still, I did not need words to be appreciated! Outside of playing music, I was still living intensely and anxiously. Sitting at a piano, I was growing in confidence and allowing myself to enjoy it so much more. It was not long before Chris and I were part of my very first band. The group was given a rather presumptuous name, of course. We called ourselves Creation One. Although short-lived, it was an outlet for me that I treasured.

At the age of thirteen, and being a member of the Church of England, my official confirmation of ongoing and independent commitment to this expression of church and faith was fast approaching. For me, it was indeed a confirmation in a very real sense of the word, in that it was an acknowledgement of the basic and long-held elements of faith that had been instilled in me from such an early age. The Christian faith was now completely embedded in my life, and I considered the step of Confirmation to be a natural one—sufficiently removed in my mind from an institutionalized view of faith that it surpassed any doubts I might have had about the process. To be "taught" in faith sounds like a contradiction, and for many people that is exactly what leads them to doubt and break away from it at a later stage. But I was a young, impressionable teenager with a solid family background who was conscious enough of the process and meaning to consider myself a believer at this point. For as long as

I could remember, faith had been a natural part of my life. Confirming this was, to my mind, the right thing to do. Which of course meant that I committed to it wholeheartedly and intensely.

My confirmation ceremony was performed by the Archbishop of Canterbury. My memories of the day are hazy, but I am certain my parents were proud and supportive. I acknowledged my faith in the unique environment of Canterbury Cathedral, fully intent on moving forward in life as a believer who would not compromise his beliefs and convictions. It informed how I was beginning to perceive the world around me—and more importantly the people in it.

As far as my own music was concerned, it seemed only natural to write about what was such a defining part of my perspective on life. I learned to play hit songs of the day, but I was also writing my first lyrics, driven by a desire to crystallize in words things that were important to me. There was no particular agenda behind this train of thought. I did not set out to write what others would consider "gospel" lyrics. To me, it was as honest an expression as I could muster, and I even felt an obligation—that familiar intensity—to communicate a message for the greater good. Being a young teenager, and quite naive in certain areas, not least in the subject matter of my lyrics, they would occasionally border on the presumptuous and sometimes even cross that line. I had learned to play guitar by now as well, allowing me even more freedom of expression in my song writing. Music and life were beginning to intertwine more and more. As a birthday present for my mother I composed a solo piano piece. I could tell it moved her beyond the measure of a mother appreciating her child's affection. Previously trapped in my shell, the experience of giving her a gift that was born out of my innate talents was as meaningful to me as it was to her. Music was starting to empower me greatly.

Julia had continued to share her enthusiasm for music with me throughout these years, frequently introducing me to new songs and sounds, artists and albums. My sister had a good basic knowledge of the guitar and sang and played beautifully, as did her best friend Beth Colebrook. Julia and Beth had a similar musical collaboration to that of Chris Kirkness and me. Beth was a gifted poet and lyricist and also played guitar. As a partnership, at least to me, they were already complete as an identifiable, recognizable music group. But as I was playing, writing

and discovering more and more new music, Julia started to include me more generally in making music together at home. It came with more of a sense of pride than surprise when she suggested that I join her and Beth to form a new group. It was an idea that made a lot of sense to me. I valued Beth's skills and by now I already knew that my sister and I could bring something special on stage. We named our new group Theophili, derived from the Greek word for "lovers of God". Again, as far as I was concerned, there was no particular agenda behind our choice of name. We were not branding ourselves in order to be perceived as an exclusively Christian trio. We were authentically expressing our lives in our writing, our music and our performances: three guitars and voices, with largely original lyrics from Julia and Beth and a few songs familiar to the crowd thrown in for good measure.

Theophili was a safe way of expressing myself musically. I had the encouragement and support of two girls who were older than me and who were also accepting and inclusive outside of music-making. Perhaps I could not have functioned as well with real outsiders in any other group. Anyway, here was an experience that filled me with gratitude. I was in a supporting role in Theophili at first, but as we continued to perform, my contribution grew as well. We started to incorporate my piano-playing into our performances, which obviously thrilled me. I was increasingly experiencing the stage as a place where I could feel appreciated, valued . . . even loved. It was a kind of recognition I had not discovered anywhere else. Even the personal barriers I had put up, making me gravitate towards the background, were overcome in time, playing with Julia and Beth. Gradually, some of my own songs started to find their way into our repertoire, and I reached another milestone: my first songwriting collaboration with Beth. The process of not only trusting another person to work with your own, very personal input, but also allowing yourself to be influenced by their own ideas, perspectives and interpretations, was much more stimulating than I would ever have thought possible beforehand. In the space of just two years I had gone from effectively being the musical "support" for my sister and her best friend, to having an increasingly leading role, playing piano and singing on stage, and eventually even having my own "solo" part of the show. So, as I was moving into my later teenage years, I was already growing into

a solo performer. Theophili eventually folded as we went our separate ways, but to me it had served as a springboard and as a tremendous encouragement. I now had more confidence in my abilities as a composer, songwriter and performer. I was already certain of my next step: enrolling in music college.

At home, my relationship with Christopher had continued to improve since my stay at boarding school. That did not mean, however, that we did not fight anymore. We still had frequent altercations, now undoubtedly also fuelled by the heightened emotions of adolescence. One particular day, we were watching television and yet another argument erupted over whose turn it was to choose which channel to watch. Yet again things escalated and angry words quickly turned into a physical confrontation. This eventually led to a real fight. Punches were thrown and almost before we knew what we were doing, Christopher and I were fully embroiled. And this was absolutely not a simple brawl, in the playful or picky sense, that had momentarily got out of hand but a genuine, hard, physical fight. By now we were both strong enough to really hurt each other, but this time we did not seem to care about that. This fight seemed different somehow. It was as if all previous arguments had reached a tipping point and there was no going back. Right now, in this moment, we were fighting for much more than just the remote control. This fight was about overcoming the other. It was about once and for all making a stand, somehow establishing the hierarchy within our relationship, right here, right now. Our struggle continued for a long time until we were both sitting on the floor across from each other, panting . . . and crying. Neither of us seemed to have the overpowering strength to win outright and, in that moment, we just looked at each other. As we stared into each other's bruised and flushed faces we both knew: what we were doing, the strife we had had since the very beginning, was ultimately pointless. It would only serve to break down what little relationship we had left in the end. There and then, on the floor of our living room, we embraced as we cried. Through our tears we could now see clearly how crazy, damaging and sad our behaviour with each other had been throughout the past years. My brother and I came to an agreement on the spot. We decided to just . . . stop. We would no longer incessantly seek confrontation with each other. This kind of incident should—could—never happen again. We *were* brothers, but we

agreed to start trying to behave *like* brothers: looking out for each other, trying to enjoy each other's company from time to time and maybe . . . even . . . discovering a kind of friendship.

That fight with Christopher felt like the closing of a chapter; it was cathartic in a way, giving me a sense of relief and hope for better times ahead. It was an emotional time for me anyway. I was going to music college in Leeds, which meant that my life would, for the foreseeable future, play itself out two hundred miles north of home.

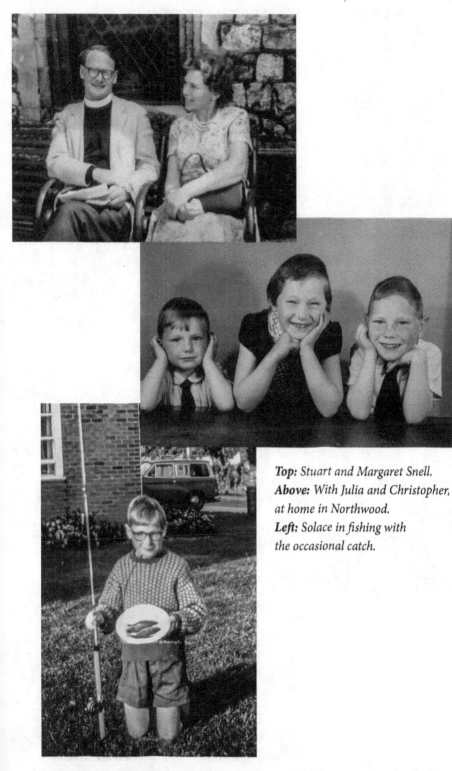

Top: *Stuart and Margaret Snell.*
Above: *With Julia and Christopher, at home in Northwood.*
Left: *Solace in fishing with the occasional catch.*

*Above: Family portrait,
circa 1972.*
Right: Marrying Sue.
*Below: Jamie, Ryan and Carla
watching dad at work.*

PART 2

Refuge

I would like to think my current work environment is somewhat unique. Here at Three Ways School in Bath I work as a music therapist and arts therapy consultant with children and young people aged four to nineteen with a wide range of learning difficulties, physical disabilities and additional needs. I have my own practice room, and it is here that I spend a good part of the week working closely with people, many of whom might be described as "lost to themselves". It is a room designed to inspire, intrigue and excite in equal measure. On entering what many visitors describe as an Aladdin's Cave, I am hoping to send a message: "explore, play, interact, discover. No rules, right or wrong ways to engage with an instrument, other than to not damage or cause harm to anything or anyone". Wherever you look there are instruments: some common, many outlandish. Stacked up against them are stuffed toys, flower decorations in wild and warm colours, pictures, lights, guitars and trinkets. It is a room unlike any other. And I call it more than merely my room; it is my refuge. It is here, in the wonderful whirlwind of impressions, that I truly find the peace of mind I often long for. This is the place that helps me quiet my thoughts, sift through the noise and discern the voices that whisper truth. The place that invites my muse.

Everybody longs for refuge in some capacity. But there are many meanings to the word, each subtly different from the other. Growing up in a Christian home meant that I would regularly hear—or sing in church—about God as my refuge. This was a refuge of familiarity. I was taught the just and loving character of God from a very young age and accepted this truth with a simple, childlike trust. My faith was slowly forged in the fire of a loving home. To hear of God as my refuge had

a familiar warmth to it. It was a truth I could—and wanted to—easily conform to.

Sometimes we tend to take concepts like these for granted. We sing the hymns, pray the prayers, listen to the words, then move on to other thoughts, glossing over immensely important and meaningful aspects of faith in a loving God. I could read a passage like Psalm 46:1–2: "God is our refuge and strength, an ever-present help in trouble. Therefore, we will not fear . . . ", but I would struggle with fear for most of my young and adult life. I have come to accept the contradictions that inevitably arise between "belief" and "practice". I see the Psalms as declarations, statements of intent, as well as an acknowledgement of truth. To believe and declare that "God is my refuge" does not mean that all my fears and insecurities will suddenly vanish like the conclusion of some mighty magic trick. I pronounce these words as an acceptance of the nature of God. He is an ever-present refuge. A sanctuary in times of need.

In the past, churches were both figuratively and literally places of sanctuary. I am drawn to the concept as it relates to both refuge and refugee. A sanctuary in a church is mostly associated with the holiest of places. But there was, and sometimes still is, a time when churches became literal sanctuaries for refugees, for people who had nowhere else to go in order to be safe. To have the status of being a sanctuary carried with it authority and responsibility. Churches were literally a safe space, reflecting the character of God as he described himself to Moses.

As a child, I could easily feel lost in what sometimes seemed a chaotic world of confusing impressions. I had learned that God was my refuge, but I had yet to really find sanctuary there to understand what it truly meant. I was only just starting out on this path of discovery: a lost child looking for refuge in music, faith, relationships and the comfort of family. But this path would have its twists and turns.

3

As my parents drove me through the outskirts of Leeds, once again I felt a growing sense of unease. We were on our way to Headingley, which would become my home for the time being, while I studied jazz at Leeds Music College. By now, anxiety was an old companion constantly present at the back of my mind, pressing against my every thought with varying levels of intensity. It should not have surprised me that I was feeling it on this particular day as we were 200 miles away from home, driving towards the unknown. I had made the conscious choice to study here, so one would expect me to have a sense of resignation about this move. It was not lost on me, however, that today marked a significant step in my life. Apart from embarking on my higher education—a high point in anyone's journey—today was a day of letting go. As we arrived at my new home and unpacked, the moment that had been lingering on the horizon finally came. My parents said goodbye and drove off. I was alone.

A feeling of utter despair washed over me as my new reality sank in. There was a horrible, turbulent and empty feeling in my stomach that was battling for dominance over my spiralling thoughts. I knew that for the foreseeable future I would not be able to enjoy the comfort of my mother's care and the familiar safety of our Canterbury home. All my doubts, fears, questions and ever-present anxieties were mine alone to face now. It was a daunting prospect. It did not help that, although I was keen on gaining knowledge and musical experience here, I found the surroundings less than inspiring. In all honesty, Leeds College of Music was situated in an area that was a far cry from the architectural beauty of Canterbury. Surrounding the College were endless rows of uninteresting buildings, roads and factories. Housing had a roughness to it, and the industrial nature of the city meant there was constant noise. Years earlier I had enjoyed my escape into fishing immensely, but I knew it would not be easy to find comparable spots here to clear my head and shut the world out. Here, the world was constantly pressing in.

In my mind, surviving this foreign land required a certain commitment from me. It may sound dramatic, but this was indeed a matter of survival for me. On occasions, reminiscent of those early weeks as a school

boarder, I literally cried myself to sleep. I was terribly homesick and desperate to go home, but knew I could not go. The feeling of being lost, of not really belonging, was palpable here. But I was not without an anchor; my faith had been informing my daily life increasingly. I was reading the Bible with a new zeal, trying to discover what was required of me in daily life as a person of faith. It was a sincere exploration of the practicality of Scripture, albeit by a somewhat intense eighteen-year-old. I was longing for a set of instructions and rules to be uncovered that would prove to be the key to any situation, not unlike a scientific formula. I needed that reassurance.

My view of the world was still largely dominated by the same anxieties that had plagued me since childhood. Things had to be right and if they were not, I could not be truly at ease. Watching the news on television, for instance, and being confronted with a report from a distant theatre of war, I would sit helpless, my mind racing. "Surely the Bible says . . . ?" I made sure I knew exactly what the Bible said as this represented to me the promise of a solution to what I saw, a missing piece to the puzzle or satisfactory conclusion to any injustice I encountered. Whenever I saw something that appeared to be a dichotomy between the spiritual and practical, like a news bulletin, I had trouble dealing with it in my mind. Whatever presented itself as a logical biblical response was then foremost in my thoughts. Seeing a report on a refugee crisis had me wondering if I should even travel to that country, pick up those in need and bring them back to the UK. Reading about poverty in a faraway land had me thinking of ways to challenge my church to send aid. The world had to be complete, whole and at peace. Christianity to me was the key to achieving this, and so I was as serious about it as anything I set my mind to. Faith was indelibly practical to me, and nothing was too inconsequential for that. Shortly before my move to Leeds I could be found wandering around Canterbury in an apparently leisurely fashion, taking in my surroundings and the people in particular. If you were to get close enough, you might just about see my lips move, often uttering inaudible prayers. I was praying for healing. If I saw someone on the street who was in distress, I would pray for solution and peace; if I knew of someone with an illness, I might stand in front of their house and pray for healing. To me, the teachings of Jesus on this subject were as clear as

he could ever have made them. If I called myself a Christian, surely this was the logical means of expression? In a sense, I was still keeping my distance, praying for healing from a healthy few yards away instead of really engaging with a person. But although I was sincere in my desire for people to be healed, with hindsight I understand that this practice was also about satisfying my own need for inner peace.

My new surroundings in Leeds drove me to take this a step further. I was anxious to establish myself more clearly in this new world, to have an easily recognizable identity that was both comforting to me and informing to outsiders. Ironically, in embracing this I let myself be led by a feeling of insecurity rather than the quiet confidence I longed to possess. As I settled in Leeds, I transformed into an overtly evangelical Christian. I lacked the self-assurance that would enable me to engage with people without my faith being immediately apparent to them. To me, it had to be clear from the outset, so I took it upon myself to find clothing and apparel that, to my mind, helped me achieve that. I covered my briefcase with "Jesus Loves You" stickers; my T-shirts would often convey a bold statement of faith or a not-too-subtle image relating to the Bible; I made sure to wear a big cross around my neck wherever I went and, since we were now living in the early 1970s, my hair had grown to beyond shoulder length, prompting me to wear a headband that had the peace symbol on it. The coloured waistcoats I wore were also a sign of the times. It must have been quite a sight for someone meeting me for the first time. This would, first and foremost, be my stated identity as I was getting to know other students and trying to get by. I felt unable to leave it to chance whether or not people knew I was a Christian and so I would let my appearance do part of the talking. While I was deeply serious about all of this, as I was with everything else, there was a comedic aspect to my attire. There was a distinct possibility that people would assume I was a hippy on a mission from California, until I started to speak and reveal a measured, middle-class (some might say "posh") British accent!

Meanwhile, my voice was gaining a more prominent role in my music. I had come to Leeds wanting to develop my skills in order to become a professional performer and recording artist. Compositional technique intrigued me, but voice tuition at Leeds College of Music was either too classical or operatic for my taste. I wanted to know how to use my voice

as a versatile, modern instrument. I wanted to know what it took to sing at the best level when faced with regular performances. In short, I wanted to know what it took to be a singing artist. A voice teacher took it upon himself to offer me some advice and, more and more, I started to consider singing to be a craft that was complementary to my piano playing. My ways of expressing myself in music were expanding as was my very own catalogue of songs. In that regard, Leeds College of Music, challenging as it was to my sense of security, was not without its surprising gifts. There were no fewer than eight Bösendorfer grand pianos located in the practice rooms. These were top quality pianos, played by the best pianists in the world. Their sleek, black design had a stately quality to it. The ivory white keys were meticulously lined up, hinting at a master's craftsmanship. These pianos were a sight to behold in themselves, but actually playing them was nothing short of pure bliss. I made sure to spend much of my spare time in the presence of one of these instruments, and occasionally a new song would emerge. Playing and writing music was as it had always been—a means of expressing what was in, or on, my heart.

Three or four years earlier, when I was fifteen, I had written a song that I considered one of my best and most personal compositions. It was called "Gethsemane". I had been reading one of the gospel accounts of Jesus' turmoil in the garden of Gethsemane. While I knew this story from early childhood, as often happens when inspecting something more closely in later years, the scene that was described so directly, so honestly, spoke to me in a very different way. It was as if I were there in the garden myself. I wanted to experience just something, however little, of the feelings of utter aloneness and emotional conflict that must have overwhelmed Jesus as he anticipated the events of the next few hours and days. I do not know the extent to which it was the awful anxiety around that anticipation, the sense of abandonment, that drew me to this particular moment in Jesus' life. But what I do know is that I found myself at the piano, playing a melody that for me conveyed something of the Messiah's emotions as if they were my own. The intro had a structure similar to Beethoven's "Moonlight Sonata", a gentle sequence of notes to which I added musical cues designed to convey something of the intense, quiet agony Jesus was living through at this moment . . . I tried to find the simple, direct words

that might convey in a song lyric the essence of Jesus' Gethsemane prayer. This song turned out to be deeply personal to me. The lyric, as I read it now, is so simple. "Gethsemane" was perhaps the first of my songs that would stand the test of time. It eventually led to the composition and recording of what has become a seminal work for me as an artist, singer and composer: *The Passion*.

The facilities at music college gave me constant opportunities to improvise, practise or compose. I would also play at home, in Headingley, often deep into the night, having discovered a chord progression, a melody or rhythmic pattern that seemed to be leading me somewhere new. It was as if a song would actually write itself during those night hours if I was just willing to stick with it and not abandon it to be completed later. When the first sunlight poured through my window and I put the finishing touches to a new piece, the sense of elation was truly overwhelming.

While the majority of my fellow students at music college were following the courses in jazz and light music, I increasingly realized that this was not at all the direction in which I wanted to travel. I was already listening to a wide variety of singer-songwriters and progressive rock bands. One particular musician from this world stood out for me, eventually greatly influencing my thinking about the piano, and keyboards in general, as a means of fusing the world of classical and jazz with contemporary rock—Keith Emerson of The Nice, and later Emerson, Lake & Palmer. His playing stirred something within me. The way he used his obvious skills as a pianist with a classical background to create a truly new, dynamic sound that would fit comfortably within the world of progressive rock was inspiring to me.

Then, in total contrast, there was Judee Sill, a softly spoken American singer-songwriter whose self-titled record was a revelation to me. I was deeply moved and inspired by the intimate and yet broad stylings of her folk songs like "Jesus Was a Cross Maker" and "The Kiss". Again, the classical influences in her writing were clear: chord sequences and melodies that immediately resonated with me were somehow *so* familiar. And, of course, the beautiful, natural way in which Judee incorporated her spiritual journey in her songs gave me hope.

I loved the music of artists like Joni Mitchell, Paul Simon, Carole King and James Taylor, but this was the first time I had come across a

singer-songwriter overtly exploring Christian themes, but not defined by, and subsequently confined to, the world of "Christian music". I began to believe that perhaps I too could find a way to make music that was the most honest expression of who I was as a person.

Being at music college meant that I was interacting with fellow musicians on a daily basis. These were peers who both shared their passion and also their observations of my developing craft. I was still often considered "the odd one out" here because of my difficulties coping with the demands and unpredictability around social norms and expectations. But I was also setting myself apart because of my desire to be free from the limitations or conformity which this course in the study and playing of jazz might impose on me.

So, what did I want, and where would I find it? Well, for sure, I wanted the musical challenges and energy of progressive rock that had so powerfully spoken to me. I also wanted the emotional range and depth that classical music provided. And yet, equally important, was the spontaneity, the immediacy and unpredictability around the world of jazz.

As I see it now, my style of playing, and my approach to composition, began to solidify at this time. There are so many influences, so many voices in a process like this. One particular observation I remember clearly was that of one of my tutors: "I watch you play the piano, but most of the work is done by your right hand," he said. "Your left hand is capable of so much more." A typical pop song written on a keyboard will have a relatively simple structure. The melody is supported by a chord progression with the right hand doing most of the work and with the left hand effectively playing the bass part. I had little interest in the typical, preferring to develop a sound and style of my own. Yet I had allowed my left hand to stay "lazy", often failing to use my musical imagination, coupled with the piano skills I now possessed having had years of classical tuition. So, I took my tutor's challenge seriously. I worked hard to develop parts for the left hand, with the aim of giving equal significance to both, thereby greatly increasing the range of notes and patterns played on the keyboard. This advice was to prove immensely important in my development as a composer, particularly when writing a work like *The Passion*, where piano was the central instrument. During the early years

of piano tuition I had been under considerable pressure from my father to put in the practice hours. It had often strained our relationship when I either tried to cut short the forty minutes required of me, or easily wandered from the much-hated practice of scales and arpeggios into the world of improvisation which gave me so much more pleasure! But for my parents it was about providing a proper push to help me realize my full potential. Now I understood and became eager to develop my playing technique but alongside enjoying the freedom to improvise and compose.

The song "Gethsemane" had opened up a song-writing vein. I was revisiting the Gospels, trying to grasp the ancient mystery of Jesus' full humanity in the light of his divinity. His suffering, and its culmination with the crucifixion at Golgotha, was so much more to me than a moment of historical significance or a basic tenet of Christian faith. In attempting to explore the very human life Jesus lived, surrounded by ordinary men, women and children caught up in extraordinary events, I chose to incorporate other characters in the story I wanted to tell. One example evolved into the song "Simon, Carry My Cross". I had written a gently flowing chord progression on the piano that carried a deep sense of aching, yearning and exhaustion. These emotions seemed just right for the moment shortly after Jesus had been sentenced to death and was collapsing under the weight of the cross he had been forced to carry through the streets of Jerusalem. I wrote the song as a monologue by Jesus, spoken to this man Simon, from Cyrene, whom the Roman soldiers had grabbed from the crowd and directed to share the burden. This approach allowed me to explore the bigger picture of the gospel whilst musically focusing on the inevitable tragedy of the cross. "Simon, Carry My Cross" was a song that spoke deeply to who I was as a musician but also as a person of faith. I had now written several songs inspired by the final days in Jesus' life, songs that were now at the forefront of my musical journey of experimentation and discovery; songs that were enabling me to find my own, unique voice. And these songs would soon be accompanied by others.

Increasingly, invitations to perform concerts started to expand through word of mouth. While participating in an event in the south-west of England I found myself with some spare time on my hands. There were no pianos available where I was staying, but there was a tiny chapel

in the grounds that housed a little harmonium. It was certainly not the obvious choice for a private composing session, but I wanted to make the most of my free time, so I locked the door of the chapel behind me and made my way to the instrument. I started to play and was intrigued by the dramatic, breathy sound caused by the instrument's bellows, driven by two pedals under my feet. The overall sound seemed to suggest an energetic, agitated melody. I started to play two rapid sequences that made use of the advice my tutor had given me: allow both my hands to contribute equally to the arrangement. The piece grew in intensity, and at the moment I knew I had unlocked the key to this song, it happened! My eyes were diverted to a bright light shining from a baptismal font at the back of the chapel, a golden cross perched on top. The sun was shining through a stained-glass window, and its golden beams rained down on the cross. As I looked, the subtle dance of light and shadow as the sun was moving transformed the cross. For a moment, without the shadow of a doubt in my mind, the beams of light on the crucifix formed the image of a skull. My mind registered it while I was still playing, and what I saw presented itself in words to me as if to gently poke me, pointing towards the obvious:

"Cross . . . skull . . . "

"This is Golgotha", I thought to myself as music and image blended into one. I kept an eye on the skull image as I played on and, within minutes, the sun had shifted enough for its light to transform it again. This time, the cross was beaming. It was a source of awe-inspiring light, its form shining outwards. If the skull had indicated Golgotha to me, this was a radiant reminder that death there was not the end of the story. Resurrection, new life, was coming. I finished the piece in about twenty minutes. The experience had moved me deeply. Music and imagery had come together in such a way that I felt this song was given to me as a whole; there were no changes needed. This was indeed "Golgotha".

As pleased as I was with writing the songs I was writing, I was also confronted with what I still considered to be my Achilles' heel: I was primarily a musician. What I wanted to communicate was ultimately contained within the music, so writing lyrics was a struggle. I was still a teenager and whilst to some these lyrics might seem sufficient on a superficial level, to me they did not reach the level of quality I was striving

for in my music. I did not just want my songs to be appreciated and heard because of a single quality. I wanted it all to be as good as it could be. I realized that I was unlikely to improve as a lyricist in a short space of time. For this to happen, I needed help.

<div align="center">4</div>

It was now 1974. I had settled in Leeds and it was increasingly clear that this was to be my home for the foreseeable future. Invitations to perform were increasing as concert organizers and audience members spoke to others enthusiastically about a new artist with a very original sound. At this time most of the invitations came from churches and, as long as the venue had a decent piano, I did not really mind where I was performing as long as I was playing my music to a genuinely interested audience. Any artist will acknowledge that performing to a live, enthusiastic audience is unlike any other experience. And while I had my sights set on the open-ended path of a performing artist, the surroundings of a church at least felt familiar.

I was a member of a church in Leeds and had quickly discovered that, while living on my own, the affirming and comforting qualities of a like-minded community served as a safe harbour. I made new friends and listened to new teachers who offered insights that helped me mature in my faith. No doubt some of them served as ambassadors for my music amongst their friends. In any case, hardly a week went by now without a concert invitation.

Over the course of these performances I was developing my own set-list based on what I perceived to be my strongest songs as well as material chosen for the occasion. There was now a series of songs that had become the centrepiece of my concert performance. I had added two songs to the sequence of "Gethsemane", "Simon, Carry My Cross" and "Golgotha". These were "Judas' Song" and "Jesus Alive!", both with lyrics written by Beth Colebrook. While the latter was a fitting way to close out my set following "Golgotha"—an exuberant piece giving voice to the realization of Christ's resurrection—"Judas' Song" was an almost

psychedelic piece, highlighting the progressive rock influences around my piano playing. The words portrayed the immense struggle with the consequences and nature of betrayal by the perpetrator, Judas. As it happens, the music had emerged from a different story. It was a musical outpouring during one of my bouts of anxiety, expressing both frustration and helplessness with the world and whatever I was dealing with at the time. In a very real sense, the song was therapeutic to me. Now Beth's lyric had wonderfully incorporated those emotions into a different story. I called this sequence of five songs *The Passion*. After all, it was in effect a telling of Jesus' final hours, crucifixion and resurrection both through the eyes of a narrator and of the characters directly involved. But the nature of songs like "Judas' Song" and "Jesus Alive!" also made the story intimately relatable to the human condition. Playing it live was always a powerful and moving experience for me as this was music that spoke volumes about both my personal struggles and the comforts of my faith. Whenever I played it for an audience I could tell people related to it in their own way. It was immensely rewarding to witness the effect my music had on people, but I could still be caught off guard when someone had been truly overwhelmed by the experience.

One such instance turned out to be key for the future of my musical journey. I had been invited to play at a local church, leading into a feature for BBC Radio Leeds. After the concert I was enthusiastically approached by a young man. His ginger hair and beard already hinted at a Celtic background. The man introduced himself as Blair Thomson, and it turned out that he was a radio and television producer for the BBC. Meeting anyone who was "plugged into" the world of media and showed enthusiasm for my work was exciting enough for me, but Blair stood out. His excitement was almost contagious as he explained to me how he had enjoyed what he had heard and instantly knew he wanted to be involved in some way. While I had had other people willing to do what they could to further my musical career, I had never had an actual manager taking care of me. The prospect was enticing. I was never comfortable with presenting my work as part of a pitch for a particular concert or project. To have someone alongside me who was eager to help me out with the marketing and business aspects of the profession was an offer I gladly accepted. Blair's connection to Radio Leeds and its facilities meant I now

had the means to work on some of the new material I had been writing. He suggested on the spot that we lose no time in recording some demos. In discussing this with him I admitted to Blair that I struggled with writing my own lyrics. He had now heard my songs, including the ones I had co-written with Beth, and seemed to understand my specific need.

"You should meet my brother Phil," he said. "He's a poet and a lyricist, and I have a strong feeling that your music and his words could be a wonderful match!"

Normally, I would be resistant to the prospect of a total stranger becoming involved in something so personal to me as my music, but Blair's level of enthusiasm was breaking down my barriers. He cared about my music and its future, so I agreed to meet his brother in the coming days. In the meantime, we set out some parameters for our future working relationship and made arrangements to record some of my songs in rough form, testing the waters so to speak, and began to focus on material that might be suitable for an actual album recording should the opportunity arise.

I met Phil Thomson a couple of days later as he travelled to Leeds. As we sat together, I immediately took to his softly-spoken manner and obvious depth, genuine interest and wonderful sense of humour. With his receding hairline and thick moustache, Phil had a learned quality about him that was interspersed with a contrasting dry wit. We had a lot in common when it came to our approach to life and faith. As we talked it was clear that this was not just a practical meeting; it was a meeting of souls. We shared so much so easily that it felt entirely natural to open up to each other about anything and everything. Unsurprisingly, that included matters concerning girls, romance and our shared struggles around expressing our feelings, but we also shared about our experiences and understanding of faith. As a young Scotsman in his early twenties, Phil had begun to reorient himself to his faith, coming from a strictly religious upbringing. I understood this process well as I was on my own journey now, influenced by new surroundings, other people of faith and the insecurities of life and love.

Talking about such weighty matters was one thing, but seeing them expressed through the written word was quite something else. The poems Phil had brought to the meeting were absolutely beautiful. I

had never read words that so eloquently and succinctly expressed both emotions and their roots at the same time. What I read took my mind on a journey. I knew I had come across someone and something truly special. I tentatively started to tell a little about myself, how I saw myself as primarily a musician, and explained my struggle with writing lyrics. Phil was keen to step in: "Let's just try something," he said. I played a few musical pieces that I knew were in need of a strong lyric. Phil listened and started scribbling away, a little while later presenting me with the result: our first collaboration. Musically, it had a yearning quality to it. The words Phil gave it turned out to be an exquisite fit. It was as if his writing had simply uncovered what was actually there in the music all along. This was the voice I had been searching for. We finished our first piece, "Longing to be Free", and joyfully agreed to write together on a regular basis.

The friendship and creative partnership with Phil had come at just the right time for me. Because I was now performing regularly, I was also receiving lots of questions relating to the availability of my music for purchase. I knew I basically had half an album already in my *Passion* song cycle, but now I was actively working towards producing enough additional material to complete a full album. My own developing musical style was increasingly crystallizing into a mixture of singer-songwriter material, classical, progressive rock and pop influences, with hints of contemporary jazz in the mix! Under Blair's guidance, I locked myself away in a recording booth at Radio Leeds and began to put a selection of songs on tape. It would help Blair to give other people he met at least some impression of my music and allow it to gain wider interest. With just my voice and piano these were very simple recordings, but they served their purpose. Blair made sure he mailed a copy to my parents' home address in Canterbury for me to listen to when I returned in a few days for a short visit.

At music college, I was becoming increasingly sure that the jazz-focused course I was following was not the right one for me. The more I experimented with my own music, the more I felt drawn to other genres, particularly classical and rock music. The relationships I developed with fellow students only reinforced that idea. I had literally and figuratively struck a chord with one younger student in particular, a gifted keyboard and guitar player hailing from Darlington. His name was

Dave Bainbridge. As a second-year student, I was helping this fresher find his feet, as it were, seeing as I knew all too well how new surroundings brought with them their own challenges. As we talked and played in one of the practice rooms it became clear that we shared many tastes in music. We both seemed determined to extend our own boundaries, reaching out towards the limits of a genre's rules. These were the kind of relationships I enjoyed the most. They helped me in the process of becoming what I was hoping to be: an artist with a better understanding of his craft and purpose. I could not say I had it all figured out yet (far from it), but the various swerving roads were at least beginning to converge, pointing in a particular direction that involved me living as a recording and touring artist.

I occasionally travelled back home to my parents in Canterbury during the holidays or for specific weekends. While the initial, devastating feeling of being homesick had subsided somewhat due to my new relationships in Leeds and my immersion in my own music, it was always a relief to come home. But when I came through the door and greeted my parents a few days after my piano and voice recordings with Blair, there seemed to be a slight hesitation between us. We exchanged our usual updates on our lives and the family, but then this unease became more obvious. At several points in the conversation they cautiously inquired as to whether I was expecting something to be waiting here for me on my return home. I was not quite sure what they meant, but their unease was clearly growing by the minute. Eventually, it came out.

"We're so very sorry, Adrian," proclaimed my mother, "We didn't realize it wasn't meant for us."

It turned out my parents had received the package with the demo tape Blair had recorded at Radio Leeds. Thinking I had sent it home for them, they had opened it up to find a cassette tape inside. Unsuspectingly, they had put it in the stereo to listen to. I immediately grasped the situation: my parents were clearly very concerned that I might perceive this as an invasion of my privacy given my history of protective resistance to playing them anything I was not ready to share. As I sought to put their minds at rest my father interrupted me to explain further. They had indeed *really* listened to the tape. What they had heard were songs that had gone through a long process. I had lived this process largely

on my own while my parents still looked at my musical endeavours in a traditional sense. To them, I was simply studying at music college to become a more rounded musician, with some considerable uncertainty as to where it might all lead. They had not realized, they now confessed, that this type of artistry and personal expression could result. I could tell they were deeply moved by what they had heard. I had occasionally "allowed" them to hear a few of my own melodies and compositions before, but listening to this tape was the first time they had consciously heard a reasonably accomplished, emotionally powerful, honest self-expression of their son as an artist. What I wanted to say with music had clearly not missed the mark in this instance. My parents proceeded to tell me at length how impressed they were by the music itself, the manner in which I expressed myself and the way I communicated my faith and view of life in these songs. As they talked about it, I knew they unequivocally understood. I had come home to receive the gift of my parents' true grasp of my musical dream.

That day marked a turnaround. Before, my parents were supportive, whilst still holding some reservations about my future. Hardly surprising given that a career in music could hardly be considered as the path towards a steady means of income, no matter how good a musician I might be. But now that they had heard some of the results of my creativity, they embraced it. From that moment on, my father in particular became one of my biggest supporters, spurring me on to pursue a career as an artist. It put the wind behind my sails. Now all I needed were the right opportunities.

An opportunity of a different sort presented itself back in Leeds when a Northern Irish friend I knew from church invited me to become a housemate. He had been renting a house that his father ended up buying for him and, faced with the prospect of so much space, it had made sense to him to offer me an upgrade on my humble room in a local manse. I gladly accepted and would now be able to spend my final year at college in a more domestic setting. Obviously, I loved the opportunity to play the piano in this new environment, even if it meant I now had a housemate to consider. Being in this house made it a little easier to meet new people as well. One of them was Susan, who was my housemate's girlfriend at the time. She was a frequent visitor and I had also seen her in church. The

first time we met I was playing the piano at the house. She came over, introduced herself and expressed an interest in my playing. I found her very attractive. Susan, "Sue" for short, had a "more than meets the eye" quality to her that made me sit up and take notice. When her relationship with my housemate ended, we continued spending time with each other. I invited her to one of my concerts at Leeds University, a move that, in hindsight, was a not-so-subtle way to impress her with my credentials. But Sue was not the kind of person easily swayed by outward impressions or skills, and perhaps this added to the mystery I found so attractive in her. I pursued her over the course of many months in the hope of securing a romantic relationship. When this finally came to be, I was over the moon. Entering my twenties was shaping up to be more than a typical rite of passage. I had the promise and security of my parents' understanding and support and, most of all, the embrace of a romantic relationship. I had much to be grateful for, wherever I went from here.

5

There was an unmistakably enthusiastic vibe coming from the crowd as I played through my signature *Passion* songs. By now, I had performed in front of an audience often enough to be used to a sudden change of atmosphere in a room, but this time I was genuinely surprised and also maybe even slightly relieved. The crowd at the concert venue seemed to be genuinely interested and enjoying what they were listening to. Now it was my turn to play in a competition that I felt could be the key to my budding musical career. Today I was part of a *Melody Maker* regional folk/rock contest. This was no ordinary talent show with the usual stark contrasts in quality between participants. *Melody Maker* was a reputable music magazine, even though on the outside it looked rather like a tabloid newspaper. Its columns were interspersed with large, striking photographs. From a distance it might be mistaken for quite a dull publication, but actually the magazine was widely known for its sharp and informed writing. Being acknowledged by *Melody Maker* meant being exposed to a much greater audience. It could make or break you as an

artist and, since I was only just starting out, surely it would *make* me? At least, that was most likely my line of thought when I found out about the contest. Under normal circumstances I would not have dared enter it. I had grown very protective of my music and was keen to be very specific in choosing the time and manner in which it was exposed to people. There was a fear on my part that my music could be misunderstood or not appreciated. At the same time, I knew that by being so protective I was limiting my chances of really launching my career. Indeed, launching it was very much on my mind. I felt I was ready to fly. When I found out about the *Melody Maker* contest, I took a deep breath and signed up. My desire to properly showcase my music to a greater audience prevailed over my fearful protectiveness. In a very real sense, I had taken a leap of faith by entering.

My songs, my *Passion* set, were developed to a point where I felt confident that I could offer something new and exciting to a mainstream crowd. But I was also driven by a now-familiar desire for my music to be received and perceived the way I intended. In this respect, playing regional concerts in churches could feel safe, highlighting the spiritual side of what my music was communicating. Here at Leeds Polytechnic it was an entirely different story. Venues like this in the city were hosting acts like The Who, Genesis and Deep Purple. When the room was empty, it had a robust, simplistic look to it, but filled with a willing crowd it could easily become a fog of noise mixed with the odour of beer and other stimulants. Being part of this competition meant the crowd had not come specially to see me. I had some of my supporters spread around the room, but this time it very much felt like I was on my own.

Each contestant was given twenty minutes to play, with a jury providing commentary in between. There was an upright piano on stage and I naturally decided to play my *Passion* song sequence. The time limit forced me to skip one song, so I ended up playing "Gethsemane", "Judas' Song", "Simon, Carry My Cross" and "Golgotha". The audience was clearly taken aback. Perhaps they had not expected this strange, hippy-like individual playing and singing alone at an upright piano to sound like this? I would like to think they were impressed, as were the judges. By the time the night was over, while I knew I had not won the competition, I remember being commended by the judges for my "unusual blend of

classical, rock and jazz". I was left with that uplifting feeling that comes from being noticed and validated by people who were listening to me without any preconceptions. I was proud to have overcome my fear and to have stepped out into the spotlight just this once.

As I was waiting around while the event was winding down, two guys approached me. One of them was British, the other American. It was the latter who took the lead:

"We'd like to talk to you. We really like what you did out there."

I was happy to receive the compliment, but I became more intrigued when the two revealed they were part of a significant management company with bands like The Kinks in their stable.

"Are you signed, buddy?" the American asked in a rather familiar tone of voice as if we had been friends for years. I felt my heart leap at the question. Certainly, this was part of what I had set out to achieve by coming here: genuine interest in my music at a business level. I had just not expected things to develop quite so fast. I replied timidly, "No . . . " and could tell that excited them both.

"We're working for Robert Wace," they explained. "Why not come down to London to meet him and see what we might be able to do for you?"

Their offer registered with me as if it were a golden ticket. This was 1974 after all, and signing a record deal or any other contract that allowed you to actually release music was considered a rarity. If I ended up signing a contract with a management company which had a band like The Kinks on their books, I would immediately have access to record labels and publishers otherwise unreachable by artists like me. But my natural desire for acclaim and the advancement of my career was locked in a struggle with fear—my fear of outsiders deciding on and about my music. I accepted the invitation and travelled to London, a little more excited when I found out that Robert Wace was The Kinks' personal manager. Just a few years before, this band had scored a top ten hit with "Lola" and were regarded as one of the UK's prime, and most original, music exports. I was my usual timid self, afraid of the unknown, politely answering his questions about my background and my music. I was wearing my insecurity on my sleeve, giving short answers to his questions out of fear of saying the wrong thing. It felt like being interrogated in the teacher's

office, waiting to hear if I had passed the test that would allow me to move up a class! There was a piano in the corner of the room, and Michael, the American, asked me to play for Robert. "These are really good songs," Robert observed in response to my performance of *The Passion* material. "What else have you written?" I mentioned some of the songs I was working on with Phil Thomson and played a couple of them. But the question was repeated:

"What else do you cover in your songs?"

Slowly it dawned on me that Robert was asking if I had non-religious-material as well. Now my mind was racing . . .

"Why does he want to hear other songs? Is he trying to bypass the element of faith in my material? Does he want to avoid my faith altogether? Make me into something else?"

I was too naive and apprehensive to share my feelings outright. Instead, my answers grew shorter while I tried to make it clear that I considered my identity to be non-negotiable. Robert's questions might well have originated from an innocent, genuine desire to understand more about my broader body of work, but I instinctively took it all as a subtle attempt to explore my artistic boundaries and, in so doing, make me somehow betray myself. This kind of interest in my music was, of course, immensely affirming, but if commercial success had to involve this kind of compromise, well, was I just one step away from a kind of betrayal of everything that was at the heart of me? Our conversation over, we said our goodbyes and over the next few days there were a couple of further exchanges. With the benefit of literally decades of hindsight, I can now see that these conversations were bound to have led to a parting of the ways. I had effectively said "no" to the challenge, the invitation to take a step into the relative unknown. My insecurity was out there in full force, shouting over any voices that might be beckoning towards new and exciting paths. Essentially, I was making it near impossible for a mainstream company to sign me as an artist. If they were seriously interested in me, they would have to adhere to the way I looked at things. I guess I just could not see how much my insecurities were closing doors even before they were fully opened, rather than having the kind of openness that comes from a confidence in your own individuality. The potential management, even the recording deal that we had hoped to explore, simply fizzled out.

Blair, meanwhile, was actively sending out tapes in order to grow further interest in my music. As he saw it, and I agreed, it was important to keep up the momentum, even though the first real show of interest had ultimately led nowhere. We were pleasantly surprised when a tape appeared to have found its way into the hands of a key music industry insider. I received an invitation for another meeting, this time with Chappell Music in central London. Interest from this publishing company was not to be underestimated as Chappell had a history that dated back to the early nineteenth century. Apart from their music publishing activities, which included theatre, they also manufactured pianos. They had developed into one of the largest music publishing companies in the UK and had been home to a variety of prolific songwriters. There was George and Ira Gershwin, for example, whose Broadway musicals were legendary, and Cole Porter, whose songs like "I've Got You Under My Skin" are staples to this day, notably made famous by Frank Sinatra. Chappell had gradually embraced more contemporary writers like Eric Clapton and, just recently, a feisty punk rock band called The Ramones. I knew they had a broad scope and interest and felt that tingle of excitement again as I travelled to London to meet one of Chappell's senior managers.

When I walked into the room it made quite an impression on me. No matter where I looked there was an abundance of expensive wooden furniture, thick leather sofas and impressive wall decorations. The room was situated on the top floor of Chappell's headquarters and exuded that sense of wealth born out of success. The manager welcomed me into what transpired to be his own luxury apartment, meaning he could effectively travel to work in a lift. My mind was fully focused on this meeting as another litmus test, a chance to get my music "out there". The executive talked about the tape we had sent him and named the songs that stood out for him. He immediately indicated that he wanted to submit one of the songs, "I Was a Stranger", as a possible contender for the 1975 Eurovision Song Contest. Exciting as the prospect was, (this was after all one of relatively few songs for which I had written the words as well as the music) it was also a source of some amusement to me. Cliff Richard's original backing band, The Shadows, were also in the running to be playing there and had been chosen to represent the UK. I had a little

chuckle to myself as I recalled the opening line of "I Was a Stranger" and imagined these words being sung at the contest:

Step on into the night where the shadows are grey . . . [2]

My potential new publisher went on to describe how much he liked "Making Me Real", a song I had written with Beth Colebrook. The piece was a tender, melodic, folk-pop song with Beth's beautiful, searching words that explored the doubts, the loneliness but also the extraordinary experience of intimacy that belong to a long, deep journey of faith, ultimately rooted in a real, ongoing relationship with God. "Making Me Real" had become very personal to me, and it was a song bound to open its writers to some vulnerability.

He then placed a cassette into his sound system, pressed PLAY, and together we listened to the song. Halfway through, as I remember it, he pressed PAUSE, said how much he liked the melody, the words— effectively what a great song this was and therefore the commercial potential it might hold. But then came the words:

"I think we are just looking for the simplest of changes to the lyric here. If we're looking for a song that might have global appeal, then pretty much the only thing you would need to do is substitute the word 'girl' for 'Lord'."

I had an almost physical reaction. Of my list of taboos, this surely was at the very top. There was an immediate sense of déjà vu as, for me, this boiled down to compromising not just my art but also my integrity, my faith. Our conversation continued, but in my mind and heart we were now treading on familiar ground. I was digging my heels firmly in the sand, determined not to allow myself to be compromised in any way.

Chappell did start preliminary work on exploring the potential of some of my songs, but during later conversations the same pattern repeated itself. I was immovable—this time on two fronts: I would not, under any circumstances, change my lyrics to achieve greater commercial potential, and I had no interest in becoming a staff writer, meaning I would be paid to write to order for artists under contract to Chappell. I was an artist who considered creative freedom to be one of my greatest virtues. In this instance, it unfortunately also meant that I did not allow myself a future

journey of discovery with Chappell. The more we communicated about the kind of material they were looking for, the more I was convinced this was not a good fit.

Within a short space of time, I had now had two interested parties, which many artists would have considered as golden opportunities. I had retreated into my shell on both occasions, fearful of exploring my art and wary of changes that I felt would undermine my carefully maintained identity. Who knows what might have been had I accepted these offers? For now, I was clinging to my safe space. But I still wanted to record my music.

In October of that same year I was invited to play at Newcastle University. My contribution would be to open up for another act: pop duo Malcolm & Alwyn. I was familiar with their music as they had quickly made a name for themselves with their debut album, *Fool's Wisdom*, the previous year. Malcolm Wild, with his long, red, mullet hairstyle, and Alwyn Wall, with his piercing eyes and dark, thick eyebrows, had previously been in a band called The Zodiacs. When they became Christians, the two decided to blend their voices and start anew with pop-styled Christian music that drew stylistic comparisons with Simon & Garfunkel and The Beatles. I was certainly appreciative of what they were doing and, since we shared a dressing room, it seemed like a good opportunity to comment on each other's work and exchange experiences. Malcolm and Alwyn responded with genuine warmth and interest.

"You should be working towards recording your first album," they said when they discovered I was still unsigned.

I told them about the previous interest and how it had left me wary of these deals. I made sure I worded my concerns in a way that left no doubt as to why: I was afraid to be changed as an artist. Instead, I simply wanted a company that was behind me without having to worry about these things. Malcolm and Alwyn seemed to understand my predicament and proceeded to tell me about Musical Gospel Outreach (MGO), the company they had worked with on their album. MGO was a multi-faceted platform, founded with a clear goal of evangelism, but evolving into a music magazine called *Buzz*, a record label and an artist management and touring division. The benefits of all these branches under one roof

sounded logical to me, but it was what Malcolm and Alwyn added that made me seriously consider it:

"You should stay within the family, Adrian. Can we arrange a meeting between you and the managing director of MGO, Geoff Shearn?"

Obviously, I knew what "staying within the family" meant. There was a familiarity and a sense of safety in Christian artists operating as if they were part of a larger family. It was driven less by a common passion for a certain music genre than it was by a passion for ministry and message. While it was still early days, the genre of Christian music was very much defined by this mindset. I had never really considered myself as a part of the Christian music scene—indeed I had very little knowledge about it—and that sentiment did not really change after this conversation with Malcolm and Alwyn. But as I thought about it all over the next few days, their challenge spoke to my insecurity. I was afraid of the unknown and this direction seemed more familiar and much safer, so the meeting with Geoff Shearn was arranged and resulted in the signing of my first recording contract.

The songs that had been subject to scrutiny already were likely contenders for side A of my first LP. I already envisioned side B as a self-contained performance of the original *Passion* set of songs. Side A would then offer a kind of balance by bringing a slightly more singer-songwriter focus. "I Was a Stranger" and "Making Me Real" were pretty certain choices. I was determined to dedicate the coming months to writing and selecting the very best original material. All I needed was to find an inspiring place with enough peace and quiet to let the songs evolve. The fewer distractions, the better. One location in particular would prove to become a place of such intense inspiration and creativity that each day would result in at least one song that I considered equal to my best work. As it happened, the little one-bedroom cottage situated in woodland on the side of a hill that descends directly to the sea, usually welcomed a rather different clientele . . .

6

The spot I had chosen to write the remainder of my debut album was nothing short of breath-taking. I had arrived at the Christian community of Lee Abbey, a site overlooking the North Devon coast with its sweeping hills and lush woodland that seemed to drape itself over the Bristol Channel. Lee Abbey was a community that had become known for hosting retreats, conferences and holidays. My plan was as ambitious as it was simple: I would write as much as I could in the time I spent here, allowing myself to be inspired by the beauty of these surroundings and the peace and quiet that was prevalent here. I would use this retreat as a catalyst. Normally, I would not expect song-writing to fit in with such a set schedule, but Lee Abbey was a remarkable place. I had been a guest of this community many times before and had come to appreciate its open, inclusive and welcoming nature, the inspiring beauty of the site and the friendship of its staff. Being here meant coming into contact with a kaleidoscope of perspectives on faith, life and the arts. It had a sharpening effect on me that I enjoyed immensely.

I connected with one person in particular: Doug Constable, one of the chaplains, who also happened to be a very accomplished musician in his own right. Doug was a composer and exactly the kind of outside-of-the-box thinker I needed. During my previous visits I had become struck by how he challenged me in my thinking and writing by pushing the boundaries of what we thought we knew about faith and life. One of my first experiences with him was being in the large meeting room of the main building, lights out, and having him preside over a re-enactment of the Last Supper. The community members had been given the roles of the disciples and were sitting on the floor with torches in hand as he handed out the bread while speaking in a hushed voice. In doing this, he managed to turn the dark room into a completely immersive experience that instilled in me an appreciation of the Last Supper that I have never forgotten. This was typical of his thinking and teaching. Doug encouraged this type of experience in my music as well. His approach was just the one I was looking for—getting way beyond the mere facts

and placing the listener in the middle of the actual story, feeling and experiencing it as if it were first-hand.

The plan was to be at Lee Abbey for a period of about three months during the summer. This long stretch would allow me to really let my ordinary life slow down to the point of it becoming a time of spiritual and creative refreshment. I knew I was freed up to do so as my three years at music college were just three months or so from coming to an end. In the light of my chosen path for the future—composing, recording and performing—my tutors generously agreed to let me finish the course early, allowing me precious months to compose and generally prepare myself for the next stage in my career. The year before I had gained my LGSM diploma (Licentiate of the Guildhall School of Music), which would allow me to teach piano in schools or to private students. Whilst this was not what I was striving for at the time, it was certainly a good diploma to have.

Given the newly signed contract with Musical Gospel Outreach and the certainty of an upcoming album, I was not about to spend all this time writing at Lee Abbey without Phil Thomson at my side. We arranged to work together for a full week during my stay. Phil and I shared a clear ambition: to write a song every day so that we would end up with enough material from which we could hopefully choose some real gems. When he eventually arrived, it turned out that Doug Constable had managed to surprise me yet again. Doug knew exactly what I needed in terms of peace and quiet and had decided that Phil and I could make use of the so-called "honeymoon cottage" in the grounds. Any reservations I might have had about such an offer (not to mention the amusement it would create for friends and family) quickly evaporated as soon as we arrived at this extraordinary, totally unique location. The cottage was situated in a part of the Lee Abbey estate that saw the hills and cliffs come together in a crescent-shaped bay, the surrounding woods muffling all sounds except those of the natural world: the waves crashing ashore, the breeze blowing in from the open sea and birdsong emanating from every corner.

So, there we were, Phil and I, spending a good part of each day writing, testing out lyrics and arrangements whilst enjoying this most spectacular view from a cottage that was usually home to newly-weds! The irony was not lost on me that this was, in a sense, a creative honeymoon, in advance

of what was certainly bound to be many months and years of seeking to establish myself as a credible composer and performing artist. The setting certainly paid off. Phil and I were greatly inspired to write, literally day and night, and slept only when our eyes refused to remain open. We did indeed achieve our goal—seven quality songs in seven days—almost all of which eventually found themselves onto one of my first three albums: *Fireflake*, *Goodbye October* or *Listen to the Peace*.

During my three months at Lee Abbey I often strolled along the many paths that meandered down from the main house, immersed in a place that could truly be described as heaven on earth. One day, I passed a painter who had set up his easel along the stone wall that flanked the path. As my eye caught his work, we exchanged the usual pleasantries and then started a conversation. He had focused on a small section of an old stone wall, no more than a square metre. This section of wall was covered in all manner of contrasting foliage. The vast majority of people would simply walk past the wall with no thought as to what visual treasures it might have to offer on closer inspection. But this artist had indeed inspected it more closely and, using watercolours, was painting the scene in exquisite, beautiful detail. I was in no doubt that I was looking at the work of a professional artist. His intricate style reminded me of the work of another English artist I greatly admired, Graham Sutherland. We spoke more, exchanged names and agreed to keep in touch. Somehow, in those ten minutes or so, I had an inkling that I just might have found someone whose artwork somehow resonated with my music. Could this be an artist to approach in the future for album cover design? His name was Eugene Press. These weeks at Lee Abbey were offering many more gifts than I could have ever hoped for.

For my time here to be worthwhile for the community as well, Doug and I had struck a deal. Typically, I would work on site for half a day and be free to write for the other half. One job that I found to be particularly pleasurable was collecting tolls on the road that twists its way through the community grounds. A small toll booth was set up where I spent hours with my feet up, playing my guitar and enjoying the weather. Occasionally, a car would stop and I would dutifully collect the small change, go back to my chair and continue playing. This was a wonderful job for an introvert like me, yet I was not deprived of regular company. Every day, someone

from Lee Abbey's Tea Cottage would come along with a small cart and serve me a nice cream tea. And the job got better still. There were several girls of my age working as members of the community, and I would receive welcome visits from them, keen to listen to my music and engage in conversation. So here I was with my feet up, surrounded by views that seemed like they were plucked from a postcard, singing and playing my guitar and being served a Devonshire clotted cream tea with home-made scones . . . *every afternoon*. Life surely does not get better than that, does it? It would be dishonest of me if I did not admit to a noticeable rise in my self-esteem on hearing that, until the toll booth was removed some years later, there still existed some graffiti on the back wall stating "I love Adrian Snell"!

Romantic relationships were not foremost on my mind, however, as I experienced an outpouring of music while I was there. I spent a lot of time with Doug during my free hours, making full use of his compositional and theological insights and creative spirit. As the weeks passed, we wrote a number of songs based on the so-called "Servant Songs" from the book of Isaiah. The concept of the "Suffering Servant", as it is described in those passages, proved a rich template and starting point for what eventually grew into a full-blown project. Doug and I set out to finish this work while still at Lee Abbey and arranged to perform it in front of the community and guests as a finished work entitled "The Servant Songs". We put two pianos opposite each other and played in front of a very receptive audience. It was the culmination of a prolonged stay that worked like a balm to soothe my fears. As Doug and I performed "The Servant Songs", there was a true sense of family bonding in the room. Although I would not record this project as a whole, I decided to file away several of these new compositions co-written with Doug for possible future use—songs like "Turn Your Vengeance", "Children of the Dream" (based on Psalm 126) and "By the Waters of Babylon" (based on Psalm 137), all three eventually finding a place on future albums. These were songs that would no doubt please MGO, but I was not writing with that thought in mind, simply with a sense of relief that I was actually now in a position to record.

At the end of the summer of 1975 we finally set out to record my debut album. MGO had arranged for it to be recorded at Grosvenor

Road Studios, a facility in Birmingham that was housed in an ornate
Victorian property. It was one of the oldest recording studios in the
area and was actually converted from living space. It gave the rooms
a laid-back quality that I found useful as I was very much in control
mode now that my music was to be recorded for posterity. There were
some familiar faces that I could rely on. Gerry Page, for example, who
I had met at music college, was playing bass on the tracks. Gerry had
become a Christian since we met and that certainly made recording
these songs feel all the more pivotal. His fluid, classical style of playing
already suited my own approach; now we were to bond on another level
as he truly understood the deeper messages these songs conveyed. MGO
had selected the producer John Pantry. The company was aware that my
style of music might be considered out of the ordinary in the protestant
evangelical world of that time. They encouraged me to entrust John,
who had considerable experience in mainstream pop, with the task of
taking the raw material and bringing it to fruition as a fully arranged
and produced body of work worthy of broad attention. John had been an
active musician and songwriter in his own right since the late 1960s, as
well as a respected producer and engineer, with credits on early albums by
the Bee Gees. His experience was unquestionable and made for a smooth
process in the studio as far as my overwhelming desire for creative control
allowed. It could not have been easy for John, who had converted to
Christianity not long before and had since become the "go-to" producer
for many Christian artists. But he understood my unwavering desire for
authenticity—musical, spiritual and emotional. What was played in these
rooms had to convey the sense of being true to myself, to who I was as
an artist, as a thinker and as a Christian.

The *Passion* songs would fill the entirety of side B, and together we
made a final selection of five stand-alone songs out of my repertoire
that would form the A-side. "I Was a Stranger" would be the opening
track, followed by the relatively new "Song for John". This slow-burning
track was a six-minute, sweeping dialogue about the hopes and doubts
of John the Baptist, foreshadowing the coming of the Messiah, and then
his receiving the assurance he so needed from Jesus himself: "Tell him
that those who were dead are alive . . . make him remember I've cast
out fear . . . ".[3] The classical rock choruses would be the first sign for the

listener that they were in for a few surprises. "My Soul Alive" and "Making Me Real" made the cut as well, and we completed side A with "This is the Time to Say", a song I had written for a friend who had recently been diagnosed with terminal cancer. Even though we only had a shoestring budget (in the region of £1,500) we could afford to commission musician and violinist Bill Thorp to arrange the *Passion* songs for string quartet and to play all four parts too!

I decided to name the album *Fireflake* after a quote from the British poet Jack Clemo. His work was strongly rooted in his faith whilst also inspired by the landscape of Cornwall. I had been given one of his books of poetry and was struck by one line in particular: "It smote with song—just a fire-flake, that clove a crater in my clay."[4] I knew this was a line I wanted printed on the back of the artwork, serving as both inspiration and a reflection of what I hoped my music would awaken in people. The artwork itself was selected in a similar way. A photograph by Gordon Strachan of a burning and smouldering field provided an image that triggered the imagination while being deliberate about how I hoped people would experience this music: as a process. As with singer-songwriter Judee Sill, whose music I had discovered years earlier, I hoped that the combination of the image, quotation and, above all, the songs would resonate for others just as her music had with me: deeply spiritual but impossible to put in a box.

I dedicated *Fireflake* to my parents. It was their commitment to my musical development that had fuelled the fire. And their total support since their own inadvertent experience with my demo tape reassured me that this album was not the end of a journey; it was just the beginning. MGO certainly thought so. In the run-up to the release of *Fireflake*, *Buzz* magazine proclaimed that "Adrian will be a really influential personality and 'Fireflake' a runaway bestseller."[5] Of course, I would be delighted if the album turned out to do well, but above all my chief concern, and prior to release the cause of much anxiety, was that people would simply "get it". But all apprehension aside, I was grateful that MGO was committed and prepared to provide the platform from which to build. Importantly, they had committed themselves beforehand to a nationwide tour. This was a huge development as most of my concerts so far had been

invitation-based. All the pieces now seemed to be in place. As *Fireflake* hit store shelves, my career as a professional music artist had truly begun.

7

To the people in the stadium I must have seemed like a little speck in the distance, but their response to the songs Gerry Page and I performed was as immediate and intense as if they were within touching distance. We were performing on May Day in the Netherlands at the annual event of Youth for Christ in the Ahoy Stadium in Rotterdam. It was 1978 and the roar of approval that greeted us was a genuine surprise, even after years of touring. It was not just the size of the audience that overwhelmed me; it was another moment in time that reinforced my hopes of appealing to a broader audience with my music and on a deeper level. Gerry and I played my *Passion* songs plus a few others with him on bass and me seated at the upright piano on stage. The Dutch responded to the music with positive and eager enthusiasm, which I later attributed in part to their unfamiliarity with the style. The rawness of just the piano, bass and guitar, with the intensity we poured into it, was turning heads. The past couple of years had seen me playing a long stretch of concerts in order to get my performing career off the ground. It had given me ample opportunity to refine my craft and identity on stage, and by now I felt able to describe myself as an international artist!

During the months following the release of *Fireflake* in 1975 I had gained a real sense of positive momentum. So much had been leading up to my first actual album that I had not fully considered what creating a follow-up would involve. My basic attitude had been that I simply wanted to write and play more. If only it were that simple . . . The financial foundation for my career in music was barely sufficient. My father, who was now one of my strongest supporters, had established a trust fund called "Living Waters" that would serve in various ways as a kind of structure for me as I pursued this very unstable career. An official album release in the so-called "Christian music scene" was labelled a success even if just a few thousand units sold. MGO even said as much, touting the

sales figures in a press release after the first few months of *Fireflake* being in the shops, no doubt trying to bank on *Buzz* magazine proclaiming it "Album of the Year". I was certainly flattered by the accolade even though I tried to play it cool.

I continued to have reservations about my music being pigeonholed in this niche in spite of its apparent success, and I remained critical of my place among my perceived peers. Media and audience both seemed to lob the Christian music label my way with regards to *Fireflake*, and I could not help but feel it was mainly because of an ideological association rather than a truly objective, critical appreciation of the music. From a distance, my attitude could sometimes be interpreted as arrogance, and perhaps there was an element of that, but above all it came from the uncompromising sense of ownership I felt over my music—my longing for it to be heard without preconceptions or the prejudice held by many towards anything defined as Christian music. In any case, releasing *Fireflake* had made me more aware of a hunger for broader acceptance. I was happy to work with MGO towards that goal as they proved true to their promise of a UK tour. Realistically, this was the only feasible means of income for the foreseeable future. I was not going to turn down the offer as I was thankful for the opportunities to play.

And so, in late 1975 I got my first taste of life on tour across the UK. If I had any preconceptions about the glamour of it all, they would have been instantly dismissed by the reality of being on the road. Between concerts I mostly slept in run-down digs or with host families. Luckily, I did not feel the need to stay in fancy hotels. My adventures had an almost nomadic feel to them: moving from town to town, playing my music and forging new and significant professional relationships. I met some wonderful people, many of whom would become firm friends. To a certain extent, touring helped me to overcome my apprehensions. What did remain awkward, though, were some of the conflicts that arose over payment for the concerts.

Touring brought me anywhere MGO could book for me. This meant I was hosted by quite a few churches and youth groups on the one hand and university or college campus concerts on the other. At events like "Freshers' Week" where I was often invited by Christian Unions to perform, a Christian artist was meant to consider his craft as a strictly

ideological mission in which reimbursement or monetary profit had no place. Sometimes, this issue did not become apparent until we were already on site or even until after the concert. There were instances where the venue, while making it clear beforehand that it had no intention of paying me, had still charged concertgoers for admission. I found it hard to cope with these issues and, sadly, it was all too easy for resentment to creep in and hard to have to wrestle with these kinds of feelings as a Christian performer. I was somewhat taken aback when spiritual arguments were used to justify something that did not seem fair at all. Injustice, in many shapes and sizes, had always bothered me. Now I was confronted from time to time with what I perceived as an injustice over honest pay while grappling with the notion that I was perceived as a *missionary* instead of an artist. In hindsight, I think I failed to realize how quickly and easily I had been sucked into a subculture and was too caught up in safeguarding my musical content, on and off stage, to really take note of it and alter course. So, my first big tour was a two-sided affair: it was a blessing in many ways, but it also further defined the course my career would take, whether I liked it or not.

Within a year MGO were asking for a follow-up album to *Fireflake*. As we started the process of gathering songs, I got my first taste of audience expectation. This would be the first time I released music to people who had already purchased some and were looking forward to more. Finally I had a voice and people wanted to hear it. I loved this experience. While I was still holding my music close to my chest as I worked with others, creating this second album gave me a particular feeling of joy which I would appreciate long afterwards. But there was also a deep sense of commitment to work as hard as needed to achieve my goals. The decision I had made to set out on this journey as my bona fide career meant that I approached it with both passion and the need to have a structured path towards the end result. The way my music was ultimately played, produced and packaged was of the utmost importance to me. It probably made me an artist that session players and producers found hard to work with, but a structure that revolved around my artistic decisions—instead of those decisions being informed by the structure—was paramount to me. I was thankful for the opportunity to be a recording artist as much as I was committed to presenting new music on a regular basis.

Luckily, I still had several songs that Phil Thomson and I had written as well as older material I had worked on with Beth Colebrook. Phil had been in fine form with his writing, and we decided to name the new album after his "Goodbye October" lyric. The track became a beautifully poetic piano ballad that had a wistful quality to it. I had come to love Phil's lyrics and was keen to include them, even if they also shone a spotlight on my own lack of lyrical prowess. My self-confidence at producing quality lyrics was still low, but the bookend tracks of this album—"Prelude" and "And in the Morning"—were my own. John Pantry, who was producing again, agreed that we should include "By the Rivers of Babylon", the modern adaptation of Psalm 137 that I had written with Doug Constable at Lee Abbey, as part of the "Servant Songs".

The *Goodbye October* album was recorded at the newly established ICC Studios in Eastbourne, which saw us enjoying the occasional beach walk between takes. The group dynamic must have been a struggle for both the musicians and John Pantry. Every arrangement or suggestion was first put through my protective filter. The degree to which I offered detailed directions to the studio musicians was probably considered at the least unconventional, if not at times intrusive. To me, that was the price of getting it right, and the anticipation we felt existed for this second album was surely an indication that it would help cement my signature style.

The choice of artwork for the album cover was important for me—a visual representation of what the listener would hear. So this time I asked Eugene Press, the artist I had met at Lee Abbey, to provide illustrations that suited the general tone and feel of the music. He most certainly did not disappoint. With his intricate style he created an image that was as thought-provoking as it was beautiful. Bursting from a doorway was a mixture of what looked like flames and plant growth as a flock of doves took to the sky. Flanked by panels that showed key lyrics from the album, it was a drawing that instantly elicited an emotional response from me. Eugene carried over elements from the main image onto the lyric sheet as well. It all served to give the album an ethereal quality that I was truly happy with. I now knew I wanted my albums to be listened to in the same manner as you would read a book. I was hoping the whole package would help people immerse themselves in the music and, in the process, come to a deeper understanding and appreciation of me as an artist.

8

"Alright . . . yes, then!"

Sue spoke up, seemingly out of the blue. It did not immediately register with me what she was referring to. I almost did not dare believe that she might be indicating that, yes, she would marry me. But it quickly became clear that this was indeed the case. I was totally elated.

It was around Easter, and we were staying in her home town of Rushden in Northamptonshire. We had just attended church and had started to walk back towards her parents' house when Sue spoke the words that filled me with a feeling of deep joy. Over the past few years our relationship had taken root. Considering these were also the years that had seen my musical career take flight, this had not been a given. I might even be inclined to say that our relationship had developed in spite of it. Sue had no musical background nor immediate family that could serve as a gateway to this very particular world. She had been working towards her degree in Russian Studies, and we shared an interest in the persecuted church in the Eastern Bloc countries. When we had first met, she took an interest in my music, but our mutual attraction superseded that. This had added to her appeal as my world was increasingly revolving around my identity as an artist. To have someone interested in me for anything other than my music was a sign of the deeper, more meaningful kind of affection that I was looking for. We were both still young, not long out of our teenage years, but when it came to commitment in a romantic relationship, I could not have taken it more seriously.

I had had previous girlfriends but, for me, getting involved in a relationship of this nature was not something transient, as it may have been for some of my friends. My mindset was somewhat different. How could it not be, considering everything else? If I was to really commit to a relationship, my intention would be that it should ultimately evolve into engagement and marriage. Otherwise, what would be the point? The ever-present longing for validation would have been feeding my fear of rejection as well. All of this meant that when a relationship was broken off by either me or the other person it was all the more heart-breaking. In a way, I experienced love the way I experienced and protected my musical

integrity. It had to be right. And when it did not work out, or when it ended in disappointment, it left a mark on my carefully sheltered soul.

Sue's "yes" had triumphed over all of this. The girl I was in love with had picked up on my thought process and responded to an unspoken question, casting aside my fears and taking my hand to help us take the step we both wanted to take. Her "yes" was as much an affirmation of the love we had for each other as it was an act of grace in light of my intense view of the world and other people. I suppose I should have been more aware that this was on the cards since Sue had suggested we visit several jewellery shops during a recent visit to Canterbury, showing considerable interest in the rings on display! But none of that mattered now. It was the happiest moment in my life as we continued walking towards her parents' home.

As we walked in, Sue took her mother aside to tell her about our engagement while I talked to her father and asked for his daughter's hand in marriage. Their response was heart-warming. Within twenty minutes of leaving the church, Sue and I were engaged and proposing a toast with her parents. We were married in December of that same year, settling into the house in Leeds I had been living in. I had so much to be thankful for, not least the support of our parents. To a sober observer looking past the obvious love we shared, two young people getting married with a career in music as their financial foundation hardly seemed the most sensible idea. Playing concerts and having income from my albums was barely sufficient. The trust fund created by my father would serve as a financial backbone—a gesture of support on his part for both my music and now my marriage too.

Our courtship, engagement and marriage had developed in tandem with my musical career. To a degree, Sue had been aware of the attention *Fireflake* and *Goodbye October* had attracted. She had also experienced first-hand the dynamics of the artist's life, which could provide its own unique set of challenges. The people I met through my music could often subconsciously interact with me out of a sense of personal connection. Such is the power of music, but it would invariably lead to a situation where Sue was with me at a concert but would be simply a bystander, as people only seemed to take an interest in me. She soon realized that social interactions between an artist and his audience were played according

to different rules from social interactions in general. It was a difficult position for Sue to be in. She was supportive of my musical career, yet those around me did not properly acknowledge her.

Added to these intricacies were my own thoughts about the levels to which my music would impact our marriage and therefore our daily lives. My protective nature towards my music during the various stages of composition was so entrenched that it kept me from sharing the process with my wife. My feelings of insecurity made me fearful of potentially negative or ambivalent responses, or even hesitation in her expression of interest that could be perceived by me as being negative. Even though her opinion really mattered to me and could have been positively constructive, I chose not to take that risk. By reacting in this way I may not have appreciated the hurt it could cause to the person closest to me. In my own way, I did bring our relationship and my music together. One of the first songs I wrote with Sue in mind was "Travelling", a piece that expressed the intensity with which I missed her while I was away on tour. As oblivious as I could be to the challenges my musical career presented to my wife, I could be equally engaged in expressing my feelings for her through that same music: the strongest language I knew.

Settling down as newly-weds did not mean that my career was taking a breather. As MGO and I worked on my third album, the international dimension to my performing quickly grew. Ad Everaars, who managed GMI (MGO's partner organization in Holland) arranged for me to perform a special concert in Arnhem, and I was also invited to a festival in Denmark. MGO seemed convinced that with the release of the new album, *Listen to the Peace*, now was the time to take the next step and cross a new frontier. In the United States, Christian music was blossoming as a genre mostly known by its informal label—Jesus music. It was a genuine movement, springing from the south-west states and spreading across the continent like wildfire. What had begun as apparently Christian hippies testifying through song was very quickly becoming a bona fide genre that incorporated a variety of musical styles. MGO was in talks with one of this movement's main labels, Maranatha! Music. The goal was to introduce me as an artist by getting my latest album signed up by Maranatha! and distributed stateside in 1978. There was no denying the logic of this train of thought. *Listen to the Peace* had the same type of

ethereal artwork as *Goodbye October*, again provided by Eugene Press. It was easy to see how the overall feel could appeal to the free-spirited audience that Jesus music brought together. *Listen to the Peace* built on a number of working relationships that had served me well up to this point. John Pantry once again produced, and the album quickly filled up with songs Phil Thomson and I had written a while before. One that particularly stood out for me was "Judas", an extraordinarily powerful poem from Phil which I sought to interpret through a gentle yet aching piano accompaniment. We added a couple more tracks from the Lee Abbey "Servant Songs" sessions: "Turn Your Vengeance" and "Children of the Dream". I also included "Travelling", the song I had written for Sue, and I dedicated the album to her.

As a whole, *Listen to the Peace* seemed a well-rounded, complete work that I was proud to have promoted across the Atlantic. The litmus test for American success was the music itself. Could America appreciate it the way it had been received on Europe's mainland? Would the cultural gap be too big? MGO and Maranatha! decided to test the waters by not only giving *Listen to the Peace* a proper American release but also by sending me on a short West Coast tour with the Sweet Comfort Band. The group was somewhat of an anomaly amongst many of the Jesus music artists. Their energetic blend of jazz-rock, funk and soul was matched only by the personality the band members (and singer Bryan Duncan in particular) brought to the stage.

When I set foot on American soil to start the tour, it truly felt like I had arrived in the New World. I was slightly intimidated by the enormity of it all. Driving to each new concert came with a fresh set of nerves and yet the tingling feeling of promise. Fortunately, the American audiences quickly warmed to me as well. The good-natured banter and practical jokes we played on each other during that short tour allowed us to let off steam and prevented us from taking our egos too seriously. On one particular evening Bryan crept up on stage and tinkered with my piano shortly before the show. Oblivious to it all, I greeted the crowd and started playing. To my horror and the audience's bemusement, it sounded like a toddler playing the keys with his elbows. I quickly discovered why. Sweet Comfort, eccentric band that they were, were standing in the wings laughing hysterically. Bryan had attached a length of Sellotape to the

front of the piano keys, cleverly hidden from view by its transparency. As I pressed the keys, they had all played as one!

The short time I spent in America felt like another breakthrough on multiple fronts. The audience seemed to embrace me in a live setting. I had also learned the value and importance of humour and a lightness of touch when touring, particularly when sharing the stage with other artists. My serious nature could easily get the better of me and consequently rob me of the enjoyment of performing live abroad. I was definitely ready for the next step.

9

"One artist particularly stood out for me tonight—any chance I could meet him?"

The man who approached MGO's Geoff Shearn in the hallways of London's Royal Albert Hall was the one responsible for the sound system that night. This was Jon Miller, a man who looked in control, as if he had been in the music business for a long time, and who somehow conveyed that unspoken quality of someone who needed to be taken seriously.

Geoff must have been instantly intrigued. After all, he knew Jon Miller as a producer who had trained under the unofficial "fifth Beatle", George Martin himself. John had heard me sing "Goodbye October" that night as we had officially launched the *Listen to the Peace* album with an elaborate live show. Geoff Shearn had taken a risk by putting on a big event at this most prestigious of venues, but he could not have been more excited as the night progressed. The building momentum of *Fireflake* and *Goodbye October* seemed to have paid off as the hall was packed, and Geoff came pacing up to me, proudly proclaiming they had sold 500 copies of the album that night. To have a well-connected producer like Jon Miller asking to be involved must have been all the more exciting. Jon was not completely unknown within the emerging world of Christian music that MGO represented. He had previously worked with artists like Malcolm & Alwyn and Graham Kendrick, and he at the time was working with Gordon Giltrap, a versatile guitar player who had just risen to prominence

in the UK with a trilogy of instrumental albums. Giltrap was a masterful artist with a keen sense of the emotional threads that bind words and music together. He had based one of his albums, *Visionary*, on the work of the poet William Blake. I knew that with the support of Jon Miller a string of connections to the mainstream music industry would open up.

Jon was one of the founding partners of a music production company called Triumvirate Productions. Although they were based in the UK, they had contacts in the United States that seemed ripe for exploration. Suddenly, we were talking about using well-known session musicians for my next record as well as engaging Jon Miller as a producer. Triumvirate were interested not only in investing money in the album but also in giving me a foothold in the USA. There was a real buzz mounting in the team I worked with. My next album would mark somewhat of a change. This 'change' related primarily to the calibre of musicians now available to me, through the production team behind the recording. This in turn would result in more professional scrutiny of the songwriting itself as well as the actual quality of musicianship. My bond with Phil Thomson was just as strong; and the visual identity given to my work through the beauty and originality of Eugene Press's detailed paintings would continue. Indeed, once I'd decided on the album title; *Something New under the Sun*, and Eugene was invited to design the cover, once again he was to fulfil everything we had hoped for, providing an image that was as bold in colour contrast as it was inspiring. A yellow sun could be seen shining down on a tree with leaves that had come to life. Colourful birds were settled on the branches in a manner that left the viewer wondering where the leaves ended and the birds began. You could argue that the photograph we used on the back, which depicted me leaning against my touring van (complete with the elaborate Adrian Snell logo), communicated a certain confidence about the future. All indications were that we had found a partner in Triumvirate that could be a gateway to bigger and better things.

Jon proved true to his word in acquiring high-class mainstream session players. Apart from the obvious professional quality this brought to the album, it gave *Something New Under the Sun* an added foundation of credibility outside the world of Christian music. And, with Triumvirate on board, the change would also lead to an increase in options. Not only

around the choice of musicians but also about the direction my work could and should take. Working with this new team also coincided with a change at MGO as it would now be known as Kingsway Music.

The songs on the album reflected my growing confidence as a songwriter even though I was still mostly leaning on the talents of other lyricists. The opening track "By the Waterfront" was an upbeat piano pop song with lyrics written by Andi Sweeney, who had been part of the Lee Abbey community when I was there for my extended stay. We had struck up a close friendship at the time, and through that I discovered that he was a gifted poet and lyricist.

As a songwriter, few songs had come so raw and direct to me as the track "Can You Get Me out of Here?". I had written the basis for the piece on 22 November 1974. It was the morning after the Birmingham pub bombings. Two explosions had ripped through public houses in central Birmingham, attacks that were suspected to have been carried out by the IRA. I had grappled with the news, the images of carnage and the thoughts of unspeakable acts that humans were capable of. Of course, it was Phil Thomson who helped communicate these thoughts by turning the voices of the victims, overcome by acts of evil, into a haunting and poetic piece. Overall, the album had a freshness and professionalism in its sound that pleased me all the more.

Something New Under the Sun was released in 1979, and among its Christian audience it sold mostly in line with previous releases. We were confident we now had the building blocks to go a step further, so I boarded a plane to California with Geoff Shearn in order to pitch the work to Maranatha! Music and work towards a proper US release. We arrived in Santa Ana where the Maranatha! studio was located, set up shop and kept quiet as the record label executives listened to the album over a stellar sound system. I was stunned by the response. It was not that the label's managers were dismissing the record outright, but their lukewarm response might as well have been an overtly negative one as far as I was concerned. There was an awkwardness as we finished the meeting, leaving us acutely aware of our wildly different levels of appreciation.

On our way home Geoff and I tried to work out why *Something New Under the Sun* had not been met with the enthusiasm we felt it

deserved in the United States. Was the overall sound of the album, and my singing voice, somehow too British and therefore difficult to place in marketing terms? In that a very large percentage of albums released on the Maranatha! label was overtly worship orientated, were songs like "Can You Get Me out of Here?" simply too secular for the particular Christian music world Maranatha! Music was serving? Whatever the true reasons, we both agreed on one thing: it was not due to a lack of quality. We strongly believed in the work; Jon Miller agreed. And to his credit, he was willing to go the extra mile.

Like so many others, Jon loved my five-song *Passion* set. He had observed, time and again, how audiences responded to this particular sequence that in itself told a story. His proposal was that Triumvirate and Kingsway jointly finance a completely new recording of *The Passion*: that I write additional material, expanding it into a stand-alone work; that we aim to turn what had begun as a twenty minute, solo piano and voice series of pieces into a fully-fledged rock oratorio; that we use the very best available session musicians and cast the characters as one would with a work of musical theatre, finding the very best and most suited vocalists for each part. Triumvirate were willing to put significant money into the project and Kingsway, as partners in the venture, would match that investment. Both parties were well aware of the effect the *Passion* songs had on listeners. So, finding a business partner willing for the first time to seriously invest in a production that would have the potential to reach an audience way beyond people with Christian faith was truly music to their ears.

I, on the other hand, was not convinced. Although on paper it all sounded great, the problem was a familiar one: these were *my* five songs, *my* sequence, *my* arrangements, *my* playing, *my* intent. To not only re-record them, but also put the work into the hands of so many others, to trust so many new people with the very thing I was most protective of, was too much of an ask.

The weeks that followed were mostly filled with lively discussions between Geoff, Jon and me. I was the one holding back on the project, while both Geoff and Jon patiently continued to reason with me. It was not until a month or so later when I was sitting across from Jon in his office that he said something that broke through my resistance:

"What if we got the Royal Philharmonic Orchestra involved?"

Jon spoke with his usual authority and can-do attitude that I had come to respect so much. I knew immediately that he was not bluffing! I hardly dared believe that he could actually pull it off, but there was no denying the wealth of connections Jon had. With newfound excitement, I agreed to start working on piano and vocal demos that we would use to inform players and vocalists. Jon sent the tapes to the Royal Philharmonic's representatives; *The Passion* was officially in the works.

A little while later Jon called. He had heard back from the orchestra. They had listened to the music and put a detailed and budgeted proposal on paper for us to consider. I could hardly believe it. *The Passion* was shaping up to be the biggest production I had ever been involved in and now it had all the ingredients necessary to break into the mainstream. With this album, Jon chose to involve the two other men who completed the Triumvirate team as co-producers. These were Rod Edwards (who was part of the Gordon Giltrap band) and Roger Hand. Between them, they shared duties as a small army of session players descended on the Redan Recorders studios in Bayswater, London.

Once I had been won over to this wonderful venture, I felt inspired as I wrote the music needed to complete *The Passion*, now with the structure of a classical rock oratorio. The original songs were all there, joined by the triumphant "Long Live the King", marking the festive welcoming of Jesus in Jerusalem that would open the album. It would be followed by the poignant and sorrowful "The Last Supper". Peter's betrayal of Jesus and his deep sense of guilt and regret were portrayed in "The Betrayal". "Son of the World", with its exquisitely beautiful lyric written by Beth Colebrook, would explore with great tenderness Mary's anguish as the mother of a son whose trial and execution she was about to witness. I introduced Pilate as a key character in the unfolding events through "The Trial", a song that pushed *The Passion* firmly into rock opera territory. Using poetic licence, I lifted "Song for John" from its original recording on *Fireflake* and re-interpreted it as Jesus addressing his mother and close disciple John from the cross. Finally, a new unaccompanied choral recording of "Peace Be with You", originally recorded on *Listen to the Peace*, would bring the work to a close as Jesus blessed his disciples and sent them out to do his work.

Each day in the studio was adding to my excitement and sense of wonder. All previous reservations had melted away as I took in the level of professionalism and musicianship that was on display. But nobody impacted me as much as the drummer, Simon Phillips. If you had been there when he walked into the studio to record his parts, you would never have thought he was already considered to be among the best drummers in the world. Simon was barely eighteen years old: an energetic young man with a lean build and dark, curly hair. His eyes squinted whenever his shy smile broke out. Jon had spoken highly of him leading up to the recording. In fact, according to him, Simon was key to the process. I was curious as to why Jon invested so much faith in one musician. In my limited experience, apart from my music-making with drummer Chris during my early teens, the role of drummer seemed to be primarily one of establishing the tempo and rhythm of a piece and, alongside the bass guitarist, steadying the rest of the band—a kind of musical glue that held everything together. I was about to receive one of those musical awakenings that would forever alter my understanding of the potential and power of an instrument in the hands of a genius.

We started the sessions by playing the piano and vocal demo for both Simon and the bass player, John Perry. As I sat across from Simon, he was listening intensively as his hands began to move. I was intrigued. Instead of simply tapping along to the beat of the song, he seemed to be exploring rhythms and patterns suggested by elements of my piano playing that, even as he tapped on his thighs and the chair he was sitting in, seemed positively inspired. Simon asked if we could start with "Golgotha". I put on headphones, took my place at the grand piano in the studio and uttered a simple countdown before starting to play. What followed was to become unquestionably the most memorable and mesmerizing few minutes of my musical career. A good rhythm section will always elevate a performance. What these musicians, and in particular Simon, were doing was something I had never believed possible. My style of playing was rooted in the fusion of classical, rock and jazz that belonged to the "progressive rock" genre so prevalent in the 1970s and 80s. Within this genre, as a pianist, left and right hand would weave together forming, at times, complex patterns of rhythms, both separate and complementary to one another. The resulting soundscape called for a very skilled rhythm

section, musically and technically. Simon's background, including growing up as the son of the internationally renowned big band leader Sid Phillips, made him well equipped to rise to the occasion. Frankly, I was in awe—totally aware of just how special this session was turning out to be. When we went to the control room to listen back to what had just been recorded, I was as excited musically as I had ever been. Simon's drumming had not just built on my playing, it had effectively transformed "Golgotha" into what came to be widely recognized as a timeless example of classic, rock, jazz fusion at its very best.

After recording the guitar parts with Dave "Dzal" Martin we relocated to the historic Olympic Studios in London. This large building in Barnes had been a cinema during the first half of the twentieth century and was later repurposed into a recording studio. It had the space to house an orchestra and its state-of-the-art equipment had given it an enviable reputation. I cherished every moment in the control room, looking down upon the members of the Royal Philharmonic Orchestra, surrounded by the same walls that had soaked up recordings of The Beatles, The Rolling Stones and Led Zeppelin. I could have watched the orchestra at work for days on end. Their conductor, Harry Rabinowitz, was on top of the tiniest note, the most minute detail. In between takes I tried to gather my thoughts, elated by the glorious sound of a world-renowned orchestra transforming my music. This was bringing to fruition everything I had been dreaming of since Jon had first mentioned the Royal Philharmonic in connection with *The Passion* recording. Simply put, I was in the presence of greatness and still view those sessions with the RPO as amongst the most privileged moments of my life in music.

After this momentous chapter in my career, in just five months' time a far more significant event in my personal life was to take place. Sue would give birth to our first child, Jamie, on 12 August. Holding my own child made me aware that my life would never be the same again. It was a strange and wondrous feeling to experience this amount of love, gratitude and uncertainty at the same time. By all accounts and appearances, I was no longer a child, but deep inside it was as if a part of me was still there with my back against the door, exhaling.

10

The spring of 1980 would be forever engrained in my memory. *The Passion* had been completed. This recording process had been the highlight of my relatively short musical career, and the work had been transformed into a more complete narrative, aided once again by Eugene Press' artwork. This time, his depiction of Jesus' final journey to Golgotha was placed on the cover to dramatic effect, its impact accentuated by the white background to *The Passion* title and logo. When it came to the music, the result of all the investment was right there for all to hear. In addition to the Royal Philharmonic Orchestra we had used the services of the English Chamber Singers and the London Welsh Male Voice Choir, bringing the same level of quality to the choral elements of the work as we had to the orchestral. Everyone who had listened to the completed album prior to release was in agreement that the band, singers and orchestra had created something truly special. At last, everything was in place for what was the official release of the album and then a nationwide concert tour.

I felt nervous. I had no doubts about the quality of the work, but Jon Miller's belief, voiced on many occasions, that this could be the album to propel me into the *big league*, left me uncertain about longer term implications. I knew Jon's experience held considerable weight, and I was confident that the whole project was in the right hands. However, I was well aware that this time there could be a conflict of interests and expectations as to the timing, marketing and promotion around the release of the album as well as the accompanying nationwide tour of the work. Kingsway and Triumvirate, whilst inseparable partners in the recording of *The Passion*, were coming from a very different place when deciding on the best plan for the next stage. Both partners had invested a lot of money in the project, in Kingsway's case significantly more than they had ever invested in an artist, or album, before. And so, while Triumvirate wanted to delay the release until the supporting structures, including the marketing and promotion, were all firmly in place, Kingsway wanted to move as quickly as possible. Inevitably, as a small company operating outside the mainstream, they were keen to see a return on their considerable investment as soon as possible. It had

become a battle of wills with me caught up somewhere in the middle. Of course, I was longing to see the album on general release and to finally share the fruits of nearly eighteen months' labour with the rest of the world. As the artist and composer, I simply wanted the album to be as widely available as possible and to embark upon a nationwide tour. Equally, I wanted *The Passion* to offer me my first meaningful shot at a breakthrough into the mainstream.

In the end, Kingsway's position prevailed. *The Passion* was hurriedly released through the usual and very limited Christian music outlets and channels. This was a cause of major frustration and disappointment for Jon, but at least there was one moment that all parties agreed on as being a major milestone: on Sunday 6 April, at 4.15 pm, *The Passion* was to have its premiere on BBC Radio 1. The entire work would be broadcast as an Easter special. Over the previous ten years I had played my music to audiences of wildly varying sizes—from dozens to hundreds to tens of thousands. This time my music would be broadcast to an audience of, potentially, millions. This "breakthrough" was immensely encouraging to Kingsway. Having one of their albums showcased on BBC Radio 1 was unprecedented and immensely encouraging, as well as for the UK Christian music world they represented, which had never experienced a breakthrough quite like this. Triumvirate, accepting with many reservations that the album was going to be released much sooner than they had wanted, now directed their efforts at putting on a quality tour.

Naturally, Jon was focused on booking the very best musicians for live performances. *The Passion* band and singers would be invited to join us for their professional and musical skills rather than their faith credentials or convictions. This resulted in an unusual team of Christians, non-believers and those with other world views but all of us aiming for the same result: making *The Passion* live concerts a musical tour de force. Jon had invited Ian Mosley to play drums. Ian was already part of the Gordon Giltrap band and was about to join Marillion, a band on the verge of global recognition and success. Jon also chose two of the singers, Debi Doss and Shirlie Roden, who had sung the parts of Mary Magdalene and Mary, mother of Jesus, on the album.

There were multiple parties involved in promoting the concerts as well. Kingsway joined forces with the evangelical organization, Youth

for Christ. I had previously worked with a Youth for Christ team, "From the King", soon after I left college, and so was known to them. Together they would work with local churches and event organizers in order to get the tour off the ground. It turned out to be a strange mix. There was the overt evangelical vantage point of Youth for Christ, who approached the concerts as flagship mission events; Triumvirate were keen on showcasing the quality of the work and, in so doing, gathering interest from as broad a constituency as possible; Kingsway were eager to make this their biggest and best Christian music tour while also looking to recoup their investment in the album.

I was trying to balance the feelings of excited anticipation and considerable anxiety, which was amplified by the potential conflict of interests that was becoming more obvious by the day. This could be my opportunity to attract the much broader and larger audience I knew was out there for my music. This time, all the pieces seemed in place to support what we all believed was a fine and beautiful album. I had loved seeing the music come together, and hearing it as a complete work had filled me with joy and excitement. But I felt as though I had lacked control in the later stages leading up to this point. Discussing the tour and tactics beforehand with Jon had reinforced my feeling of inadequacy. I knew I was probably on the right path, but someone else was in the driving seat. With rehearsals behind us there was no going back. *The Passion* tour began its UK run.

Performing these songs live with high-end production values was very powerful. I had been accustomed to being the only one on stage, sometimes accompanied by Gerry Page or a small set of musicians, but these nights were special. Importantly, I was able to enjoy the first shows because it was clear that everyone involved knew what they were doing. Whatever the backgrounds or beliefs of the different players, all believed in the work and were determined to give it their all. Each person had his or her own way of preparing themselves for their role as singer or instrumentalist. For some it was prayer; for others it was meditation. Our singers Debi and Shirlie would meditate in their dressing room before a concert. They were doing so early on in the tour when a member of the Youth for Christ team came into the room and witnessed their ritual. Within minutes there was a crisis.

We were summoned by Youth for Christ representatives who made it clear, in no uncertain terms, that as far as they were concerned it was unacceptable, not only to have non-Christians in the band, but worse still, people who were using TM (Transcendental Meditation) as part of their routine of preparation for the concert. Before I could fully grasp what was going on, I was engaged in heated discussion about what was to be considered *Christian*, what could be tolerated and what principles a person of faith should hold. I was agitated at first, but soon became angry and distressed. To me, this represented the worst of evangelical Christianity: condemnation without grace or empathy, claiming to want to expel what would be wrong in the eyes of God and wounding a person in the process. To have this be such a matter of contention on a tour that had my name on the poster made me feel all the more responsible for the way the singers were being treated. I had so appreciated the way we had all shared this journey so far, on and off stage, safe in the knowledge that I should not, could not, *would not* ever devalue anyone as a person based on their lifestyle choices. In fact, I had experienced great enrichment through these new creative relationships, learning so much from musicians I now counted as friends. I greatly appreciated them for the people they were and did not feel threatened in my faith at all.

This made it all the more horrible when the whole situation escalated to the point where Youth for Christ senior leadership demanded that we replace Shirlie and Debi with Christian singers. I was livid and determined not to let this go unchallenged. When alternative singers were suggested, I held firm and flat-out refused to fire them. To me, this was no longer just an issue about sharing the stage with people holding different world views; it had become a matter of justice and morality. The level of frustration and shame I felt about the way Debi and Shirlie were being treated was like nothing I had experienced before in my career. If I could not share the stage with perfectly good and generous people who had made a great commitment to the work, but did so from a different vantage point, it put into question the integrity of the whole *Passion* project, the album and the concerts. For the Triumvirate production team and associated musicians and singers, this would be their first experience of a concert tour promoted and hosted by evangelical Christians. I was ashamed and embarrassed in equal measure.

In the meantime, news of the crisis had spread. *Buzz* magazine had printed a story about it, marking a first by linking the words "Adrian Snell" and "scandal". There was a backlash with some concert promoters even withdrawing their support for the tour. Eventually, Youth for Christ stepped back from their insistence that we replace the two singers, but the damage had been done. Whatever excitement and joy I had experienced leading up to *The Passion* tour, there was now sadness and disappointment in my heart, and as we embarked upon the rest of the UK tour all that had passed during the last few days hung like a cloud over the team. Happily, the audience response to the concerts was hugely enthusiastic, but it was impossible to turn back the clock. As we played our next concerts, we all knew it was not the same. The tour remained a strong experience for audiences, but it had the overwhelming backdrop of upset, disappointment and scandal.

I had apologized to Debi and Shirlie and tried to explain why things had heated up the way they had, but I could not find any reasonable justification to help them understand; there was nothing to understand. In a sense, most difficult of all was trying to explain to them, Jon Miller and all those involved from the Triumvirate team how something as absurd as this could have happened at all. My many apologies to the singers felt inadequate in addressing the hurt and bewilderment caused to them personally. But I was relieved and immensely grateful to them and Triumvirate that they expressed appreciation for my stance and remained committed to the rest of the tour.

I remember the saying, prevalent at the time, that "The Christian Army, blinded by ideology, appeared quite willing to wound its own soldiers ... ", and I now had first-hand experience. This episode had left me scarred by those I had understood to be my spiritual brothers and sisters. It was a wake-up call. Until now I had found my way in the evangelical world of Christian music as someone who appreciated the underpinning elements of faith and, as such, spoke the language. At the same time, though, I had been critical of the way faith as the catalyst for Christian music might often seem to produce music and lyrics of inferior quality. No doubt there were those for whom this perception bordered on arrogance. But what had happened had crossed a line. For me, Christian music had been exposed as a vehicle that was willing to

let ideology override creativity and quality. Seeing as I was still under contract with a Christian music label, would I also be subject to that perception? And, perhaps most distressing of all, would my music, my work—and the enormous amount of *myself*, musically, creatively and spiritually that I had invested in it all—be somehow swallowed up into a world of short-lived, somewhat disposable, often artistically and critically panned products of a subculture, barely seen as a serious contender in the mainstream world of music and the arts in general?

For the first time, I actually felt trapped.

11

The aftermath of the release and tour of *The Passion* was a bitter-sweet experience. I had made sure not to let the outward furore interfere with my relationship with the singers Debi and Shirlie and talked to Jon Miller about where to go next with Triumvirate, while Kingsway continued to carry *The Passion* onward. The early sales projections proved to be right: the album was selling well—at least to the smaller audience of Christian music listeners. I was grateful for a measure of relative success but also very aware that it was inadvertently skewed.

The decision to release the album without a mainstream contract in place seemed to have had the added effect of limiting its audience. It was not receiving anywhere near the level of attention and therefore actual sales needed to cover the large costs of production and promotion.

Ultimately though, this did not deter us from the course we had set ourselves. I was definitely not ready to give up on my deeply held ambition to reach beyond the boundaries of Christian music. And neither was Jon Miller. We started looking at ways to ride the wave of this growing momentum and start working on a new album that would focus on my singer-songwriter identity. It would be a conscious effort to produce music with broad appeal whilst staying true to my artistic integrity and instincts. We were determined to seek a path that would steer clear of the many negative assumptions and the very real bias against Christian music that could so easily absorb the chances of further exposure. If that sounds

a little harsh, the reality of my experiences around the last few projects made it impossible for me not to think that way when it came to my solo career. Which is why an entirely different and immensely encouraging response to *The Passion* was most welcome.

It was a surprise to get a call from David Winter, then Head of Religious Broadcasting for the BBC. What he had to say filled me with renewed hope. He spoke enthusiastically about how the premiere of *The Passion* on BBC Radio 1 had been really well received. So well, in fact, that BBC Radio were now inviting me to compose a new musical project for their Christmas programming. The relief and affirmation I felt from this development is impossible to put into words. It confirmed to me that not only *The Passion* itself, but also my credibility as a composer was secure. So, after an exploratory meeting at BBC Radio headquarters in London, I joyfully accepted what had now become my first proper, fully funded commission . . . from no less a partner than the world's best-known and respected broadcasting institution: the BBC. I also knew, without a doubt, that it was Phil Thomson whom I would invite as lyricist for this special project.

I had been invited and commissioned by the BBC to compose a work with a particular focus on the deeply human story to be told of Mary and Joseph. There was potential scandal around this couple—Mary, who was quite likely around thirteen years old, and Joseph, significantly older, were betrothed . . . but Mary was inexplicably pregnant and, most importantly, preparing to give birth to no less than the Son of God! As we sat around the table in David Winter's office exploring all sorts of possible titles for the work, he suddenly came up with *The Virgin*. I was immediately taken with this powerful, slightly provocative identity we planned to give to the album. The BBC was keen to have a work that mirrored the structure of *The Passion* in the sense that we would identify the key characters, tell the extraordinary story, and write the musical from their perspective.

Apart from the central characters (Mary, Joseph and the angel Gabriel) we felt there were other voices that needed to be heard: prophets who had foretold the birth of the Messiah, Mary's cousin Elizabeth, King Herod and Simeon (known as the "God-receiver") who was at the temple in Jerusalem and had been told he would not die until he had seen the Lord's Christ. When it came to choosing who would be cast to voice these

characters, I had rather more input than last time. Naturally, I cherished the prospect of working with top-class musicians like Simon Phillips and John Perry again. As for the voices, after the experience of *The Passion*, it was much easier to identify the person who should sing the most important role—Mary, mother of Jesus. Shirlie Roden happily agreed to do this, providing just the kind of continuity between both works that felt natural and appropriate. I took the part of Joseph.

Jon Miller, who would produce the work, saw *The Virgin* as an opportunity to capitalize on his relationship with an American manager named Ray Nenow, who was working with Pilgrim Records, the label I was now signed to. Ray was said to be well connected and you only had to consider the people he put forward to play and sing on *The Virgin* to know this was true. First was the singer Bonnie Bramlett. She had become a star as part of the husband and wife duo, Delaney & Bonnie, earning a reputation for her heartfelt vocals that suited a number of styles. Jon and Ray felt her voice was perfect for the part of Elizabeth. When she arrived in the studio with all the presence of a true star I had to agree with the managers: this was something special.

And Ray had more surprises for us. He had taken a few Christian artists under his wing who would not only assume roles on *The Virgin* but would later prove to be mainstays in their field. There was the wonderful, mild-mannered Norman Barratt, who would come to life like a raging fire when playing guitar. He was a great fit for the emotional extremes found in the character of Herod. Then there was Paul Field, who was fresh off his run with the band Nutshell and embarking on a solo career. He would be an innkeeper, as would my former producer John Pantry. Ray then introduced another of his protégés: Joe English, a singer who had reached the heights of music royalty as part of Wings, the ensemble that Paul McCartney toured with. Joe had become a Christian and, in a sense, had traded the high-profile life of VIP hotels and sold-out stadiums for the more ragged and often semi-professional reality of Christian music. He had formed his own band, the Joe English Band and recorded its debut album *Lights in the World* the same year *The Passion* was released. Joe agreed to voice the part of the angel Gabriel, and I was delighted at the powerful, high-range, rock vocal he produced in the recording.

Because *The Virgin* recording included several speaking parts, I decided to ask my brother Christopher to voice one of the prophets. While it was a minor speaking part, I had faith in my brother to deliver, and he did not disappoint. I was sure Christopher appreciated being asked. He was striving to become an actor, but somehow his career path had not been as successful as he had hoped. It did not help that my parents were now supporting me wherever and however they could, but my father was hesitant to do the same when it came to an acting career for my brother. This was no simple matter of favouritism, as my parents loved us both dearly. For my father, it was a matter of practicality winning out. He did not see—*could not* see—acting as the area in which Christopher's talents were best spent. It must have been hard on my brother, who had spent the past couple of years watching my parents do whatever they could to support *my* talent, while stopping short of doing the same for him. It was a strange reversal of roles when I stopped to think about it. As a little child I had always had the impression of Christopher being favoured or protected more than me, seeing as he was the younger brother. Asking Christopher to give voice to the very first prophet heard on the opening track "Light of the World—Part 1" carried with it the weight of my belief in him and an expression of our greatly improved relationship.

The Virgin was broadcast at Christmas 1981 on BBC Radio 1 coinciding with the album release. Not for the first time I would be frustrated by the lack of effective promotion and marketing for the album, especially given such a high-profile opportunity as the Radio 1 broadcast upon which to base a campaign. For the album to have stood a realistic chance of breaking out way beyond a Christian audience, it would have needed promotion in record stores, articles and interviews in the music press, songs featured on radio playlists . . . and more besides. Perhaps it was then that I faced up more honestly to the limitations that would be a permanent part of my career as long as I held on to my safe and familiar surroundings where I was supported, but where there was little artistic challenge.

The disappointments around the album release were compounded somewhat by one of its few live performances. We had been happy to accept an invitation to play at Greenbelt, a music festival that was at some point billed as a place where one would have "a Bible in one hand

and a newspaper in the other". It was a festival that did not believe in the testimonial character of Christian music taking precedence over its artistic merits. It had seemed like a good fit to introduce *The Virgin* leading up to the holiday season, but by the time we hit the stage the heavens had opened up, high winds wrought havoc with equipment and stage notes, and our depleted audience was well and truly soaked!

The Passion and the release of *The Virgin* relatively soon afterwards may have left part of my audience with the impression that I was first and foremost a composer of large-scale, rock opera works. The humble beginnings of *Fireflake*, through to *Something New Under the Sun*, along with my singer-songwriter credentials, had possibly receded to the background in the public eye with the understandable draw towards the large-scale spectacle of performances of *The Passion* and *The Virgin*. I had, in fact, already written enough songs, many with Phil, to form the basis of a new solo album. These songs and instrumental pieces covered themes and ideas better suited to a regular, secular record label. However, it was to Kingsway's credit that they allowed me the artistic freedom to record and release *Cut*. After all, their fundamental remit was to advance the Christian faith through music with devotional songs designed for congregational and private worship—not quite the same as those I had produced.

So, in autumn 1981 Kingsway Music released *Cut*, produced again by Jon Miller and Triumvirate. We all felt it was now important to shift focus once again to a market in the United States—way across the Atlantic Ocean, an ocean that was about to dominate the news.

12

A defiant Margaret Thatcher was announcing on television that a British task force was to set sail towards the Falkland and South Georgia Islands. The islands had been taken over by Argentinian forces, and the British response had been swift. With diplomacy failing, thousands of troops from the navy, air force and army were now on their way to the far end of the South American peninsula, bound for what clearly threatened to be

armed conflict. As Sue and I were watching it all unfold on the evening news, it felt eerily familiar to me. Surely this was the kind of global news that had caused me inner conflict as an impressionable teenager: the kind of conflict that had me looking for a proper spiritual answer and context, safely within reach. This time, however, the news hit much closer to home.

Five years prior to this crisis my father had been appointed Bishop of Croydon. It was a title that carried with it the position of Bishop to the Forces. As with everything, he approached this responsibility with great empathy. And there was also the struggle that came from being confronted with the suffering, heartbreak and worries of the families whose sons and daughters had been shipped off to war, families who were desperate to hear any news that could let them know their loved ones were safe. As crisis turned to conflict in what was now designated "Operation Corporate", I watched my father face one of the deepest struggles of his life. For the first time since the Second World War, a Bishop to the Forces was to provide spiritual guidance and comfort to British personnel in direct conflict. Newspapers, tabloids and magazines were flooded with bold headlines that had their way with puns like "The Empire Strikes Back" or even "Britain 6, Argentina 0", desensitizing the tragedy of war by comparing it to popular movies and a sports match.

My father, meanwhile, fought his own battle. Those higher up in the chain of command had left no illusions as to what they felt the job of the Bishop to the Forces needed to be. As far as they were concerned, he was to have a ceremonial role, be wheeled in as a visual representation of the church and then wheeled out again, ready to be called upon when they felt it was appropriate or opportune. Stuart Snell took a radically different approach. His take on the position of Bishop to the Forces was that of a hands-on approach. He insisted on being the voice of the church, its pastor to service personnel as well as its comforting hands for their families. With the death toll mounting, his inner turmoil followed suit. How could he comfort the families of fallen soldiers and proclaim the inclusive redemption of the gospel while at the same time face a public framework that was dehumanizing "the other side"? By June that year hostilities had ended. Almost one thousand soldiers from both sides had lost their lives and thousands more had been wounded. My father

visited the islands the following year, conducting a memorial service and consecrating cemeteries while taking a personal interest in all those affected by what would from then on be called the Falklands War.

While there was the obvious and overt strife in this situation, my father's struggle in this conflict was, deep down, one of integrity. And it resonated deeply with me too. His resistance to the expectations laid upon him had everything to do with what he felt was the purpose of faith and the position a person of faith was to have towards their fellow human beings. He was unwilling to ignore his convictions and empathy for the sake of ceremony. I admired him for his principled stance and the example it set for me. If I were to take it to heart and put it into practice myself, it would certainly mean an equally principled approach to my career in music and what I perceived as its function to my audience. But, in my case, the gap between authenticity and the practical reality was an apparent problem in the music industry.

What was now widely referred to as the Christian music industry seemed to me to be rooted in shallow expectations. Musical quality could easily suffer on account of lyrics that read like simply-worded tracts. And the dominating position lyrics had in the genre did not really allow for a creative push musically. On the industry side, little was done to improve the situation. In fact, the growth of the genre as a whole seemed to be taken as a sign that this was the way to go. I had certainly met musicians and artists that were keen to produce quality music that pushed the boundaries. There were incredible singers and wonderfully thoughtful writers, but at the end of the day albums often seemed to cater to a mindset that was looking for quick profit margins instead of challenging the listener to engage with life in an authentic manner.

Seven albums into my career, I struggled with the reality of that kind of commercial music. My struggle was not born out of naivety alone but more out of a sense of responsibility and a need for authenticity, modelled on my father. I believed then, as I do now, that faith speaks to all aspects of life, including musical taste. I wish I could say that I held a balanced view of my craft and position, but the reality was that I felt torn. I did not allow myself the freedom of expression that came from a truly liberating faith. Instead, the cultural trappings of organized Christianity meant that fear and uncertainty played a hidden but very much present role. The fear

of how I was perceived, of my intentions coming through muddled or skewed, the fear of outright rejection, of making wrong choices . . . this all played a part. However, I would be remiss if I did not acknowledge both my genuine desire for my music to be authentic and the genuine belief the staff at Triumvirate and Kingsway had in my music. We did our best to navigate the waters after each release, trying to figure out if the songs resonated with a larger audience for the right reasons. And we were all still very much open to new adventures in the United States.

A new plan had been brewing following advice from Ray Nenow. It was agreed that I would start writing songs with Tom Douglas, one of his American writers. Once we had enough material I would travel to the United States and record it for a new album using the Joe English Band as the musicians. The idea was clear: by involving a US crew, developing songs that moved more towards the American mindset and vocabulary, as well as recording an album on US soil specifically for the Christian market there, we would move all the pieces into place in order to have a genuine shot at opening up America to Adrian Snell.

On the heels of *The Virgin* this would be an album unapologetically aimed at a Christian audience. *Midnight Awake* was released in 1983. Although the album received positive reviews from several magazines, it did not take long to discover that *Midnight Awake* had essentially fallen between two cultural identities: too British for the American Christian audience, whilst too American for my loyal European supporters. But I had gone as far as I felt I could in order to connect to US culture and tastes. I still chuckle when I hear some of the lyrics that were born out of that effort, like the mention of "factory whistles blowing" in "Still Your Heart", and then the cover image showing me shivering, wrapped in a scarf, with London Luton Airport's lights in the background. If anything, this album succeeded in communicating that I had stepped out of my comfort zone, perhaps in a way that was not really helpful.

Feed the Hungry Heart was, in many ways, a return to familiarity. I rekindled my writing relationship with Phil Thomson and turned once again to Eugene Press for the cover art. We had also signed a new recording agreement with Word Records, a label that was well established in the Christian music world and was operating with a separate imprint called Myrrh. Word Records had branched off in the UK as well, so it

made sense to commit to a label that was able to release my music almost simultaneously on both sides of the ocean.

The new album received more favourable reviews than *Midnight Awake*, being frequently described as "a return to form". Flattering as it was, I knew where it was coming from. From the eclectic opening song of "Welcome to the Circus" and on through the subsequent tracks, the album felt refreshed. If you had asked me at the time, I would not have hesitated to point out the factors that had had a recent impact on my faith and world-view and, subsequently, the music. First of all, Sue had recently given birth to our second son, Ryan. The responsibility of fatherhood had overwhelmed me at times, but I must stress that, due to me being on the road so much, Sue was faced with the challenge of parenting our two young children, soon to become three with the arrival of our daughter Carla, and was on her own for long stretches of time.

Having witnessed my father's struggle with his responsibility to maintain authenticity surrounding the Falklands War, I had picked up a book by a theologian called Clifford Hill. The book's title was *The Day Comes: A Prophetic View of the Contemporary World*. This had intrigued me as the use of the word "prophetic" often suggests a sneak peek into the future. I had kept on trying to cope with the injustice and suffering of this world by means of song, conveying the chaos in "Welcome to the Circus" while communicating what I knew to be the true fulfilment of humankind's "God-shaped hole". On the new album, this took the shape of songs like "Only Jesus" and "Feed the Hungry Heart", both of which became favourites during live performances.

Reading *The Day Comes*, I was eager to learn what Hill's view was on the state of the world. We had seemingly thrived as a society in terms of wealth and development, yet darkness never seemed more than a moment away. It was that ever-present darkness that had begun to eat at me, since I was increasingly convinced that Scripture was not to be used as some type of spiritual home improvement, plugging leaks and repairing holes in a foundation, waiting for the next problem to present itself. I was looking for clues that would reveal the relevance of Scripture to me in new ways, and what Clifford Hill described as being prophetic really struck a chord in me. He said that prophecy should focus on "forthtelling the Word" rather than "foretelling the future". I had begun to grasp what he meant

by this. If the "Word" was the Word of God, it was a Word spoken and written from the perspective of a God who was both beginning and end, a God who made himself known not just to cultivate a relationship with us but also to allow us glimpses from his eternal perspective.

I set out to read the book of Revelation after reading *The Day Comes*. I found myself profoundly caught up in the hope and promises flowing from the visions given to John. I decided to end *Feed the Hungry Heart* with a song that would be an interpretation of words and images from the opening chapter of the book of Revelation. As such, "Alpha and Omega" closed the album as a hopeful, prophetic declaration of a future that would see all things made new. At the time, it felt like a majestic conclusion to an album I was very proud of. But it later turned out to be a song that would mark just the beginning of my personal journey through history's deepest darkness, a journey that would deeply impact and shape me and my music for the rest of my life.

Above: Let the outfit do the
talking, Fireflake era.
Right: Early days, casual
wear, sharp focus.
Below: Focused in concert, 1984.

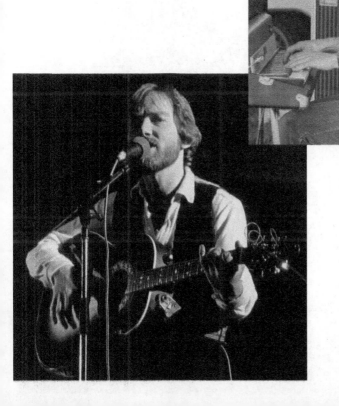

Something New Under the Sun
Adrian Snell

LISTEN TO THE PEACE ADRIAN SNELL

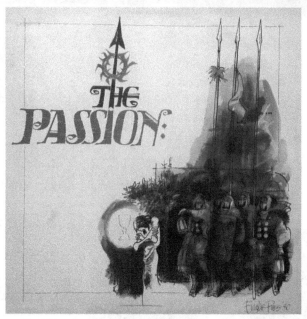

THE PASSION:

ADRIAN SNELL Goodbye October

ADRIAN SNELL FEED THE HUNGRY HEART

Above: Meeting Princess Diana, concert for the Leprosy Mission.
Opposite: Original cover artwork by Eugene Press.
Below: Relaxing with Sue.

Above: Performing The Passion *on Dutch television.*
Below: With the cast of the televised performance of The Passion.

PART 3

Lost Children

I have always related to the biblical parable of the shepherd that left the ninety-nine sheep to look for the one that was lost. By today's standards this would seem irrational. We live in an age of risk management, cost effectiveness and efficiency. The act of going out of your way to seek out an individual in order to return it to a group, a community, a shared experience . . . is something almost counter-cultural. But as a new father, I could relate to this story with a fresh conviction. There was nothing I would not do for my children. In fact, I would not characterize this as a conviction but more as an instinctive need to protect, to shelter, to meet the need for a safe space.

It would be many years later that I would come across a description that let me look at this paternal instinct with fresh eyes. As I was listening to BBC Radio, a father was being interviewed. He explained how his son had been bullied in the playground and he had seen the hurt it had caused his child. The man went on to articulate his immediate response, namely, that just prior to the intervention of another adult he was quite simply overwhelmed by an almost primal urge to rush to the scene and protect his son using whatever means were necessary, including physical violence. He made it clear that he was not by nature a man easily drawn to violence. He described his feelings at that moment as a "fierce love". The moment he recounted this, I understood—immediately and completely.

We often observe this kind of fearless, protective instinct in the animal world. Witness the ferocity with which a lion protects its cubs in the face of threat or danger. Real love and devotion between people, especially for our children, our flesh and blood, is risky. It feels comforting, safe and logical to feel and express love when all is well, when our children are living in safety and comfort. It is when our children become lost—sometimes

to themselves—or are facing any kind of danger, that our unconditional, selfless love is needed the most. It is at those times that our love becomes fierce, ready to overcome any obstacle or threat in order to reach our child, to correct the wrong, to provide shelter, refuge, once again.

When I decided upon *Fierce Love* as the title for my album (and subsequently this book), I sought out a few dictionary definitions of the word "fierce": frightening in action, eager, intense, strong, uncontrolled, are a few of them. One could legitimately, I think, attribute a degree of irrationality to the behaviour you might associate with those definitions. Many of us see irrational behaviour as something negative, something to be feared whether coming from us or others. But what is rational about love? What on earth is rational about loving and caring so much for another person that, in certain situations, we might be willing to sacrifice life itself in order to offer ultimate, complete protection? And that is surely no more apparent than when reflecting on the love parents have for their children.

The idea of God being a *fierce* God, ready to protect his children in ways that we might deem frightening, is a challenging one. Of the many names or descriptions given to Jesus in the Bible, one of my favourites is "Lion of Judah". Now that I had become a father, I was about to embark on a phase during which I would identify with lost, vulnerable and hurting children in ways I had never expected. Their stories would be seared into my heart, fanning the flames that drove me to want to protect, to comfort, to heal; to make certain their voices were heard. And whilst finding and sharing in their stories I would find myself frequently overwhelmed by exactly that . . . fierce love.

13

Lying in bed in the guest house at an army base, I had trouble sleeping. I should have known it would not be easy to get a good night's rest. From the moment I had arrived here, I had felt it. A sense of unease, of something pressing down on this place in northern Germany. I would never use the word "oppression" lightly and did not do so now. It felt as

if an invisible, spiritual war was taking place and that it was somehow linked to this area surrounding the town called Bergen, impacting on everything that took place here, including the concert I had given just hours ago.

I had come here as part of a tour of British Army bases around mainland Europe together with Dutch colleagues and musicians. Unorthodox as that might sound, the connection with my father as Bishop to the Forces and my growing interest in Europe's twentieth-century history, sharpened since reading Clifford Hill's *The Day Comes*, had played a part in getting me here. This feeling of unease had persisted as we set up our gear and during the concert itself. We played a selection of *The Passion* and some of the newer material from *Feed the Hungry Heart*, ignoring the occasional heckling from sceptical squaddies when there was a series of technical problems. It is never a good thing to have this happen in a performance as the carefully crafted mood and atmosphere can easily be demolished by equipment failure. I discussed it with the army chaplain after the concert. He apologized for the heckling, then asked me how I felt it had gone. I started by uttering a general statement about the audience's reception, but quickly felt compelled to say more.

"To be honest, I have rarely felt such a sense of oppression during a concert performance," I said.

I was puzzled by the seeming lack of surprise on the chaplain's face.

"Are you aware that we are no more than two kilometres away from the site of Bergen-Belsen, the former concentration camp?"

Of course, I thought. We had been so caught up in the usual practicalities of the day that I had not even registered that Bergen and Belsen were two little villages, linked together and now infamous, forever to be referred to as Bergen-Belsen, one of the Nazi death camps. Tellingly, the chaplain had known immediately what I was referring to as I described the spiritual struggle that I felt here. He started pointing to specific spots in the landscape surrounding us.

"Do you see that patch of green there? It may well have been a mass grave. And over there is where the former SS headquarters were located."

He then proceeded to describe how soldiers had frequently broken down in this place, apparently no longer able to bear the weight of this terrible, invisible burden. An image came to me: these soldiers were

designated keepers of the peace in this time of Cold War, stationed behind an iron curtain that had divided Europe both geographically and ideologically. This place had forced them, as peacekeepers, to cope with the horrific acts of man, the macabre inheritance of a war that had spilt the blood of millions.

Knowing all this now gave context to the oppression I felt. And I understood how the knowledge and history of this place could confront people in such a way, so that they had to respond. I felt I had to respond as well. I asked the chaplain if we could visit Bergen-Belsen the next day, which he agreed to. We returned to our guest quarters and tried to sleep. In vain. What's more, as I was lying here now with eyes open, I could feel the floor and bed vibrate as an ominous sound echoed from afar. It was as if a giant drum had reverberated over the landscape. But it sounded like muffled explosions. I had never experienced an actual war, yet these unnatural sounds felt exactly like one. I turned away from the sound, closed my eyes and tried to go back to sleep . . .

The next morning we set out to visit Bergen-Belsen. I talked to my Dutch colleagues as we made our way there, and admitted to not getting much sleep.

"I spoke to an officer about the vibrations we felt," I told them. "Apparently, they're due to a NATO exercise." An exercise that was still in full effect, apparently. As we were walking, we could feel the ground beneath our feet shudder from each new explosion in the distance. It felt like these were constant, sensory reminders that we were in a place of turmoil, a place that could not distance itself from the realities of the threat of war and the weight of its dark history. As we entered through the gates of Bergen-Belsen, history became even more real. We stepped into a memorial like no other. The first thing I noticed as we started walking around was the silence. Not a word was spoken. There were no ambient traffic sounds or regular clatter of a crowd. It was a reverent silence, but still we could feel the earth beneath us tremble from the NATO exercise.

Scattered throughout the patches of green were stone markings. Some were built up, pyramid-shaped, on the side of what seemed like an artificial hill. Others were tablets, placed at regular intervals as far as the eye could see. It was unmistakable; we were walking through a graveyard. As we made our way alongside these stones, I read the inscriptions.

They were written in various languages, but had one thing in common: a number. The number of people that had perished here and had been put into a mass grave. Every few steps, these numbers kept going up: 500 ... 1,000 ... There was no measure by which I could possibly rationalize what I saw here. Tens of thousands of lives had ended here. Countless people had been killed in unspeakable acts of evil, their bodies buried beneath us.

As I moved from stone to stone, I experienced something I could not explain. There was a voice speaking directly to my heart. It was as if someone was standing beside me, speaking out loud. I would never characterize this lightly, but I felt it was God speaking to me at that moment. And the nature of what he spoke to my heart was:

"Do you see what I see? Do you hear what I hear? The innocent blood of tens of thousands cries out to me from the ground. And yet here, where my children lie buried, still there is no peace on the earth, because still you rehearse for war."

Blood crying out from the earth: an indictment against humankind. I could not help but think of Cain, who had slain his brother Abel in the field, consumed by jealousy. The account in Genesis 4 is brief but confronting in showing God's response.

"What have you done? Listen! Your brother's blood cries out to me from the ground." (Genesis 4:10)

It was a painful revelation, standing in this place. History seemed locked in a cycle of repetition. Humankind had spilt blood in its earliest history and continued to do so. It cried out from the ground, then and now. And just as God had not been indifferent to that cry when he confronted Cain, he would surely not be indifferent now. Over the course of my faith journey I had clung to the character of God that was most revealed in Jesus' personification of his Father: unconditional love, forgiveness, peace ... but Cain's story left no doubt that God was also Judge, speaking with authority over his children. I felt, at this moment, standing on the site of the former concentration camp, that God was indeed *still* listening to the innocent blood of these tens of thousands, crying out for justice from the depths of the earth. And God was still Judge.

But how to reconcile the presence of a righteous Judge and the promise of justice when surrounded by the result of what had seemed like unhindered evil? While some people had resisted injustice, why had God not called out: "Where are your brothers? Your sisters?" Was there a purpose to this perceived silence? What, in essence, did God have to say to the Church today about these dark chapters in our history? What was he saying to us as we continued to prepare for conflict whilst remaining wilfully ignorant of the facts, the reality behind this recent, terrible history?

When I returned home, I began to work on a piece that would let the language of music convey the impressions of my visit to Bergen-Belsen. Sitting at the piano, I tried to recreate the rumbling sounds of the gunfire and bombs. I tried to recreate the tension and oppression I had felt in that place: the cries from the ground, the injustices of history and the looming presence of war. I knew I had to turn to music to find a way of expressing the conflict I felt within me after experiencing what I knew in my heart was God's voice. I also began to dig deeper into this dark chapter in Europe's history and, in particular, the Holocaust. As much as one might feel they know the facts from history lessons at school, the cold statistics come to life when you visit the place where it actually happened. I was struck by one statistic in particular: out of the six million Jews murdered during the Holocaust, 1.5 million were children under the age of fifteen. The number kept staring back at me: *1.5 million children*. The ultimate acts of evil, carried out over the most innocent and vulnerable. How could people inflict this kind of suffering on one another? How could I reconcile this fact with the representations of God as the God of Love, the Father, who takes care of his children, who watches over us? What did history mean in the context of who I perceived God to be? The question of God's place in history and what that meant for us now had become increasingly important to me.

I did not have to wait long to find a place and a context where I would be able to articulate these momentous questions, knowing there could never be black-and-white answers, only glimpses of daylight in the spiritual fog. Within a few weeks of returning from Bergen-Belsen, I received a letter from Clifford Hill, the author of *The Day Comes*. I was thrilled to be in contact with the author of such an impactful book. He

approached me to tell me he knew of my music and to put forward a
request:

> I am organizing a conference that is to take place in Jerusalem
> next year. It will bring people together from all over the world—
> people with a specific calling. A ministry to seek out God's heart
> for the world. We want to explore the question: "What is God
> saying to His world, His children right now, in the present day?
> What is God's heart for us—firstly His church, and then through
> His church to our societies as a whole? Surely the Creator of
> the Universe could not be silent in the light of the appalling,
> murderous history of the 20th century?"

"This is extraordinary", I remember thinking as Clifford Hill laid out
his vision for the 1986 conference. These were precisely the underlying
questions that had informed my search through the recent history of
Europe, culminating in the Holocaust. Then he went one step further:

> Would you be interested in writing a musical work to express this
> outpouring of the heart of God? A work we could present as part
> of the conference in Jerusalem and as part of a call to the nations?
> Would you be willing to do this?

I was typing my reply barely seconds after finishing reading his letter: "I
cannot think of a greater privilege. Let's meet up to discuss what shape
this would take."

As we began to discuss this project in depth I was drawn to my song
"Alpha and Omega" from *Feed the Hungry Heart*. I could not fully grasp
why at this stage, but something was telling me that it would become
integral to the work I was about to start composing. And I already had
the music, as yet untitled, that I had written in response to my experience
of Bergen-Belsen. These two pieces of music seemed, on the surface, to
be polar opposites, but I was about to discover how they would connect,
even frame the work that was to come. My life—to be more specific, my
faith—would not be the same afterwards.

14

I was standing in a dark room at Yad Vashem, the Jewish memorial to the Holocaust, located on the western outskirts of Jerusalem. Translated, Yad Vashem means "a memorial and a name", words taken from Isaiah 65:5: "Unto them will I give in my house and within my walls a memorial and a name better than of sons and of daughters; I will give them an everlasting name, that shall not be cut off." (ASV)

I was surrounded by thousands of lights, each one representing a child's life lost in the Holocaust. There were too many to count. In fact, the room felt like I was stepping into the sky and immersing myself in the stars. It was silent except for a single voice, slowly naming each and every one of the victims. These children were not forgotten. Their names were spoken as an acknowledgement of the worth of their lost lives; an ever-continuing memorial that would have an impact on millions of people. I was certainly deeply affected.

This was my first visit to the Holy Land, to lay the groundwork for the conference at which I was to present my new work. I had come here to follow the path that my visit to Bergen-Belsen had opened up to me. I was keen to learn from the rich history of the Jewish people, though I was not sure what to expect. Contrary to what you might think, I had had no desire to visit Israel before now. Many people would assume I had, especially following *The Passion*, but I suppose I associated a trip with being a tourist in a museum. I had been interested primarily in the tangible present. Going to Bergen-Belsen had opened up the pages of history and awoken my heart to the plight of the Jewish people. It had given me pause to reflect. What was to be my response to the darkness that confronted me there? What could I say through this yet-to-be-completed work? Exploring this would mean that I, as a Christian, would have to come to a place of acceptance that the Church to which I belonged has a dark history when it comes to its theology, its teaching and actual practice towards the Jewish people over many centuries.

During the flight over, I had already been introduced to aspects of the practice of Jewish faith I had never fully explored—how interwoven into daily life it is, for example. Orthodox Jews were constantly making

their way to the back of the plane to pray. As soon as it touched down, an excited shout went through the cabin, a pure expression of the gratitude and joy around homecoming—Jewish families returning to this land that they had been linked to for thousands of years.

I already knew I would visit Yad Vashem on this trip. I needed to know, truly *know*, much more about the Holocaust in order to bring all my heart and soul to the music I would be composing in response to what I learnt, discovered and grappled with over the coming days. On arrival, I made my way along the Avenue of the Righteous Gentiles. This path is flanked by long rows of trees, each dedicated to someone who stood by the Jewish people in their time of need during the persecution. I realized as I was walking how everything at Yad Vashem was there in the service of education and remembrance. Not just a general acknowledgement of a piece of history but true remembrance. Names. Faces. Ages. Every name had its own story. It was a truly sobering experience to walk through room after room and grasp the staggering scale of the Holocaust, of which the concentration camp at Bergen-Belsen was just one part.

There was a whole room at Yad Vashem dedicated to the "Art of the Holocaust". The extraordinary paintings to be found there have seared themselves into my soul over many years, immensely powerful visual expressions of what could never be adequately described in words. I moved on and made my way to the children's memorial. Immediately, they caught my eye: hundreds of children's drawings, no doubt often encouraged by parents and teachers as a way of coping with the awful reality of the ghettos and concentration camps. Some children drew what they sought to hold onto, or dreamt about, of their normal lives before all of this: family, a warm house, the shining sun, a colourful garden, a butterfly. And the colours were as bright as their imaginations. Others were simply too traumatized to draw from a place of childish innocence. They drew reality: soldiers, explosions, barbed wire, dark shades and greys that reflected their experience of daily life. It was heart-breaking to see.

Then I noticed the poems. There was one section of the room where there were displayed literally hundreds of poems written by the children of the Terezín Ghetto/Camp situated just outside Prague, in what was then Czechoslovakia. I discovered that these poems had survived the

Holocaust because they had been so well hidden by the teachers who had encouraged the children to write them. I was drawn to one particular poem entitled "Fear". It had been written by a twelve-year-old girl named Eva Picková who was murdered in Auschwitz a year or so later. I began to read:

Fear

Today the ghetto knows a different fear,
Close in its grip, Death wields an icy scythe.
An evil sickness spreads a terror in its wake,
The victims of its shadow weep and writhe.

The poem concludes:

No, no, my God, we want to live!
Not watch our numbers melt away.
We want to have a better world,
We want to work—we must not die![6]

I was amazed at the ability of a twelve-year-old child to express so powerfully such an existential struggle. I was moved to tears by Eva's ability to speak directly to me across the passage of time. I did not yet know how or when, but I instinctively knew that "Fear" would most certainly have a place in the story I was to tell. I copied the words into my notebook and moved on to the Hall of Remembrance.

Scattered throughout this room were stone plaques listing the names of the various concentration camps and the number of men, women and children that had been systematically slaughtered there. There was total silence . . . save for the sound of people's tears . . . and as I stepped out of the Hall, once again I could not hold back my own. There were so, so many tragic stories here, but I felt that my tears, at this moment, were for the children. So much innocence lost; so much pain inflicted upon the most vulnerable; so much potential eradicated from countless European villages, towns and cities in the space of five years. Then and there, I knew that I was on a path that would take me way beyond the upcoming Jerusalem conference and my music commission.

This was now becoming a challenge to my faith and my understanding of humanity as never before. And the indictment upon the Christian Church, historically, was unavoidable. To our immense shame, we as a people, a body, were truly culpable, at times directly, but more often through complicity, false teaching, prejudice and wilful ignorance. There was no denying it.

As I revisited the children's drawings and poems, my heart and mind were full of conflicting thoughts and contradictions. Here I was, just outside the City of Peace—Yerushalayim, a place that had witnessed and endured centuries of conflict and war, a city more times destroyed and built than any other on earth. Where did Yad Vashem fit into God's promise to his people? Indeed, in a sense, what other questions *should* we ask? And what does the Creator of the Universe, the Father and Mother of us all, say in response?

That Friday evening, as we were about to move into the Sabbath, I stayed with the host family that was introduced to me through a mutual friend. Pam and Shmuel Suran were Jewish Christians and the kind of warm and vibrant personalities you simply want to be around. Pam was an artist herself. We spoke in depth about my visit to Yad Vashem. I shared just how deeply it had affected me. Then we listened to my first demos of the material I intended to use in the upcoming project. Immediately after listening to the opening piece, an instrumental track, Pam sat up and asked:

"Adrian, with all these sounds like muted explosions and gunfire— what is it about, how did it come to be, does it have a title?"

"No," I admitted. "Stylistically, I envision this whole work as a kind of contemporary oratorio, and this is definitely going to be the opening piece. For me, it sets the scene somehow. There's a powerful story behind it, but as yet I just don't know what to call it."

Pam insisted that I tell them the story. And so I did. Everything, from the arrival at the British army base, my visit to, and experience of, Bergen-Belsen and then, unmistakably, the voice of God . . . to my heart.

I finished my story. There was a brief moment of silence. And then Pam spoke: "You have written a Kaddish." Shmuel nodded silently, solemnly, in agreement. Pam quickly realized from my expression that I had never heard this Hebrew word let alone understood its meaning.

As she beautifully, sensitively explained it to me, what had been so powerfully revealed to me as I stood in that open field, now found its completion somehow.

"A Kaddish," she told me, "is a prayer that praises God as the creator and author of life itself, whilst mourning the dead. It is a customary Hebrew prayer that is spoken at the time of a person's death. Many of the people in the death camps had no one left to mourn them, no one to remember them. A truly shocking reality is that, uniquely during the Holocaust, Jewish men, women and children recited the Kaddish over themselves . . . You have written something wonderful for Jewish people. You've written a Kaddish for Bergen-Belsen."

I was stunned at this insight. "Thank you," I uttered in response. "Yes, I see it now. This is what the piece says. It is a Kaddish."

An article by Ephraim Gastwirth later confirmed it to me and gave more context to what was indeed to become the opening piece of this new work. He talked about three concepts in a Kaddish. First, how there is life and hope in the midst of death. It is in essence a hymn of thanksgiving that we can live and declare the greatness of God. Second, it is an acceptance of God's will—a submission to the ruler of the universe. Third, it is a prayer for the future of humankind and for the fulfilment of the prophecies of the unity of humankind in the worship of God. The Kaddish concludes: "May he who makes peace in his exalted places, make peace upon us and upon all Israel."

On reading this, I knew for sure that this was part of the thread that began in Bergen-Belsen and that would eventually connect such darkness to the exquisite hope to be found in the chorus of my song, "Alpha and Omega":

> So rejoice, the Holy City comes,
> Oh rejoice, the New Jerusalem,
> Oh rejoice, be ready now
> He comes to take His Bride
> He is Alpha and Omega, the Beginning and the End.[7]

The struggle that was personified in Israel's name, the great themes of the prophet Isaiah and the promise of that Holy City that would form the basis of this work, would begin with this "Kaddish for Bergen-Belsen".

Back home, I called Phil Thomson. There was no doubt in my mind that he was the person I wanted to accompany me on the journey, helping me to give voice to this revelation. He was delighted to do so. We decided early on to contact Clifford Hill and talk in more depth about the overarching themes of the work. We gathered notes, shared ideas and started writing. Gradually, we came to a clear structure. *Alpha + Omega* would be divided into chapters. The first, opening with "Kaddish for Bergen-Belsen", would be "God's Case Against Mankind". We wrote several songs that voiced the indictment against, and the folly of, humankind: the fierce proclamation heard in "The Nations Rage and Fall"; the tender but tragic "Nobody Listens"; the heartbreaking, musically ambitious "Guns of Peace". The second and third chapters would come under the heading: "God's Warning of Judgement". The song "No Escape", based on Isaiah 24, contains some of the most graphic, unsettling language in the Bible, when giving voice to God's wrath and anger at the abuse of his gift of life. I expected and intended that this piece would cause unease. We had, we have, every reason to feel uneasy.

I had often performed in Christian circles where God's love was celebrated and proclaimed as absolute, everlasting and unwavering through Christ. What was an error in thinking was that God should therefore no longer be described as a God of wrath. Surely the promise of the Messiah was an expression of both God's judgement and his love. Phil and I based the song "Child of Darkness" on Isaiah 1, voicing God's heartbreak at his children going astray, living in fear.

We knew the songs of *Alpha + Omega* would be fundamentally an expression of God's relationship with his people. In this relationship lay the key to understanding from the perspective of past, present and future, darkness and light. The fourth chapter would be "God's Great Love—The Way of Salvation". We had written several songs exploring the character and unique perspective of Christ: "Man of Sorrows" and the upbeat "I Am the Way" were to become the centrepiece, the turning point of the album, whilst "Lord Have Mercy" would become the congregational, hymn-like bridge to the final chapter: "God's Promise—The Hope of Mankind". With

songs like "Streams in the Desert", "And They Shall Prophesy", "And in That Day" and "Alpha and Omega—The Beginning and the End", we delved deep into the prophecies of Isaiah and Micah as well as the book of Revelation. This was to be a triumphant crescendo, expressing in music what the people of Israel proclaimed in their exile, their pain and the refuge of their land: the hope of true salvation, breaking the chains of fear forever, fulfilling the promise of Messiah and the new Kingdom of Heaven and Earth.

We had the songs. We had the structure. Next, we needed to commit this vision to tape. I had asked both my old college friend Dave Bainbridge and sound engineer/guitarist Neil Costello to co-produce *Alpha + Omega*. We decided on an unconventional approach for the recording. My home in Leeds was to become the studio. The downstairs lounge was the main control room. Neil had set up a mobile recording unit. We used an upstairs bedroom for vocal recordings and other parts of the house for various instrumental sections. Before long, our house was a maze of machinery, instruments and cables. I would navigate my way between my children's toys, past furniture we had moved out of the way and up the stairs to sing these songs in my bedroom while Dave and Neil played keyboards and guitars in the living room. We lived in a semi, and it was nothing short of a miracle that we had not one complaint from our neighbours during the recording sessions. I also cannot overstate the patience and grace Sue showed during these weeks when my music all but literally consumed our daily lives. The children loved it. What child would not love all these magical machines, providing a constant stream of all sorts of sounds? I managed to involve the family in the recording as we went on, and we made new friends as well.

I asked our bass player, Les Moir, to suggest who he felt would be the best saxophonist and flautist for this project. He immediately and wholeheartedly recommended David Fitzgerald. Les reassuringly stated, "I'm absolutely sure Dave's heart will be so into this music!" "And his style of playing, his soulful sound, is just so suited to your work," he added. It was no empty boast. As soon as David arrived and played the first bars of his saxophone solo on "Guns of Peace", I knew yet another part of the picture was in place. His playing expressed everything I had felt and now sought to reproduce musically in the different songs: the cries

of 1.5 million children like Eva Picková calling out, insisting that she be heard; the cries from the grounds of Bergen-Belsen and all those other theatres of war and genocide. I was already privileged to be enjoying the wonderful musicianship of Dave and Neil; David's playing somehow lifted the work into another dimension.

For the vocal on "Child of Darkness", I had enlisted the Northern Irish singer, Joanne Hogg. I had met her before in the Netherlands when we were both visiting a conference. Joanne had shared some of her demos with me and had asked me for advice. I was greatly taken with her voice. It was expressive, haunting, tender, depending on the moment or the needs of the song. She was the perfect fit for "Child of Darkness". Coincidentally, Dave Bainbridge, David Fitzgerald and Joanne Hogg struck up a friendship during these recording sessions, a friendship that led them to explore another project, inspired by their interest in the history of European Christianity and named after an island off the Scottish coast that that has been described as the birthplace of Christianity in Scotland. Within a few years of recording *Alpha + Omega*, they would go on to form the Celtic-influenced band: IONA.

Once we had completed everything we could achieve at home in Leeds, we headed down to the capital and prepared to record live drums and percussion and then the choral elements of the work. We booked the wonderfully named "Chocolate Factory" in Wood Green, London, for drums and percussion. The final sessions for the recording were devoted to the choral and congregational parts. A fine choir can truly lift, even transform, a song. And I knew one particular choir, and their chief director and arranger, that I was sure would be right for the album. Located right next to the BBC headquarters in London is All Souls, Langham Place. The church's resident choir, the All Souls Choir, was directed by the passionate, wonderfully motivating Noël Tredinnick and was frequently used for BBC programmes. We decided to record the choir and the congregation of All Souls live at the end of a Sunday evening service, adding an appropriately dramatic element to the final moments of recording. There was still the final mix-down to complete as well as a few other finishing touches, but essentially we were now ready to present *Alpha + Omega* to the world. It was time.

And so, at last, in March 1986, I once again travelled to Israel to

prepare for the world premiere at the Jerusalem conference. This was to take place at the Binyanei HaUma, an international convention centre situated in central Jerusalem. It was a massive building, easily able to welcome an audience of 3,000 people and with an impressive stage. The venue was perfect for our first ever performance, here in the heart of Israel. It would be a concert like none I had ever performed before, not least because there would be new contributors to the performance in the form of two dancers and an interpretive movement artist, Randall Bane. The involvement of dancer and choreographer Richard Frieden happened almost as a result of a chance meeting.

I had just left a Jerusalem cinema with my friends Pam and Shmuel when we encountered a good friend of theirs. They introduced him: "This is Richard—Richard Frieden. He's a dancer . . . he's *amazing*." Unbeknown to me at the time, whilst I was engaging in conversation with Richard, Pam was gesticulating wildly behind me trying to signal that I was in Jerusalem to perform a world premiere of a new work, and that he *just had* to be involved.

To my delight, Richard needed almost no convincing; he completely and immediately grasped the vision behind the work. We sat in Pam and Shmuel's home later that evening and listened to the completed recording of *Alpha + Omega*. I tentatively looked Richard's way from time to time—this was a very vulnerable moment since very few people had as yet heard the finished work, and here was a man who had pretty much committed to joining me on stage for the performance. His response was, quite simply, overwhelming. Through tears and a broken voice, Richard said of this work more than I could have possibly hoped for or imagined. It was as if he somehow "owned it" for himself. He felt it deeply in heart, mind and soul. And it is hard to put into words the privilege I felt as I sat with these three Messianic Jews (Jewish people who have come to faith in Jeshua, Jesus), and how as a Gentile Christian I was so accepted, honoured as a new friend and respected as a composer. Over the next few days Richard, fellow dancer Mikhael Murnane and Randall Bane worked on the choreography for the performance whilst I assembled and rehearsed the musicians and singers who would be joining us for the concert.

The day I had been working towards over the last year had finally arrived. It was 26 March 1986. To my delight, Sue had been able to fly out

for the concert, bringing eight-month-old Carla with her. It meant a great deal that Sue would be able to experience this very special moment with me. At 8pm I took to the stage and positioned myself at my keyboard. Behind me were the rest of the performers, including an eight-piece choir, Richard, Mikhael and Randall—a unique blending of expressive arts. The introduction was made. The lights went down. The rumbling of "Kaddish for Bergen-Belsen" started.

Over the next hour *Alpha + Omega* had its world premiere in Jerusalem. The response was extraordinary. I can still feel the thrill when I think back on it decades later. Many people were in tears, deeply moved. Judging from their response, I think many were greatly challenged. It felt humbling to have played for this many people, to have them hear something of the heart of God expressed through my music—his cry, his call, his challenge, his anger, *yes*, but also his love and the promise of a new kingdom "in heaven and on earth". A hope and the promise of salvation. And the offering of a way forward.

When Sue, Carla and I boarded the plane at Ben Gurion Airport just outside Tel Aviv we were filled with a profound sense of gratitude. There was *so* much to be grateful for, but as the aeroplane climbed above the clouds until the land was no longer visible, I had no idea at all what the future of this work could or *would* be, beyond finishing the album and releasing it as an LP, audio cassette and, believe it or not, the very first CD release from the recording company I was signed to. We did not know yet that it would take us, literally, around the world. And the children of the Holocaust would lead me to still deeper places . . .

15

The old city of Prague is a majestic place. On this early autumn day in September 1987, I was eager to explore the historic city centre with its fifteenth-century buildings, the famous astronomical clock that dates back to medieval times and the castle complex overlooking the bridges that span across the Vltava river. I had made a special request to the Czech friend who was serving as my guide. While I enjoyed the hospitality, I

did not want to merely be a tourist. Before the end of my stay I wanted to visit the Jewish sites in order to follow the thread that had begun at Bergen-Belsen and then continued with my visits to Jerusalem and Yad Vashem.

A few years before, in 1983 to be exact, I had played a concert at a Baptist church in this city. I had been anticipating my first visit to Czechoslovakia, and specifically to the capital city, Prague, with much excitement. Sue had studied Czech in Brno, and judging from her stories and experiences, there was much beauty to be found across the country, and its people were welcoming and intriguing. It was, however, still a country under a strict communist regime. Some of the stony faces in the crowd were likely to be the expected surveillance rather than the reserved response of the conservative elders in the church. That visit had opened my heart to Czechoslovakia. Now *Alpha + Omega* had brought me back to these welcoming people through a performance in that same church. Back to Libor Mathauser, my contact (choir director and former assistant conductor of the Czech Philharmonic Orchestra), who had staged that original visit. Back to the youth choir Jas ("Brightness"), which so enthusiastically embraced the possibilities of contemporary music. And back to the rich history and culture of Prague. Unbeknown to me, the country was only two years away from a peaceful revolution that would give its citizens the freedom they had longed for.

Right now, my mind was set on tracing the Jewish story of this place. We visited a historic synagogue, a graveyard that was the resting place of the writer Kafka and ultimately the Jewish Children's Museum. As soon as I entered the place, my mind flashed back to the Children's Memorial at Yad Vashem. Here in Prague the museum naturally focused on the display of letters, poems and drawings from the children in Terezín. It was not long before once more I came across Eva Picková's "Fear".

Perhaps you have had such a moment in your life when something can be considered providence rather than coincidence. I, for one, was moved by what I considered to be an affirmation that I needed to work this poem into my next musical project. Then I noticed another poem. It was dated 1944 and was apparently written by a young boy named Hanuš Hachenburg. He had died in Auschwitz at the age of fifteen. As with Eva Picková's words, his had survived him to bear witness.

Terezín

I was once a little child,
Three years ago.
That child who longed for other worlds.
But now I am no more a child
For I have learned to hate.
I am a grown-up person now,
I have known fear.[8]

These tragic words, written by a child who was forced to live in an adult nightmare, were like a chorus to Eva Picková's heartfelt cry of "We want to live!" Hanuš Hachenburg had so tragically and accurately captured, through confrontation with war and persecution, the loss of innocence that I had also seen at Yad Vashem. Both felt central to what I wanted to convey next on my journey. I decided to include "Fear" and "Terezín" on my next project, which I would name Song of an Exile—in Hebrew "Shir Golah".

The record label, to their credit, was giving me room to explore this story in the manner I saw fit. Ian Hamilton and David Bruce, who were at the helm of Word UK, had been immensely enthusiastic about *Alpha + Omega* as a work and about the overwhelming responses we had received everywhere. In a short amount of time it had gone on to become the highest selling Christian album in Europe ever. It clearly connected with people from all walks of life. Concert invitations were following thick and fast throughout Europe, and it had freed me up to new ways of musical expression I had not considered before. Once the album was released, I had started to tour the work and make use of mostly local choirs to support the songs. I would never have anticipated this when I was recording my first album almost fifteen years earlier. The simple stage set-up and unusual pairing of myself on piano and Gerry on bass—highly appreciated by me as it was—now felt like a distant memory.

But at this moment in time, with the performances of *Alpha + Omega*, it was undeniable, night after night, that this work and this approach was touching on something existential in each and every one of us. My desire to further explore the Jewish story and roots of my faith had first led me to the Holocaust. And I knew there was more to be told of this chapter through music.

Word UK trusted me to deliver a work that was based on Jewish poems and had no mention of the name of Jesus. This may seem trivial, but in the world of Christian music this was considered controversial. In fact, I would later learn that selected shops refused to stock *Song of an Exile* due to what they claimed was a "lack of Christian content". I found this to be increasingly offensive the more I embraced the completely Jewish roots of Christianity, not to mention the Jewishness of the Messiah, Yeshua. These authors and their poems spoke of the God of Abraham, the very same God we as western Christians proclaimed was the same yesterday, today and forever. The distinctions that were made felt increasingly manufactured, superficial and plainly mistaken to me. I knew *Song of an Exile* would speak to the Church, if the Church would allow itself to listen.

The subject of *exile* had been on my mind for some time. After all, the journey of the Jewish people is, time after time, a story of exile and return. Driven from the land and scattered, eventually throughout the world, in what became known as the Jewish Diaspora. And then the return to the land, now spoken of as "making Aliyah", literally meaning "the act of going up to Jerusalem". To tell their story of exile meant that I had to come to terms with the shadow that anti-Semitism cast over the legacy of the Church in Europe. When I presented my idea to Word UK, I anticipated it would spark a debate. The next step for the record company, especially following the success of *Alpha + Omega*, would logically be to gravitate towards a similar project: another sweeping, thematic piece in line with *The Passion* or *The Virgin* perhaps. I had different plans. I proposed a work that, structurally, would be a departure from what had gone before: a musical exploration of the plight of Jewish children in the Holocaust with the two poems "Fear" and "Terezín" at the heart of it. I wanted to include passages from the prophets, particularly Jeremiah and Isaiah:

> "A voice is heard in Ramah,
> mourning and great weeping,
> Rachel weeping for her children
> and refusing to be comforted,
> because they are no more."
>
> *Jeremiah 31:15*

But Zion said, "The Lord has forsaken me,
 the Lord has forgotten me".
"Can a mother forget the baby at her breast
 and have no compassion on the child she has borne?
Though she may forget,
 I will not forget you!"

Isaiah 49:14–15

I had been studying Jewish literature in more depth since a friend of mine in Leeds had introduced me to a collection of translated Hebrew poems. From them and other sources I had selected four more poems to be included alongside "Fear" and "Terezín". These were pieces that I felt told fundamental aspects of the story of the Jewish people in a profound way that spoke to my Christian faith. These poets and authors inspired me through the beauty of their words and imagery, through the tragedy of the pain and suffering they voiced and through the hope and belief they expressed that one day they would be worshipping the King of the Universe back in the land God had provided for them. There was "Shir Golah" by Menahem Dolitzki, a poem that touches on centuries of oppression, being forced into exile and left to wander the earth. I knew this had to be the first poem on the album leading into "Lament for Jerusalem". This passage from Lamentations encapsulates the sorrow felt upon the conquest of Jerusalem and the slaughter and expulsion of its Jewish inhabitants. The long and varied history of Jerusalem was in itself a reflection of the pain and suffering of the Jewish people. I had found and set to music a beautiful poem entitled "God's Beloved", written by an unknown Yemeni author, probably in the fifteenth century. The album would conclude with "If I Were Here", based on a poem by the sixteenth-century poet, Yisrael Najara. For me, this piece both was and still is the most profound and moving expression of the tender relationship of total trust between God and his people.

If I had any doubts about my chosen structure and poems, they dissipated quickly upon reading the book *Night* by Elie Wiesel. Richard Frieden had insisted I read it and made sure I had a copy when I returned from Prague.

"Read the book first, then the foreword," he said.

I did exactly that. Few books have left me quite so broken-hearted, so moved and challenged on so many levels, as this book. Elie was fifteen years old when he entered Auschwitz. He would go on to describe his descent into this hell on earth through words that moved me to tears on many occasions. His mother Sarah and younger sister Tzipora were murdered in the death camp. Eventually he and his father, Shlomo, were moved to Buchenwald. Shlomo was effectively worked to death before liberation came on 11 April 1945. Although Elie survived these two death camps during those years, as well as losing mother, father and sister, he also lost his country of birth and he lost his faith in God.

Having finished the book, I understood even better why Eva Picková and Hanuš Hachenburg had to play a pivotal part in the structure of *Song of an Exile*. But I was grappling, deeply, to know how to respond to the utter darkness laid so bare in Elie's book. Following Richard's suggestion, I proceeded to read the foreword to *Night* by François Mauriac:

> The child who tells this story here is one of God's elect. From the time when his conscience first awoke, he had lived only for God ... Have we ever thought about the consequence of a horror that, though less apparent, less striking than the other outrages, is yet the worst of all to those of us who have faith: the death of God in the soul of a child who suddenly discovers absolute evil ... ?
>
> And I, who believe that God is love ... what did I say to him? Did I speak to him of that other Israeli, his brother, who may have resembled him—the Crucified, whose Cross has conquered the world? Did I affirm that the stumbling block to his faith was the cornerstone of mine, and that the conformity between the Cross and the suffering of men was in my eyes the key to that impenetrable mystery whereon the faith of his childhood had perished?
>
> We do not know the worth of one single drop of blood, one single tear. All is grace. If the Eternal is the Eternal the last word for each one of us belongs to Him. This is what I should have told this Jewish child. But I could only embrace him, weeping.[9]

This is it, I thought as I closed the book. *This is the response*. The embrace of the child, weeping in pain, knowing that the land has indeed "risen up again" from the ashes of Auschwitz and Bergen-Belsen. I, as a Christian, could and would marvel at such a turn of events. And I wanted the musical intricacies of *Song of an Exile* to reflect it all.

As we prepared to record *Song of an Exile* in July 1988, I found out my father needed open-heart surgery. Before he was to be admitted to hospital, I visited him and my mother in St Albans. He was calm and at peace, despite the obvious risks associated with such invasive surgery. I walked with my father around the grounds of St Albans Abbey and we had one of those conversations between son and father that I would remember for the rest of my life. We talked of the possibility of death. I did not know it at the time, but my father had taken it upon himself to chronicle his family history in a series of audio recordings. He knew that, however unlikely, he might not survive the operation and had wanted to make sure that everything that needed to be said would be on record. In doing so, he had gained this remarkable peace. After our walk I played him the recording of "Lord Have Mercy" and an early demo of "Lament for Jerusalem". I also gave him a copy of my interpretation of Psalm 27; "Wherever I Go, You Are There".

My father was admitted to hospital while I was entering the studio to record *Song of an Exile*. Forty-eight hours later he called me from his hospital bed.

"I've been listening to your arrangement of Psalm 27. I'm doing well, I'm well prepared, and I'm due for surgery later today."

The same day, as I was preparing to fly to Scandinavia for a series of concerts, my mother called to let me know the operation had been a success. I was able to begin my journey with a profound sense of relief. As I sat in the departure hall at Heathrow Airport, I heard my name announced over the airport tannoy system.

"Would passenger Adrian Snell please report to the information desk?" Once there, I was told my mother was trying to contact me, and I should phone her immediately.

"Something has gone wrong. Can you come at once?" My mum spoke with an urgent tone to her voice.

I made my way to the hospital as fast as I possibly could, rushed up to my Dad's ward and met my Mum, sister Julia and brother Christopher. Mum explained the emergency: "Dad came through the operation all right, but something went wrong afterwards. Something to do with his blood pressure. They operated immediately and he's in intensive care."

I walked into my father's room and was shocked to see every machine imaginable connected to his body. He was unconscious. The nurses were careful not to give up hope. The family agreed I should go and do the Scandinavian concerts. There was nothing I could do here, right now. I boarded a plane, played the concerts and came straight back. As soon as I came back into the room, I knew that the phone call I had had with my father before his operation had been our last conversation. His condition had worsened. His body was literally fighting to survive, and it was hard to witness the anguish he appeared to be in, even though he was not conscious. I could only bear to see this for short amounts of time. My brother Christopher, however, was a rock. He would stay for hours on end at my father's bedside, constantly speaking to and praying over him, frequently wiping his forehead with a cold, damp cloth.

This image of my younger brother caring so tenderly for my beloved Dad made a deep and lasting impression upon me. Here the child had somehow become "father" to his own Dad.

The words from Isaiah 49 that I had spoken over the musical introduction to "If I Were", the final song on *Song of an Exile*, were constantly in my mind and heart:

> See, I have engraved you on the palms of my hands . . .
>
> *Isaiah 49:16*

We had decided to use the painting of a butterfly by a child from Terezín to form part of the illustration for the album cover—an expression of the fragility and beauty of life and the childlike hope held onto even in the face of death. But I never expected this Scripture, which had spoken so clearly into the stories of the Jewish children of the Holocaust, to speak so clearly to my family now. There was nothing more to be done. As difficult as it was, I had to alternate between the studio for the ongoing recording sessions and the hospital. We all knew it was only a matter of

time. And it was. My father passed away four days into the recording of *Song of an Exile*.

In some respects, it felt completely inappropriate to be recording an album during this time. I was still unsure about the decision to travel to Scandinavia at such a vulnerable time and now faced the same uncertainty about the wisdom of immersing myself in music making in a recording studio far from home. But as we worked on the new material, the recording process itself became a profoundly personal expression of grief. The recording of *Song of an Exile* was not making life difficult for me; it carried me.

At Dad's funeral, each member of the family contributed something they felt able to do. Typical of his care and attention to detail, my father had previously written his requests for certain readings, hymns and other music to shape the service and amongst those was my song "Goodbye October". I did not feel strong enough emotionally to sing live, but the recording was played over the church sound system.

When I returned to the studio, I wrote down words that would be included in the album artwork:

> I will forever be grateful to my father for teaching me what a father's love for his child should be. More than anything his life pointed me to the very love of the Father God.

There was a strange atmosphere in the Square One studio in Manchester. After his immense contribution to *Alpha + Omega*, I had asked Dave Bainbridge to produce the album. The studio engineer, also a producer in his own right, was Steve Boyce-Buckley. Steve was a highly competent craftsman who had a tendency to follow his gut instinct during recordings, continually challenging preconceptions in a wonderfully creative and, at times, surprising way. I love this way of working on a recording: as far as possible allowing everyone involved a freedom to bring their own musicianship, their own thoughts and ideas to the process. And as far as I was concerned, the end results fully justified this organic approach to the making of *Song of an Exile*. There were times when it felt as if all of us—the musicians, the producers, myself—were struggling with unseen shadows: be it practical problems, relationship difficulties, personal loss

or other worries. This all added to what was already an emotionally charged time of music making.

One particular moment I will not forget came when Steve suggested a gifted singer he had worked with to bring the vocal solo that bridges the two distinct sections of the poem/song called "Fear". Melanie Williams arrived for the session. She had recently released the single "No Sovereign", and listening just once to this song had already convinced me that her voice was exactly what we needed here. With her striking looks and personality, Melanie easily commanded the space around her. She listened intently to the recording several times, then stepped into the vocal booth. What followed, improvised in one take, was one of the most hauntingly beautiful vocal "cries" I have witnessed at a recording session. When she came back into the control room, I was almost speechless. I could only hug her and thank her for completely understanding and interpreting the almost inexpressible soul cry that lay at the heart of Eva Picková's poem:

> No, no, my God, we want to live!
> Not watch our numbers melt away.[10]

Undoubtedly, within the tones of Melanie's voice I was also hearing my own anguish over the loss of my father. Music continued to heal through its unique expression of grief and hope. This was equally the case with David Fitzgerald's saxophone parts, most especially in his soaring solo in the instrumental section before "If I Were". Indeed, I was to have the same response to a profoundly beautiful moment of musical improvisation that I had to Melanie's vocal. In his typical manner, having listened to the backing track a couple of times, David stepped into the recording studio, picked up his saxophone, closed his eyes and sought to find the notes and tone that Dave Bainbridge, Steve and I had asked for. After three or four runs at the solo, David was clearly becoming frustrated, sensing that all of us, including him, were looking for something more. And time was running out. The day's sessions were almost over, and David had a long drive back home. It was clear to me that the problem lay within the mixed messages and different expectations coming from three people who all had some influence over the musical direction of the album.

I stepped into the studio, took David aside, out of range of the microphones, and asked if I could pray with him. Somehow, I knew just how important this moment in the recording was and would become. And I knew David felt exactly the same. There had to be complete musical freedom in the studio. He needed to be entirely free from suggestions and expectations of others and reach deep into his soul to find the notes and approach to this solo that were undoubtedly there, awaiting release.

A beautiful peace came into the studio. I returned to the control room, sat in my chair and the tape rolled. And then it came. In one totally inspired take, David reached deep into his heart and soul and played the most achingly beautiful saxophone solo I had ever heard. Indeed, David had played something that could not be improved upon, although he insisted on another couple of tries. In fact, to this very day, whenever we perform this piece, David returns to his own score, painstakingly notated by him after the recording. He also recognized that there could never be a better solo for this piece of music than the one he had played.

When I eventually came to record the vocal on "If I Were", I was able to sing with the quiet joy the song needed. *Song of an Exile* was complete. Never before had an album been such an emotional roller coaster for me. It had brought me to many surprising, deeply meaningful places. And this journey was not over yet.

16

The little boy battered the door to the hut that was locked in front of him. His small fists pounded the wood, rattling the lock. His cries turned to sobs as he kept punching. It was a picture of utter frustration and helplessness. Even more tragic was the fact that this boy was out here, late at night, in the refugee camp of Traiskirchen, near Vienna. I had just played a concert in the YMCA hut this boy was railing against. We had packed our gear in the car when I noticed him wandering about, all on his own. Apparently, there had been no one to pick him up. Everyone had already left. The boy was alone.

The crowd tonight had been a melting pot of so many nationalities: Polish, Romanian, Chinese, Bulgarian . . . It had been a noisy concert with children on the front row who did not remain still even for a second. There was the constant murmur of translators, the excited sounds of refugees who had come here tonight to break free, if only for a moment, from despair and frustration. Traiskirchen was home to the largest refugee camp in Austria. At the time, the 1980s had been labelled a decade of crisis, particularly in relation to the large number of refugees who had fled their homelands in desperation and made their way to the relative safety of parts of the European continent. Many of them had fled from behind the Iron Curtain. There were the children of Romania, over a hundred thousand of them, who had been orphaned or separated from their parents. Such was their plight that they had been given a name: "Ceausescu's children", referring to the dictator who ruled Romania from 1965 to 1989. Just before the concert I had been greeted by an enthusiastic young Romanian man, sixteen years old, who spoke in broken English: "I am so glad to meet you here! Back home where I used to live, one of the songs we loved to sing was 'Only Jesus'". What could I say in response? This boy, in his childlike enthusiasm, had referred to a song of mine which now took on a deeper meaning for me.

> Who's gonna mend my broken heart?
> Who's gonna give me a brand-new start?
> And when the rocky road is tough
> Whose love's gonna be enough?[11]

The song originated from *Feed the Hungry Heart*. I could not possibly sing "Only Jesus" from now on without thinking of these child refugees with broken hearts, longing for a brand new start, making their way across a metaphorical, and often literal, rocky road to a new home: to safety, love and inclusion. This child opened my eyes wider to the function music had for the downtrodden, the oppressed . . . those in exile. I could tell there was great need in this camp and the Swiss girl I met there, a volunteer for many years, confirmed it. She was a living example of kindness and care, but her innate sadness betrayed deep frustration and resignation over a harsh truth: governments abandoned these men, women and children;

help was insufficient; bureaucracy was rampant, leading to even greater frustration amongst refugee families and the camp staff. In a particularly vulnerable moment, this girl had confessed to me that, had she been a refugee in this place, she would have taken her own life. It was a shocking thing to admit, especially given the fact that this girl was a Christian. I had become increasingly critical of the Church as my world had expanded to include the lessons of the oppressed, the hungry and the forgotten. Now, the little Romanian boy who was banging on the door became another image that would be forever engraved on my memory. To me, this child represented the plight of refugees that was one of the themes at the core of the music of *Song of an Exile*.

Song of an Exile was a work of remembrance, of the great human tragedy of the twentieth century, which in and of itself was a continuation of the centuries-old persecution of the Jewish people. The album represented a time of personal loss for me with the death of my father. I was moved to hear from my dear friend Richard Frieden, who on hearing this news had gone to the Western Wall to pray Kaddish for my father. The image of Richard, his head bent in prayer and his hand on the wall that remained of the Jewish temple in Jerusalem, contrasts starkly with the image of the little boy pounding his fists on the door of the hut in Traiskirchen.

Nevertheless, perhaps these two expressions actually share important common ground. Our cries of frustration about cruelty and injustice and the quiet prayers of grief uttered over a lost one both demonstrate a longing for God's peace. When I sang "Lord Have Mercy" from *Alpha + Omega* during the countless concerts of this era, it was with these cries in mind.

Song of an Exile was a cry for remembrance, the voice of longing for peace. It had also become a work that enriched my faith and brought me to people whose stories and wisdom I highly valued. One of those people was Rabbi Hugo Gryn.

As we prepared to launch *Song of an Exile*, the record company, Word UK, planned a press launch. Rather than simply getting this album to the shops, we wanted to spread the word about its underlying message and subject matter and hopefully ensure it connected with the Jewish community. So, David Bruce of Word UK set out to have a meeting

with the Rabbi at the West London Synagogue. We were aware of him through his regular contributions to *Thought for the Day* and *The Moral Maze* on BBC Radio 4. Perhaps he could help us find a way into this community that was relatively unknown to us? What David told me when he returned was remarkable. He had shown the Rabbi the various poems and materials that would be used for *Song of an Exile*. Hugo looked them over with interest and commented:

"Yes, I know this one. 'Now take your ancient staff, O plundered Jew' . . . beautiful. And a reading from Jeremiah . . . yes, very powerful."

The moment Hugo Gryn came across the poem "Terezín", he paused, remained still for several moments and then spoke:

"I was in Terezín."

David was surprised and a thought shot through his head. Hugo would have been just a boy himself at that time. Could it be . . . ?

"There is another Terezín poem here," he pointed out. "'Fear' by Eva Picková."

Hugo Gryn looked David Bruce in the eye.

"Eva Picková was related to me," he said.

While saying those words, he held onto a cigarette as it burned away. Another moment passed. Right now, all the stories and materials I had presented to David in the run-up to *Song of an Exile* had suddenly become as real as they could be. There can be an unspoken barrier of time and space between us and our history. Hearing about a tragedy is different from being faced with it first-hand. Now, David was sitting across the room from someone who had an intimate knowledge of Terezín and the very children whose poems had formed the heart of the work.

It was a surreal moment for David, and Hugo was clearly moved too. The Rabbi pledged his support on the spot and was able to get committee approval to launch *Song of an Exile* at the West London Synagogue. I was immensely touched by Hugo's generous support and encouragement. This man had suffered at the hands of fascism and anti-Semitism, but now, having survived the Holocaust, he was determined to confront the barriers that divide people, breaking them down through interfaith dialogue. And here was I, a Gentile Christian artist who was on his own journey of discovery and understanding, trying through the words of

Jewish authors to face the questions posed by the Holocaust and searching for the voice of God in it all.

After hearing *Song of an Exile* in its entirety Rabbi Hugo Gryn sent a letter to Word UK, which read:

> I have now had a chance to listen to Adrian Snell's recording and am even more enthusiastic than I was when we just had our brief conversation. The words are moving and the music is accessible and direct and creates just the right mood. I hope it will do well . . . Familiar as I am with the story of the children of Theresienstadt [*the German name for Terezín*], I cannot but be deeply touched by the fact that a Christian artist has given some of these children's poems a new opportunity to encounter a generation they could not know. It is a way in which memories can be kept alive and tribute paid to some very lovely and vulnerable spirits.

I spoke at the launch about my motivation for creating *Song of an Exile*, about the mystery and the miracle of the Jewish people and their enormous significance to the world. I explained how I believed this history was central to our understanding of God as Creator, of God as a Father who loves his people, who is faithful to them, stands by them in every moment of tragedy and horror, of God as King who intervenes and who will continue to intervene in world events.

Then, as the Rabbi looked on, I concluded with these words:

"Finally, may I say this. Those here who know my previous work will know of my deep Christian faith, expressed in different ways through albums like *The Passion*, *Feed the Hungry Heart* and *Alpha + Omega*. To those who may wish to ask why as a Christian I should choose to work with Jewish poetry I would want to say simply this—my faith is completely rooted in Judaism. All the writers of both Old and New Testaments were Jewish, with the exception of Luke. The prophets (such as Isaiah and Jeremiah), the Psalms, particularly those of David, have for so many years inspired me in my faith and in my writing. Without the Jewish people I would have no Messiah, for Jesus is, of course, a Jew. The early church was Jewish and without their courage and commitment how would the Gentile world have received the Christian message? And today,

men like Elie Wiesel inspire the world with their courage, their insights, their experience. I am then deeply indebted to the Jewish people . . . "

I invoked the name of Elie Wiesel as someone who had lived through the darkness and used his platforms to speak out. He gave a speech at the International Scholars' Conference on the Holocaust in July 1988, when he spoke these challenging words:

"I belong to a tradition that believes the death of a single child is a blemish on creation . . . "[12]

This was what I too had come to believe.

Men like Wiesel spoke for the exiled from personal experience. I was beginning to embrace the responsibility of being a voice to the Church, seeing as this was not only where I had come from, but also the community the largest part of my audience still identified with. I had increasing trouble identifying with the Church. As a passionate Christian young man, I had often grumbled childishly about formalism and traditionalism. My father would patiently hear me out, only to then respond in his typical manner:

"The Church is like a family. You can grouse and moan, but you still belong, warts and all!"

Now, over a decade later, I felt as if that sense of belonging was somehow tainted. There had been the negative experiences brought about by the insensitivity of other Christians during the UK tour that had accompanied the launch of *The Passion*. But those paled in comparison to my journey through the darkness of the Holocaust and the failures displayed by those in the Church who had failed to stand up to it. Before I had even completed *Song of an Exile*, in May 1988 I had toured *Alpha + Omega* in British cathedrals. These concerts reflected my inner struggle. As a musician, it was wonderful to experience the echoing majesty of these places, these cultural landmarks. At the same time, I wrestled with what that culture represented to many. The sense that the Church was viewed as outdated or irrelevant in today's society was something I felt I could not ignore. And I tried to make that clear during the interviews that preceded the performance. With the benefit of hindsight, I recognize that my growing unease with the established church led me to voice sentiments in a less than tactful manner.

When, on occasion, I referred to these majestic buildings, central to the cities they visually dominate as, for some, looking like magnificent tombstones of religion, of course I was wanting to make a point about cultural relevance. But I should have chosen less-provocative words and appreciated the extraordinary power and beauty that comes when worshipping God in exactly the same place as literally millions of other people of faith over centuries. My own journey of faith that had resulted in *Alpha + Omega* and *Song of an Exile* had hardly had a mellowing effect on me. This history, these themes, were now embedded in my heart and mind and emboldened me when I had the opportunity to speak out.

Song of an Exile finally had its world premiere on Saturday 4 February 1989 at London's Royal Albert Hall. It was followed that night by a presentation of *Alpha + Omega* featuring the Norwegian youth choir Reflex accompanied by singers from all over Europe—500 people in all and making this the most sweeping, expansive performance yet. Thousands were in attendance. There were the talented musicians and fellow travellers who had brought this work to life so many times before: Dave Bainbridge, David Fitzgerald, Caroline Bonnett. There were dance interpretations by Danny Scott and Sandy Phillips. It all culminated in a night that felt like the warm embrace of friends. A true moment in time for me, whilst elsewhere the people of Europe were more and more caught up in the chaotic changes as the Iron Curtain was disintegrating.

17

"Could you please leave your gear and come with me immediately? The princess would like to meet the singer."

One does not argue with an official who is sent by royalty to summon an artist. And I most certainly was not inclined to start. I quickly put my keyboard in its flight case and hurried along with the man, past the ornate columns and arches that line the nave of Peterborough Cathedral, on my way to meet Princess Diana in person.

The Princess of Wales and I were both here in relation to the Leprosy Mission. I had become involved with the charity after being invited to

travel to some of their projects in India and Nepal. She had recently
become Patron of the Leprosy Mission and was the distinguished guest
at the service here in Cambridgeshire, also dedicated to the work of this
organization. I had been asked to play and had decided to sing "Feed the
Hungry Heart", the song that expressed the spiritual calling each of us
had in the face of brokenness.

> Heal the broken heart, feed the hungry soul
> So many people waiting to be whole.[13]

I could tell that "Feed the Hungry Heart" had moved Diana, and it was
not hard to imagine why. She was very empathetic to the plight of the
lost and downtrodden. As such, she broke with the often-aloof reputation
royalty had. Moreover, people were not drawn to Diana because she
was perfect. She was not, which made people identify with her all the
more. All those who loved the Princess, loved her for her contradictions.
She was able to relate to many different people from so many different
parts of society. With her compassionate heart and lack of pretence, she
demonstrated what it was to be human and to reach out. To her, this
included physical contact with those suffering from leprosy. It broke
down superstitions about the disease. Leprosy is not contagious with
normal contact, but the afflicted often still live a life of exile, forced to
suffer the brutal fate of isolation, never to experience love and affection
the way it was meant to be. Later, in an interview, Diana revealed part
of the reason why she felt at ease with these outcasts: she did not have
to pretend with them; in their presence she was just a sister, someone
who cared. And most importantly, she was not afraid of touching them.
When she hugged and spent time with them, she was as free as she could
possibly be from the world's media, which was obsessed with her image.
I believe the Leprosy Mission was more than a cause for her; I felt it was
also a passion and refuge.

Sure enough, after I arrived at the reception I was quickly introduced
to Diana. The Princess expressed how she had enjoyed the song and
added how it had struck her as strange to have a song like this sung
in the context of a cathedral. I understood how she would have been
part of an establishment where contemporary songs like this were rarely

played or sung in church. We briefly spoke before she moved on to the many other guests. It was a mere moment in time, but it was a moment I would not forget.

Years later, after Diana's fatal car accident, a DJ and radio host was given the task of cataloguing her music collection. British media embraced the story to gain a peek into the records that the Princess had listened to. They were surprised and, dare I say, a bit baffled by what they found. Alongside classical music and albums by Elton John and Lionel Richie were several records by a relatively unknown English fellow named Snell . . . Suddenly I found myself involved in a stream of interviews, explaining the connection: how Diana had received several of my albums after that first introduction at Peterborough Cathedral. This turned into a point in time where, however briefly, I had the satisfaction of what I had craved from the beginning: access, a podium beyond the confines of church walls and the Christian music bubble. It was a reminder of the power of music to connect across any divide. And it was almost ironic that it had come about thanks to something completely unrelated to music.

When the Leprosy Mission had originally approached me to work with them, I was quickly intrigued by their cause, but I was also still dealing with the grief of my father's death months before. Recording *Song of an Exile*, with the poetic witness to some of history's darkest hours, was emotionally taxing in and of itself. Laying my father to rest and trying to come to grips with the reality of life without him was nothing short of overwhelming. In those moments, music once again saved me. I had started to take walks in the area around my home, thinking back on the relationship I had had with my father. In my own way, these walks became conversations with God. Perhaps it was a mirror to those times spent roaming through Canterbury before starting music college. Then I was young and passionate, straightforward in my thoughts on faith. Two decades later, my walking prayers had changed. They did not simply speak about suffering, but were informed by it. The prayer for healing I had spoken over the families I passed by all those years ago was now directed inwards. God was there. The journey of *Alpha + Omega* and *Song of an Exile* had not driven us apart. I had seen raw expressions of grief and the need for survival through the eyes and words of children. Their stories had brought me to the counsel of some of the wisest men I

had ever known. They, in turn, had given me a new perspective on God as a Father.

My trip with the Leprosy Mission was to start in November. A few weeks prior to the trip and just weeks after my father had passed away, I was walking up in the Yorkshire Dales, when several pieces of a puzzle fell into place. I felt the closeness of God the Father; I felt the closeness of my own father. And music came close to my heart. Songs were forming which would in large part be about my own father. Over the next few months, I started writing and gathering material that would become my new album—*Father*.

I had decided to include a new recording of "Goodbye October" on the *Father* album. Since the song had been played at my father's funeral, I had come to listen to it with new ears. When I sang the lyrics as if from my own father's perspective, it was not hard to see why he had been drawn to it. The song could be a deep expression of a man in the autumn of his years, a father looking back at his life, clinging to the promise of a new eternal season. I also turned to the Psalms, working them into lyrics and music. It was a daunting task to find and write lyrics that would do justice to him.

The music started to take shape as I was mourning, but I also knew there was more to come. I boarded a plane for India, intent on opening my heart on this trip working with the Leprosy Mission; to have it inspire more music. I was not yet sure how it would relate to the finished pieces so far, but I was committed to having the people I encountered on this journey speak to my grieving heart.

The purpose of the trip with the Leprosy Mission seemed straightforward enough. I was to allow myself to be inspired by all that I saw and experienced in their local projects and would then write an artist's response. The result would, hopefully, be heard on a subsequent tour with the organization when I would share my experiences in stories and song. It sounded intriguing enough on paper, but it was hardly sufficient to prepare me for what I would encounter on this trip. We flew to Asia bound for a city named Miraj, close to Pune, the second largest city in Maharashtra.

As I set foot on Indian soil for the first time, my senses exploded. The whirlwind of smells, noises, music, tastes and colours impressed me as if

I were a child in a toy shop. Looking out, I could see majestic mountains lining the horizon, their ragged structure imposing over beautiful hills: a stunning backdrop to a mesmerizing society. I was quite happy to surrender myself to it all. This was a feast for the senses and, as such, ideal territory for an impression-hungry Adrian Snell to get lost in. I embraced the chaos, the noise and the heat as much as I did the fantastic food and hospitable people.

Crossing into Nepal, my party and I (including officials from the Leprosy Mission) made our way towards one of their projects I had come here to see. We passed Kathmandu and made our way into the hills, surrounded by increasingly beautiful nature. It was the kind of beauty that made you question why people could not fathom this world having a divine origin. We followed a winding path that seemed to disappear into the mountains. As we suddenly came to a clearing where our destination, the Leprosy Mission's Anandaban Hospital, was located I was rendered speechless by what we saw. "Anandaban" was Nepalese for "Forest of Joy". What an immensely appropriate name for all that opened up before us—the most extraordinary display of creation I had ever witnessed. For miles on end, a beautifully flowing plain stretched out in front of us; beyond it were the Himalayas. Spectacular shades of brown and green seemed stacked up against the mountains dressed in angelic white. I stood there amazed, in awe at the beauty and serenity of this place.

The staff of Anandaban Hospital welcomed us, and immediately the superficial contrast with the beauty of the natural surroundings was striking. This hospital was a haven for the poorest of the poor, all suffering from leprosy. There were people of all ages here, wrapped in bandages that hid their deformities. With others, the afflictions could not be hidden. These were broken people, but their suffering was more than just physical. They were outcasts, often banished from friends and family, part of a lower caste and left poor, with no hope of true acceptance in society. Even worse, these people were considered (and considered themselves) cursed by God. The thought of these precious men, women and children burdened by not only the physical devastation wrought by leprosy, but also, in effect, condemned to suffer as some form of atonement for a past wrong, seemed particularly cruel to me. It was an injustice I could not witness without returning to the questions that were so prevalent during

the recording of *Alpha + Omega* and *Song of an Exile* and my visit to Yad Vashem. How could people in the twentieth century *still* face this kind of suffering? Where was God in all this?

A partial and practical answer was clear in the work that the Leprosy Mission was doing here. As a disease, leprosy is treatable. Further damage to nerves, skin and limbs can be prevented if leprosy is treated at an early stage. But beyond the medical interventions, the Leprosy Mission was working tirelessly to reshape the perceptions people have of leprosy sufferers and restoring their dignity through some form of reintegration into society.

During my days at Anandaban I would visit the patients on the ward. Where possible, using an interpreter, I engaged in conversation, but more often did what came more naturally: to sing and to play my music. Yet again the extraordinary power of this alternative language of expression revealed itself in the beautiful expressions on the surprised faces of my unexpected audience. But the more I came to know my new friends, the more my discomfort over their situation was to be offset by the spirit of these people. It was there behind their eyes and in their demeanour, revealed through a gentleness of spirit and a quiet dignity. These men, women and children had been deemed unworthy and literally untouchable by the outside world. But here they seemed to carry a humility and respect for others that was, perhaps born out of resignation to, and acceptance of, their fate; also a depth of gratitude and the early seeds of hope born out of the love, care and healing expressed in every interaction with the wonderful hospital staff. Somehow, as Rabbi Hugo Gryn had helped me see in my struggle with the troubled history of humanity, God was very present in all aspects of this world and in the cruel normality of everyday life for these, his children. Present in the pain, the sadness, the rejection and in the healing, the joy, the love and acceptance. There was no one whose story impressed this more upon me than that of Padmahari.

Padmahari had been a patient at Anandaban for twenty-five years by the time I visited. In effect, it had become his home. He had been abandoned at the door of a hospital in Kathmandu and eventually brought here. Leprosy had inflicted much cruel damage on his body. By the time treatment had begun, the disease was already too far advanced to save

various parts of his body. His nose and all his fingers were missing, eaten away over time. His feet were disfigured as well. On top of that, Padmahari was blind and diabetic. One might expect to meet the broken shell of a man, silent, alone, defeated and full of resentment, but you would be very wrong. I tentatively reached out to hold what remained of his right hand. Immediately, a big warm smile broke out on his face. The top part of his head dressed in a knitted, tightly-fitting, beanie balaclava hat, he greeted me with what I could only describe as genuine and welcoming joy. As we talked, I was captivated by his beautiful personality. He was affectionate and open-hearted, and his sense of humour was infectious.

The Anandaban staff confirmed my first impressions, and more of his story unfolded. Padmahari may have been abandoned by the outside world, but here his life radiated with faith, love and inner strength. Long ago someone had introduced him to the Bible. Over time, as the words were read to him, he had come to wholly believe in God's love for him: that Jesus' death and resurrection were as much for him as any other human being. He had become a deeply committed Christian, and the childlike commitment to that reality made him a beacon of light and a great source of inspiration and love to the other patients. One such patient had been a little boy brought in with a spinal injury along with his dying father. The boy could not walk and had to crawl on his hands and knees. He and Padmahari struck up a close friendship, and when his father died, they became inseparable, living together side by side, whether during daytime activities or asleep at night, slowly healing scars through the unconditional acceptance of one another. Their relationship became an almost iconic image of Christlike living as they brought an emotional and spiritual wholeness to each other:

> Blessed are the poor in spirit . . . the meek . . . the hungry.
>
> *Matthew 5.1ff.*

These words, spoken by Jesus and taken from his Sermon on the Mount, sometimes known as the Beatitudes, were to become my first response, both spiritually and artistically, to what I had encountered here. They spoke to the character of God as Father and Mother. They had profoundly informed the character of my own father.

Blessed are those who mourn . . .

Matthew 5:4

These words bridged the gap between the pain I felt over his loss and the pain over the injustice, suffering and rejection people had to endure from fellow human beings. God spoke to each and every one of us here. We were all meant to be whole in the kingdom of God, and I had seen the workings of that kingdom here, allowing us a glimpse of our future beyond the darkness of this world.

Jesus' words of blessing felt so alive in me that I knew I had to work them into music. In my head, I devised a provisional arrangement. In a few months the resulting song would become the opening track of my *Father* album, and I would decide on the song title "Compassion".

When I travelled back to the UK, I had mere days before we were to enter the studio to record the album. It felt important to begin the recording process whilst all these immensely formative experiences were fresh in my mind. The producer for *Song of an Exile*, Steve Boyce-Buckley, had brought so much creativity and musical depth to that album that I decided to turn to him again as the main guide through the making of this deeply personal project.

All the emotions I had experienced over the past months, coupled with the indelible images and stories triggered by my visit to Bergen-Belsen, somehow came together.

The album would, of course, be dedicated to my own father. And in the title track I sought to express the heart of all he had been and had meant to me. As I penned the words "my defender, my protector, my provider . . . " I was overwhelmed with both a sense of deep loss and even deeper gratitude. It struck me that in searching for words that would truthfully describe our relationship, I was using many of the same words that I would use if asked to describe the place of God in my life. But my father was acutely aware of his failures, doubts and weaknesses. And this awareness brought him to a place of deep humility and compassion. I loved him even more because of this and increasingly found myself praying that in this respect, my own children might eventually be able to describe their father in the same terms.

Throughout the album, many of the Psalms I had immersed myself in before my trip to India and Nepal had resurfaced. There was "The Lord's My Shepherd", an adaptation of Psalm 23; I worked Psalm 57 into the melodic "Hide Me in Your Shadow"; Melanie Williams, who had moved me to tears with her searing, gut-wrenching vocal part on my interpretation of Eva Picková's "Fear", lent her hauntingly beautiful voice to a reading of both Psalms 131 and 139.

There are few words in the Bible that move and inspire me more, that leave me with a more indescribable hope and sense of comfort, than those drawn from Revelation 21. And I decided to speak these words as an introduction to the album's closing song, "No More Tears". I could hardly imagine then that I would come to sing these words at the funeral services of each of the remaining members of my birth family: my elder sister, Julia; younger brother, Christopher; and mother, Margaret. But, of course, the vision and the promise contained within them were, and are, for us all, as they are for afflicted and discarded people everywhere; as they are for Padmahari and all Anandaban's patients; as they are for Eva Picková and the children of the Holocaust.

> Nothing but goodness,
> nothing but peace,
> nothing but Heaven's sweet release.
> Don't you know,
> it's all coming true?
> One day we'll be shining new..[14]

Music had once again proved to be the ever-loyal companion, guiding me to a deeper understanding of God and my place in his story.

18

At first, we heard them approaching in the distance. A menacing roar of grinding metal and revving engines, no doubt meant to intimidate the citizens of Vilnius. Then, from our hotel room window, we saw them

rolling down the streets: Soviet tanks making their way to key positions in the Lithuanian capital. Dozens of vehicles drove by before our eyes, making their way to the Parliament building. It was past midnight and I realized that what we had initially planned as a six-concert tour of *Alpha + Omega* through all three Baltic states—Lithuania, Latvia and Estonia—had now entered completely unknown territory. Lithuania was about to face one of many forceful reminders, demonstrations, of the might, power and reach of the Soviet army across all three states. These, and subsequent events, now somehow, suddenly, elevated the importance of this series of concerts.

The marketing of these performances had already resulted in headlines: "The performances will take place in the presence of the composer, accompanied by the musicians from the original recording." And where we could, we would now also be able to refer to the backing of this wonderful choir, formed from young, gifted and proven singers from East Berlin and Prague. As we all crossed the border between Poland and the Soviet Union, we were well aware of the political turbulence and social unrest throughout the region. But we could never have imagined that the exact six days during which we were to perform *Alpha + Omega*, two concerts in each of the Baltic states, would shortly afterwards be referred to across the British media as "six days that changed the world". This was August 1991, and these were the days of the coup against President Gorbachev, destined to end in failure, but which marked the beginning of the end for the Soviet Union. History really was in the making.

My manager at that time, Aad Vermeyden, and I had been working towards a tour of Eastern Europe and the Baltic states for a long time now. Somehow, I knew we were also called to bring the underlying message of *Alpha + Omega* to each of these emerging countries currently living in fear and with an overwhelming sense of danger. After all, the Iron Curtain was being challenged, threatened, before our very eyes. Our first stop was to be the city of Lublin in Poland. As well as a planned, scaled-down performance in the town, all the musicians and singers had been invited to visit the Majdanek concentration camp, the closest to the Baltic states, but only one of the Nazi death camps located in Poland—the most infamous, of course, being Auschwitz.

Things got off to a chaotic start. We had planned on making 3,000 cassette tapes available for sale with the intention of using the proceeds to encourage some of the wonderful initiatives we were discovering. But the manufacturing process had been delayed, and we were informed that the company were unable to confirm or guarantee the delivery date. In addition, somehow it transpired that vital sound and lighting equipment had been left behind in the Netherlands, meaning that members of our technical team would have to rush back, retrieve it and rejoin us in Lublin. These were relatively common worries associated with a concert tour; they would soon seem very trivial. The tour bus was mainly occupied by thirty young singers from two choirs: ImPuls, drawn from gifted singers from all over East Germany, and Jas, whose members came from towns across Czechoslovakia.

At last we arrived in Lublin. Only then did I realize that this was the town that had received an estimated 360,000 people, mainly Jewish, before transferring them to Majdanek where the vast majority were murdered. As we prepared to continue into the Baltic States, performing *Alpha + Omega* to audiences who were excitedly anticipating our arrival, it suddenly became absolutely clear that our singers needed to embark upon their own journey of understanding. Many had received a very controlled, politically scripted education concerning the Holocaust and European history in general over the previous fifty years. So, a visit to Majdanek was proposed and every single one of the young singers, without hesitation, asked to join the group of anxious pilgrims.

Majdanek's memorial was a well-preserved portion of the camp itself. We walked through the barracks where thousands of children's shoes were piled up, making mounds on the floors of their various quarters. This image of footwear as far as the eye could see had a profound impact on me as well as on our choir director, Hartmut Stiegler. Later that night we opened our concert back in Lublin itself with "Kaddish for Bergen-Belsen", this performance made all the more intense because of what we had just witnessed at Majdanek.

The following morning we all set off early, allowing time for any complications that might arise as we crossed the border into the Soviet Union on our way to Lithuania, where we were due to perform a concert two days later in Šiauliai. The authorities clearly thought we were out of

our minds. A tour bus of at least forty people was driving headlong into danger. We began to gain a sense of the real and concerning situation that was unfolding, literally hour by hour. We were excited. Adrenalin was flowing. Here we were, a touring company, about to perform *Alpha + Omega* with its powerfully relevant and timely message literally in the middle of a real-life theatre of events that could just as easily have been the inspiration for it.

However, the mood in the bus quickly changed when our friends from East Germany and Czechoslovakia began to understand what was actually taking place as we travelled. David Fitzgerald was listening intensively to the BBC World Service through his headphones. Those of us leading this unprecedented expedition asked the bus driver to stop. And together at the side of the motorway, we shared the information and the challenge. And as we were speaking, there were Soviet tanks on their way to Vilnius, the capital of Lithuania—our destination! This was a show of strength and dominance designed to frighten and discourage the people of all three Baltic states in their fight for independence from the Soviet Union.

At last, late in the evening, we drove into Vilnius and found the only international hotel in the city. We managed to feed everyone, assign rooms and then prepare for a good night's sleep. And then the tanks rolled in . . . As the convoy of army vehicles made their way to the city centre I felt an urge to go out into the street and join the masses that were now also making their way to the main square, determined to protect government buildings from the oncoming enemy troops. It was no surprise to me that David Fitzgerald had exactly the same intention. "This is history in the making," we agreed. "There's no way we're going to watch all this unfold on a TV screen in a hotel lobby while everything is played out just a kilometre away." Together we scrabbled across the hotel grounds, mounted a few fences and ran across a road or two, determined not to miss anything.

So, there we were: two British musicians, walking along the streets of a capital under siege. The crowds around us were showing a quiet resolve. There were people of all ages. Men, women and children, all determined to protect the Parliament building. Standing there, knowing the tanks were around us and hearing ominous updates about the military

occupation, it is hard to describe our feelings. It was actually eerily quiet, even though a huge crowd had gathered around the rectangular pond and the green patch of trees that divided the square. Occasionally, a message would be delivered over a speaker. Beside us, another small group was huddled together bent over a transistor radio. All of them were hoping for the best but expecting the worst.

Every so often someone would come out of the building and make a short but passionate speech. Although neither of us could understand these Lithuanian words, we were most certainly caught up in the determined, uncompromising mood. When the "Chairman of the Supreme Council of Lithuania", Vytautas Landsbergis, made his impassioned plea, we sensed a change in the atmosphere. These were men, women and children facing potentially life changing hours ahead. It was only a day or two later we learned that in warning his people to be "ready for anything tonight might bring", he had also added: "This is a farewell if we lose our lives."

As David and I stood side by side, no words were needed. We really did feel the weight of history. Leaving Parliament Square to return to the hotel in the early hours of the morning, we were well aware that there would be no certainties the following day. Yes, there could be bloodshed and chaos, but we were absolutely certain that we were here in this very place, at this very time, for a God-given reason: there was no coincidence whatsoever around the timing of our forthcoming performances of *Alpha + Omega*. In our own quiet and limited way, God's heart expressed through this work was to be deeply felt during these six concerts in six days through Lithuania, Latvia and Estonia.

Our tour bus used the back roads out of Vilnius the next day in order to evade the tanks. By the time we arrived in Šiauliai, word had spread of our determination to make sure the concert should go ahead as planned. The audience in the main theatre, I was told, was diverse: a reflection of the broad cultural appeal Christian artists had here. I was very much encouraged to hear that, within Lithuanian society, Christian artists had been at the forefront of protest against injustice and oppression, their voices leading a chorus that was now marching towards freedom. The Christian message was welcomed and respected: an acknowledgement of its relevance for today's society. That night, the message of *Alpha + Omega* would be poignant indeed.

Leading up to the main performance, ImPuls sang "Rejoice", an arrangement of the Beatitudes. As the youth choir lifted its voices, the fact that we were here during this time with the message of "Alpha and Omega" became more surreal to me. Hartmut Stiegler announced the next song with a word of encouragement. As the choir began to sing the folk song that was considered a second national anthem in Lithuania, I heard another noise. I turned and was moved to tears by what I saw. Every single member of the audience had risen to their feet and, with military planes roaring overhead, and Soviet tanks and troops still positioned just outside the city, each and every one sang the song of national identity: "Lietuva Brangi" ("Precious Lithuania").

When the time came for me to take the stage I did so with a simple prayer: "May *Alpha + Omega*, the words, the music, the message that *you* have placed so deeply on our hearts, speak with great power to the people gathered here." There were other songs that I performed that night, and at each of our six concerts, that connected so profoundly to the realities of these days. Hartmut had written a beautiful arrangement for the choir of my interpretation of Psalm 27 ("Wherever I Go You Are There"):

> The Lord is my Light and my Salvation every day
> He is the Stronghold of my life in every way
> If an army were around me, even then I would not fear
> For You Lord, are with me wherever I go.[15]

Song after song was bathed in fresh relevance. "Kaddish for Bergen-Belsen", the first song in *Alpha + Omega*, was followed by "The Nations Rage and Fall":

> Why do the nations rage and fall
> The people plot in vain against the Lord? . . .
> The walls are trampled to dust . . .

These moments, I knew, would stay with me for the rest of my life. As we continued to travel through the Baltic states, the map of Europe was already changing. Before the end of the year millions of people would be celebrating a freedom they had not known in many decades.

Each night, as I sang the closing, prophetic words of *Alpha + Omega*, I knew in the depths of my heart that, as I stood and sang, this was yet another extraordinary, God-given chapter in the story that had begun at Bergen-Belsen.

19

There are many kinds of fear. And as diverse as they can be, they have wildly varying effects on us. I remember the fear I often had as a young man: the fear that permeated almost everything I undertook as a musician; the fear of being misunderstood, of my work somehow missing the mark, of it getting lost in translation. My identity was precious to me. Perhaps too precious, allowing fear to take hold. This was a fear of perception. Deep down, it was narcissistic in nature. I did not have enough self-confidence to let my music truly speak for itself. I consider myself blessed having met the likes of Phil Thomson, who could weave lyrics that transcended my particular fear. Without him, projects like *Alpha + Omega* would not have become what they ultimately were.

The words of Eva Picková's poem "Fear" spoke of a deeper, more existential fear. It spoke of life and death and the dread of true evil. Maybe I had initially been drawn to that poem because of its title and how I felt it touched something inside me, only then to find out that Eva's experience was almost unfathomable to me as someone who had lived in relative peace and comfort. If you grew up in a sheltered, loving, Christian home like I did, the notions of fear and control would seem strange to you. But I believe there were aspects to my faith that touched on these things. Such was the intensity with which I identified with a Christian lifestyle, where I thought every aspect of my life would need to be controlled in order to keep me worthy of God's grace and forgiveness. There was, subconsciously at least, an ever-looming threat of a fall from that grace.

I had nurtured my Christian identity out of a fear of being misunderstood and, as a result, I had never really allowed myself the freedom to truly let my music take on any subject I wanted. Whatever I did, it had to somehow explicitly be placed in the context of God

and faith. My heart's journey that had begun with *Alpha + Omega* and continued through *Song of an Exile* was all rooted in my faith and, as such, there was a measure of comfort there. The response had been massively encouraging. These were works that were both deeply personal to me and, at the same time, aimed at the Church as a whole. They took on a life of their own, as was evident when choirs all over Europe embraced *Alpha + Omega* and began to perform the work. The theatre group, Dance Eternia from Sweden, went as far as producing a large-scale interpretation of my music from *Alpha + Omega* and *Song of an Exile*. Set to drama and dance, it represented the way my music had evolved and spoken to a larger audience and culture.

For most artists, this would be considered success. For me, all of these developments felt like unique challenges to my identity and my faith. I wish I could have enjoyed it more but, truth be told, in 1992 I was as intense as I ever had been—perhaps more than ever. I was so utterly wrapped up in the music and subject matter of *Song of an Exile* that I did not really allow myself to enjoy the experience of touring the work as most artists would. I certainly had a sense of humour, but I drew the line at jokes or pranks that would, to my mind, undercut the pure and serious nature of the music. Each night during the *Song of an Exile* concerts I would open the evening with a short, introductory solo set. I was positioned behind the keyboard towards the front of the stage. One night, several of my fellow performers decided on a prank. During my opening song I was completely unaware that one of them had come on stage, dressed as the theatre caretaker, broom in hand, and was determinedly sweeping the floor as if nobody was there! Unsurprisingly, this drew laughter from the crowd, but at the time I felt it was deeply inappropriate.

By this time, the struggle with how people perceived me as an artist had taken on new forms. Because of the themes and choice of biblical text within *Alpha + Omega*, my music was being described as prophetic. But when I started to come across articles describing me as a "musical prophet" I became concerned, knowing as I do how quickly labels can stick and be repeated, particularly when they convey something intriguing, something headline-grabbing. And then, potentially, comes the typical cycle that belongs to a media-obsessed age: from elevation to expectation,

followed by scrutiny for something that will destroy the image, bringing back down what had been falsely built up in the first place.

Unfortunately, contemporary Christian culture was just as capable of creating its own celebrities as the secular, mainstream culture. While we may justifiably be seen as skilled, passionate and, hopefully, inspiring communicators, we are just as full of contradictions, just as vulnerable and flawed, as any member of our audience. It was not hard to imagine what might happen to my career if I was found to have fallen short of the standards expected of me: my music could quite possibly lose much of its audience.

All these things were stirring in my heart as I worked on material for my next album, eventually entitled *Kiss the Tears*. I had lengthy discussions with Phil Thomson about how we should approach these songs. On the one hand, I felt a kind of freedom from the emotional and spiritual weight I felt I had been carrying over the years that had resulted in *Alpha + Omega*, *Song of an Exile* and *Father*. I was now eager to return to the territory of singer-songwriter.

We set out to write songs that were simply born out of circumstance, not out of any particular agenda. My record label were happy to support me in this direction, displaying a trust in their artist and a willingness to live with the uncertainty around what might be the result. I found this immensely respectful and encouraging. The explosive opening track, "Roller Coaster", would be in stark contrast to the far more ambient beginnings to the previous three albums. The words and music were true to the title, with Phil's stream-of-consciousness lyric and my eclectic music.

For the confronting and haunting "Bullet in the Mother's Womb", I set out to interpret Phil's immensely powerful poem with music that would fully support his words. The inspiration for the poem had come from the true story of a pregnant woman being shot in Northern Ireland during the Troubles. Her child was born alive, but inside its body was the bullet that had pierced them both. Miraculously, both the mother and daughter survived, but I found the story hugely confronting in what it represented. Even the unborn were not safe from war and violence. A physical bullet was a stark reminder that one generation could quite literally inherit the dark deeds of another.

"Where You Are" was written for Sue. I think it fair to say that the vast majority of songs within the pop/rock/soul/jazz genres are, in the end, love songs—or at least expressions of the writer's feelings for and about another person. So, writing a song for and about your partner is not straightforward. For sure, it has to be truthful—this is no imaginary or part-invented person, allowing for words that will rhyme nicely and encourage audience participation. No wonder, then, that in more than forty years of marriage, I have only directly written three songs for Sue: "Travelling" on the album *Listen to the Peace*, and "Where you are" and "Intimate Strangers" on the album with that title.

"Favourite Song" remains to this day a particularly favourite song of mine to sing live. I had decided I wanted a song on the album that would be all about my beautiful, then six-year-old daughter, Carla. Phil and I explored the world inhabited by our little daughters—Phil had two of his own—and this was the song that emerged. From time to time, Carla joins me on stage. She is a wonderful singer in her own right, and on those occasions when we perform "Favourite Song" we cannot help but share a knowing smile as we sing the words:

> You're an Angel at the breakfast table,
> a ragamuffin home for tea.
> A Princess of a world of wonder . . . so wonderful to me.[16]

All of that remains true to this very day . . . except the first one . . . I am not entirely sure that Carla was ever really "an Angel at the breakfast table"!

I think there is something very beautiful, intimate and loving about these three emotive words "Kiss . . . your . . . tears", and I have used them in other contexts over the years. When I read them, the immediate sensation that comes to mind is that of the salty taste of tears absorbing the bitterness of hurt.

As a composer, you can never know when a particular piece of music will connect with listeners immediately and widely. When it does happen, it is wonderful and immensely affirming. My instrumental piece, "Coverdale", was one such composition. Our family was about to make the move from Leeds to our new home in Bath. Leaving Yorkshire was a bittersweet experience. These were the hills, the farmhouses, the fields

and country villages that had been the backdrop to many walks. I wanted "Coverdale" to express the peace I found in that place, one of many dales weaving through this exquisite part of Yorkshire.

When *Kiss the Tears* was eventually released, I should have been more grateful for what I had achieved as an artist than I actually was. In truth, this was still a time of inner struggle, of the continued longing to move beyond, to have access to a far broader audience globally. I had continued to have discussions with management and the record company as to how we might reposition me as artist with musical and lyrical relevance to the mainstream music world. I increasingly understood that although I was working with people who passionately believed in me and my music, and who fully supported my vision, in reality they did not have the tools, nor the networks and marketing skills to help me get past the Christian subculture. Nevertheless, I was also convinced that the journey that had begun with *Alpha + Omega* and continued through *Song of an Exile* and *Father* was incomplete.

My instincts would be proved right. But it would once again be the plight of children that would surprise me with new revelations along the way . . .

20

The more I read from the piece of paper that I was holding in my hands, the more I saw it as one of the most beautifully worded letters I had ever received. It had come out of the blue. Of course, I was used to people writing to me to express appreciation of my music, pose a question or maybe voice a criticism. Sometimes I would get very invested in what was shared with me through this medium. Words written down have a way of getting under your skin. This current letter was particularly enthralling. The man who had this way with words was David Potter. He was a Baptist pastor who was now the director of an organization that (at the time) was called "Cause for Concern". It was an organization dedicated to promoting a greater awareness of, understanding of and support for people with a variety of special needs and learning difficulties.

David wrote about how he had been at the *Alpha + Omega* and *Song of an Exile* concert in the Royal Albert Hall in London. It had left him deeply moved, in no small part because of the poems of *Song of an Exile* and the way in which that project gave children a voice through artistic expression. It had convinced him to make a special request, so we decided to meet. David Potter turned out to be the kind of person who could win you over through his abundance of empathy. His articulate and compassionate way of speaking had me hanging onto his every word. He proceeded to ask me if I would be interested in creating a work that would serve as a gateway into the world of people with learning difficulties, and special and additional needs. David had been inspired by *Song of an Exile* to envision a project that would help create awareness through the vast potential of art. Cause for Concern would commission the writing and recording of this work. The brief was simple: try produce a piece of music, a musical, anything that would introduce the subject of learning disabilities to a greater public.

I had to admit to David that I had never really thought about this type of project. At the same time, I was undeniably intrigued. Something stirred inside me as he laid out his vision for the organization which would later become known as "Prospects". David spoke of the impact that the combination of poems and music in *Song of an Exile* had had on him, and I could sense his excitement at the thought of another project that might raise people's awareness to the often-hidden dilemmas, questions, confusion and prejudice surrounding people with learning disabilities. It also hit close to home: he and his wife Madeleine had a daughter, Rachel, who was a person with Down's Syndrome. In talking me through his vision David also stressed the spiritual aspect in all of this. Who could dare to define what was "normal"? Were we not all, in some form, subject to limitations or disability? Even if they are not *outwardly* apparent, surely we wrestle with our *inner* demons that prevent us from peace or spiritual wellbeing?

This I could, and can, certainly relate to. Surely God's definition of "normal" is radically different from what our society has adopted as the norm? In our everyday lives so much is focused on outward appearance, masked emotion and the perception of "holding it all together". Perceived flaws are seen as a weakness, an obstacle to acceptance. Differences in

people with a vast range of learning and physical disabilities are seen as inherent problems which frequently result in a child being marginalized, excluded or even unwanted, rather than "mysteries to be loved" as the priest and author, Michael Mayne, expressed it. How different God's normal is. His is defined by a perfect Love. It is a Love that has instilled a sacred dignity into human life. It is a Love that is powerful and purposeful, fierce in its pursuit of us. Looking at it through these eyes, a child with learning disabilities is no less normal than any other human on this earth. I knew this was a cause and conviction that spoke to the aspects of art—and music in particular—that I had championed for so long. To give a voice to the voiceless; to lift the veil of ignorance or indifference to what is quite practically a matter of the kingdom of God. I said "yes" to David Potter's request. This would be my next endeavour.

Both David and I were in agreement about the general approach. There was a spiritual aspect we were very aware of, but this project would need to serve the larger world outside the confines of the Church. I was keen to have such an approach anyway. The heart-wrenching stories I had heard and read over the years had taken a hold of me and I had always felt that I could not write adequately about a character, or voice it in the first person, without envisioning myself in his or her place. It had served me from a songwriting perspective, but now it had led me to a place of inner conflict. In writing for *Song of an Exile* it had become about more than being a voice to a child. I felt, in creating the work, as if I were the child. In a way, wrestling with those difficult themes *I* was the lost child. I did not lose my faith in God . . . but during that time, I did lose my sense of security in the Church.

Rabbi Hugo Gryn had served as a beacon to guide me through these dark places. It was one of his statements that had given me the insight I needed to continue on my path, away from despair. In the darkest times, the question was not, as he put it, "Where was God in Auschwitz?" but rather, "Where was man in Auschwitz?" It changed my perspective on this horrible chapter in history. What had happened was that man had committed an unspeakable act: the act of dethroning God. And when God is dethroned, the unthinkable becomes possible . . . and then doable. Hugo helped me realize that God had not abandoned his people, but rather that man had dethroned God. It helped me in recovering a sense

of direction. But I was still suspicious of the Church, thinking about how all this not only could happen, but did.

In creating the new project, which we now decided to call *Beautiful or What?!*, I wanted to be very careful not to draw loose parallels between children with learning disabilities and the plight of those who had died in the Holocaust. There was, however, a shared element that surfaced in the creation of these two projects when it came to the children. In both cases, they were confronted with a society that designated their very being as unwanted, to the point of trying—in different ways—to remove them from the public eye, taking away their place and voice. I could not hear the stories of how a European government decided to put children with learning disabilities in separate parts of a city without invoking images of the ghettos. I could not get over the root of this separation in both situations: the harsh reality of children designated as unwanted or undesirable . . . and cast aside.

It was clear that I would need guidance not to let these lingering impacts dictate my approach to this new project to the point of muddying the waters. This was not about war or persecution. This was to be a musical work committed to promoting understanding and acceptance of the very specific plight of children, men and women with learning disabilities, and a spiritual dimension would also be there. There was only one person I knew who would be up to the challenge with lyrics that spoke to my heart while complementing the music. Naturally, I called Phil Thomson. We started work on *Beautiful or What?!* by deciding on the form. This would be written as a musical, adaptable into a stage play. Phil and I talked about exploring the themes in a fantasy world with two main characters: a girl with undefined learning difficulties and her rag doll, which would be presented as a living character. Phil proved to be more than up to the task. More than ever, this felt like a collaboration that transcended my personal identity as an artist. This was, of course, a commission that set it apart in my body of work. But the input Phil had in both the lyrics and concept made it clear to me that this was to become much more than "the next Adrian Snell album".

As Phil's lyrics came in, I was transported to the isolated world of this girl through wishful dream sequences and harsh moments of reality. What emerged through the songs was not so much a plot but a sequence of

events and experiences. The character of the rag doll gave us a wonderful freedom. We could inject it with wisdom that defied its dilapidated, one-eyed appearance. It was a constant companion to the girl, despite having been thrown around and battered to bits in her frustrations. There was a distinct image in our minds when we talked about her situation. She would be in a cage, with the rag doll trying to encourage her to come outside. But each time she tentatively placed a foot outside the cage, she would quickly find out what the world is really like: a place that is unfriendly towards her; a place that does not understand her. The image of the butterfly would return throughout the story, alluding to freedom and the promise of a new beginning, a new life. We introduced other characters along the way, like her father, mother and brother, as well as a frustrated teacher who was unable to handle a girl with learning difficulties.

The songs of *Beautiful or What?!* turned out to be as diverse and unexpected as the album title. We gathered a brilliant cast of vocalists while I took it upon myself to voice the rag doll. Caroline Bonnett brought her wonderful, expressive voice to the part of the girl. Mal Pope was the brother and Annie McCaig the mother. Opera singer Jonathan Veira voiced the father in "Kiss the Child Goodbye". One track had the family watching a television programme called *Handicap*, while "You Never Seem to Learn" showcased Neil Costello's evocative guitar-work, expressing a sense of frustration on the part of the teacher. And then there was "Homocystinuria Aria", a unique track that featured the Bath Abbey Boys' Choir chanting the most peculiar lyric:

> Cystathionine synthetase is an enzyme in the pathway, converting
> methionine to cysteine . . . [17]

I will readily admit that I had never envisioned such a lyric gracing an album of mine. The boys' choir sang these tongue-twisting terms with haunting clarity while we built a wall of sound, as unusual as the lyric, around it. "Homocystinuria" is the medical term for an inherited genetic disorder, and the language of the track gave the sense of an uneasy, clinical approach to a disability.

I was particularly pleased with the songs on the album that had our lead character's various exchanges with the rag doll: "Touch Eternity",

"Beautiful" and one of the last songs, "Silence", which saw the girl finally come to terms with the fact that she is who she is. Most importantly, she is who God made her to be, so she cannot be anything else.

With the album complete, it was time to design a stage set for live performances in order to fulfil the commission. Our production team got to work using the songs and the album illustrations, beautifully rendered by fellow musician and graphic artist, Jon Birch, as a guide. What they created was both evocative and inspiring. A life-size "butterfly cage" was built, and for most of the performance our lead character would be inside it at the far end of the stage with our rag doll always trying to coax her out. There was a seating arrangement centre stage, which was at times a sofa for the family watching television, providing a backdrop to the domestic scenes, and at other times it accommodated a panel of experts.

As we set out to perform *Beautiful or What?!* live, I would look around, with all the inspirational props behind me, and feel like I was actually being transported to a different world. In all my career I had never done anything like this. I knew how to present a musical work akin to a rock opera, but this was a merging of many forms of artistic expression—music, drama, dance, art. In a sense, this was everything I had longed for, but only here, only now, in the context of something I could never have imagined even two or three years earlier, it was coming to fruition.

Without doubt, the greatest, most meaningful compliment Phil and I would ever receive relating to *Beautiful or What?!* was the moment when, directly after they first listened to the finished album, both with tears in their eyes, Madeleine and David Potter expressed this: "As parents of a daughter with Down's Syndrome, but knowing neither you nor Phil have had that experience, we are astonished at the way you have managed to interpret 'our world' . . . the insights and accuracy you have brought to this work that resonates so deeply with our actual, daily lives . . . "

I am not sure that I have ever felt more humbled and complimented than when I was invited and commissioned to harness my creative skills to a subject so far from my direct experience, yet so close to my deepening desire to understand, to experience somehow, the world from the perspective of my friends from the community of those with special and additional needs.

As it happens, *Beautiful or What?!* was only toured sparingly over the next year. As quickly as it got off the ground, it disappeared again. This special work still belongs to the category in my heart of "a work in progress" in that I am very sure that it will resurface, will find its rightful place and time. Looking back on it, I know I must have approached it as a standalone project, but I could not yet see that the child and her rag doll had planted a seed in my heart. It was only a matter of time until it would start to germinate.

21

As I began to sing the words of "If I Were", another variation of the warm coloured glow, this time deep orange-brown, rested on the large columns behind us. It illuminated the massive engraved stone slabs behind us and highlighted the pillars that surrounded us like giant, silent witnesses. These were stones carved out of the bedrock in such a way that they appeared stacked up, helping to instil a sense of relevance to what was most surely one of the most beautiful places I had ever performed in. Most of all, I was overwhelmed with a profound feeling of the past nine years coming full circle. It was 24 August 1994, the eve of my fortieth birthday, and here we were: me, David Fitzgerald, Caroline Bonnett and Richard Frieden, performing *Song of an Exile* in the Valley of Communities at Yad Vashem in Jerusalem.

Even without the added professional lighting, the Valley of Communities was an impressive place. This monument at the Yad Vashem museum had been dug out of natural rock. There were no artificial walls erected, no embankments added to what the earth had revealed. And in keeping with Yad Vashem's impactful method of remembrance, the names of Jewish communities (over five thousand) that had once existed on earth and subsequently disappeared were engraved on the stone walls. The imagery of this place spoke volumes. A millennium of Jewish life in countless communities, wiped away as if swallowed up by the earth, only to then be revealed and remembered by clearing the earth, forging a path to remember for the sake of the future.

Performing *Song of an Exile* on this very spot, this place of remembrance, was a great honour. I had felt truly privileged to be granted this opportunity as a *Gentile* Christian artist in this, the very heart of Jewish remembrance, singing the words of "Fear" by Eva Picková, of "Terezín" by Hanuš Hachenburg, trying to express in music the journey of suffering they and millions of others had endured. For over eight years now I had tried to step into the lives of the men, women and especially the children of the Holocaust. It had brought me to places I could never have imagined. And the more I sang this collection of songs, the more I started to regard the *whole* work as an extended Kaddish, the prayer that "mourns" and "praises" at the same time. After a time of great suffering, the story of the Jewish people is also one of deliverance. Out of the ashes of the Holocaust came the rebirth of Israel. It marked an end to 2,000 years of exile. As Hugo Gryn would explain to me, the word "Zion" was Jewish shorthand for the kingdom of God here on earth. This was a kingdom that could become visible and perfectly realized, even though it was not yet so today. This expression of longing, the expectation of the kingdom of God, was of immense importance to me. It helped bridge the gap I felt had opened up between me and the Church at large. To explore God's faithfulness to the Jewish people spoke to me personally as well. I felt it was a deeply reassuring and faith-affirming experience to know and see that God was right there with his children, "closer than breath", experiencing their suffering as deeply as his love was boundless.

Throughout the night, Richard Frieden had added drama to the performance with his expressive, passionate dance interpretation. We were performing in the very city that is central to that promise: Yerushalayim—in Hebrew, the "City of Peace". I felt drawn to this city for what it represents. The coming fulfilment of God's everlasting promise. A place where God dwelt with his children, a land that would eventually become a beacon to the world.

I had fully embraced the continuing importance of the Jewish nation in shaping God's plan for the world. It had shaken me out of what I would now characterize as a state of theological complacency. Having grown up in the Anglican Church, I was familiar with the wing of the Church that professed a "replacement theology". The idea that the Church had inherited all the promises given to the Jewish people, thus replacing them

as the vehicle by which God would fulfil his purpose for humankind, is something I completely reject.

In some respects, I was feeling something of the lost child again—not in terms of my beliefs and world view as such—more around that sense of home, where I truly belonged. There had been safety in growing up in the Church and, by default, embracing its theology. But now that bond had loosened and slipped away. I had thought there would be safety in my faith, providing comfort during my days at music college, but I had ultimately felt isolated. There had been a safety in writing and recording *The Passion*. I had thought no Christian would disagree with my description of these fundamental events and their significance for humanity. But even in this I had concerns expressed to me by listeners who were troubled by some of the words. I suppose I was feeling adrift in the broader community of my brothers and sisters in the faith. I no longer felt comfortable within the church of my childhood, teenage years and early adulthood, but how and where was I to find a new place of belonging? All this was deeply personal, rooted in my journey of faith.

At last, the next chapter in my musical journey became clear: I would take the listener along the different stages of Jewish history, told with the words of Jewish authors and poets, prophets and the Messiah. I had gained wonderful friends who had held up a mirror to me in proclaiming their beliefs, understandings and interpretations of the Jewish scriptures. It was my hope that this new work might also become a 'mirror' to those from the Jewish community, by using words from entirely Jewish sources. Words that would finally lead us all to "Yeshua Ha Maschia"—Jesus *the* Messiah.

City of Peace was the title I decided upon and, of course, there was intended to be some irony in the title. This city, Jerusalem to most of the Western world, has been more times destroyed and rebuilt, more fought over, than any other city in the world.

Once again, the timing around the composing and recording of *City of Peace* had much significance for me. Jerusalem was about to celebrate 3,000 years since her founding by King David. This is where I had had the privilege of premiering *Alpha + Omega*, just metres from the Old City, proclaiming John the Divine's vision:

> Oh rejoice, the Holy City comes
> oh rejoice, the new Jerusalem
> rejoice, be ready now
> He's coming to take His bride
> He is Alpha and Omega, He's alive.[18]

Enthusiastic support for *City of Peace* came from one person in particular: Rob Richards, director of Shoresh, a wing of the Church's Ministry Among Jewish People—CMJ. This organization was originally formed as a response to members of the Anglican Church insisting on finding ways of bringing Christian outreach into the many Jewish communities in our midst and further afield. But, under Rob's wonderful and visionary leadership, CMJ was now just as much a vehicle for Gentile Christians to learn, understand and then apply their new understanding in the daily life of their own churches and communities. To my great delight and immense encouragement, Rob managed to secure the kind of generous financial commission that would enable me to take time out to write and record *City of Peace*.

The album opens with "Prayer for Travellers". I was immediately struck by these words found in a Jewish prayer book by my mother just days before our journey to Israel. The "Shema Israel", found in Deuteronomy 6:4, were words I would certainly set to music:

> Hear, O Israel: The LORD our God, the LORD is one.
>
> *Deuteronomy 6:4*

I was clear from the start that I wanted *City of Peace* to offer glimpses into the whole story of the Jewish nation and their relationship with God. It would include musical interpretations of the promises to his children—his covenants—and the implications arising from these, including his laws for life and living that, if followed, would keep them from going astray.

The work would attempt to take the listener through various moments in their turbulent history, referring back to the central, the most significant event of all: the coming of the promised Jewish Messiah, Yeshua, his life, his death, and his resurrection. The album would end with a vision of the final renewal of all creation, the coming of God's kingdom on Earth,

the restoration of Yerushalayim and the joy and dancing in the streets of the "City of Peace".

There would be two parts: part one "Moriah" and part two "My Every Breath". "Moriah" refers to the mountain region where Abraham almost sacrificed his son, Isaac, an event foreshadowing the actual sacrifice two thousand years later of God's own Son, the "Lamb of God".

"My Every Breath" would continue to draw from psalms, biblical texts and poems that speak of the coming peace and renewal, the new kingdom and the fulfillment of all that God has promised. But alongside these immense, majestic, prophetic themes, are the deeply personal, intimate expressions of our relationship with God. And actually these songs are amongst those I most love to perform. Songs such as "Like a Child that is Quieted is My Soul". These tender, vulnerable words bring us right back to the relationship central to everything—that of the little child to its devoted mother and father: Mother, Father, God:

> O Lord, my heart is not lifted up
> My eyes are not raised too high
> I do not occupy myself with things
> Too great and too marvellous for me
> But I have calmed and quieted my soul
> Like a child that is quieted at its mother's breast.[19]

The more I read these texts, the more I found their language so beautiful and poetic, often with a childlike simplicity and trust in a God who only ever wanted his children to flourish, to live life well . . . in peace, with hope and in joy. If only these texts were more in the consciousness of the Church, I thought. If we were prepared to open our minds and hearts to the idea that so many of the biblical prophecies have this double edge, in that they speak to both then and now, we could all rejoice in the fact that what God spoke and promised then is every bit as true for us in the twenty-first century.

As the album draws to a close, this journey through such an extraordinary emotional landscape would be expressed in particular through two contrasting songs: "Shalom", based on an anonymous early "Yemenite" poem—beautiful, intimate words of love between a bride

and her groom—and the title track "City of Peace", drawing from the book of Isaiah.

I saved the poem that still moves me the most until last. One of the collections of poems I discovered was that of the Yiddish writer, Aaron Zeitlin. He was plagued with guilt having survived the Holocaust whilst the rest of his family perished. Many of his poems were a profound expression of grief and loss, whilst seeking to reconcile his faith to the tragedy and horror that had befallen his people. He wrote about the endless struggle between them and their God and also their struggle to find acceptance and a welcome in foreign lands throughout history. "I Believe" was my setting for one of his poems. These words so masterfully revealed the one truthful answer I now knew to the question: "Where was God in Auschwitz?" This poem showed me, cried out to me, whispered to me: "He suffers *with* me."

I Believe
If I become a storm
Or if I blaze in rebellion against Him
Is He not still the one who bleeding in my wounds
My cries still praise, my cries still praise

I believe He suffers with me
If I cry out against Him
With me He cries, with me He cries.[20]

The ever deeper understanding of a God far from absent in times of suffering and darkness, but rather *intimately* present to the extent of "bleeding in my wounds", was to help create a renewed foundation for my own journey of faith.

As David Fitzgerald, Richard Frieden and I premiered the work in Jerusalem in June 1995, the album at last complete and published, I sensed the closing of a chapter. I had travelled from the "guns of peace" at Bergen-Belsen to the "city of peace", Jerusalem. The stories of the children of the Holocaust had brought me to the darkest places, but now I felt able to move forward with a new and deeper confidence in the beliefs that had shaped my world view.

The lost child was coming home . . .

22

Artists thrive on contrasts. To put it in other words: the creative spirit of an artist is often awakened by the tensions that are to be found in contradictions. The songs that truly speak to many people from all walks of life, over prolonged periods of time, have that much in common. They steer clear of predictability, overly simplistic lyrics or easy answers. And more often than not, these songs tend to be born out of real-life experiences. As a young man who discovered the power of music as a means of communication, I found that I gravitated towards this kind of artistry. Artists like Bruce Springsteen, Joni Mitchell, Van Morrison, Björk . . . all seemed to be able to communicate with such brutal honesty and intimate openness about their lives, allowing others to join them in the process of discovering truth. It was as important to me that music was truthful, as well as speaking truth. There is a subtle yet distinct difference between the two. And from the moment I had embarked on my journey as a recording artist, I had been caught up in the world of Christian music, where speaking truth—or rather, the Truth—took precedence over all other aspects of music. This had felt restrictive.

Like anyone else, I have lived through, and continue to live through, my share of strife and struggles, failures to live up to my own expectations of myself—let alone the expectations of others. I continue to believe that as an artist there are lines to be drawn when exploring personal themes and experiences that might cause hurt to others in so doing. Certainly, my journey of faith and the perspective on all things that comes from my world view, is well represented in much of my work. But there has always been that instinctive filter when considering how much, exactly what and when to write about personal relationships and convictions, family and friends. And that dilemma is at its greatest when some of those experiences have been, quite literally, life-changing. To share them more widely through song or lyric would, in certain senses, bring about a betrayal of trust. Inevitably then, that creates a tension between the longing for total freedom as a composer and the fact that this total freedom cannot be absolute if these are the values you are determined to live by.

The years leading up to and following *City of Peace* were certainly steeped in contradictions. On the one hand, it felt like a spiritual homecoming, the sense that I had embraced the truth of God's light speaking in the darkness, thankful for the children whose words had helped lead me to that insight. On the other hand, the search for my own identity, personal and spiritual, had become more intense than ever. Of course, it is the people closest to the artist living this intensity, often to the point of self-obsession, that have to bear most of the negative consequences. Nevertheless, after the release of my first completely instrumental album, *Solo*, recorded entirely live on a beautiful Steinway grand piano at the Michael Tippett Centre in Bath, I felt ready and able to write and record an album exploring very contrasting themes to those of recent years: *Intimate Strangers*.

Central to the making of this album was my good friend, Jon Birch. We had worked closely together on *City of Peace, Beautiful or What?!* and the remake of *The Virgin* (*Light of the World*). Jon is a wonderfully innovative, gifted producer, songwriter and visual artist, and I knew that, in allowing myself to be more experimental than before, I could trust Jon creatively to help me deliver an album that I would be proud of, however much of a surprise it might be to my established audience. The music would wrap itself around the listener in a slow dance of samples, bass and echoing vocals. We decided to leave the lyrics out of the booklet. These songs would need to be simply about the listener having to listen with as few distractions as possible, including written lyrics to pore over as the song was playing. Looking back, I see how much of the material on *Intimate Strangers* was both an expression of the reality behind the album title and a cry for healing and forgiveness for the hurt we cause those we love most . . .

All I've known is hunger for the healing to begin . . . [21]

The imagery of children and lost childhood was never far away. It was there in "Infants and Angels" and "Fire and Ice".

Who stole the smile from the face of the child in my heart?[22]

"Where your River Flows" and "Intimate Strangers" would examine something of the mystery, beauty and pain, and indeed the inevitable contradictions, in all meaningful relationships where there is both intimacy and distance:

> You know me so well . . . yet you hardly know me at all.
> I keep my distance, you hurt when I fall.[23]

Both of these were my interpretations of lyrics written by Phil Thomson, but at this point in my creative life I now had much more confidence in my ability to write my own words. Subsequently, four of my lyrics ended up on the album.

"Where your River Flows" carried much significance for me. I wrote this for my son Ryan. Any parent will know of those times when you long to reach your children and when, for so many possible reasons, there is a distance. This is a kind of emotional pain unique to that "Fierce Love" between a father and his child: when you know for sure that words alone cannot break through that invisible barrier. At those times of developing, changing relationship—however much reassurance others might offer "you'll come through this"—it means little in the face of the here and now.

In the words of this song I felt able to say, through chords and melody, what I so wanted to. And in making the gift of a song to another person, there is none of the intensity, the tension, that invariably fills the space around two people trying to make themselves understood in conversation. The recipient can receive the gift of words any time, any place he or she chooses.

Jon and I were in full agreement that this was a record that should be listened to "late and loud", as I even ventured to suggest in the album cover notes, preferably with a good glass of wine in hand.

I could not write and record an album like *Intimate Strangers* without including an interpretation of Dylan Thomas' immensely moving poem "Do Not Go Gentle into That Good Night". This poem had been important to me ever since I was a child. Before I was even a teenager I had chosen it as my entry in a school reading competition which I won! I do not remember how or where I had first discovered them, but the words of

this poem had become deeply engrained in me. This heart cry from son
to father on his deathbed were all too familiar to me:

> Rage, rage against the dying of the light . . . [24]

As I easily recalled the image of my own father "raging" against death,
reddened with the heat of his body doing battle, clinging to life, these
words had attached themselves firmly to my soul with the passage of time.
There were the opposites again in simple terms: simultaneous aspects so
true of love. The fierceness and yet the tenderness . . . the fear and yet
the longing. So there Dylan Thomas was, another lost child just trying
to find the right words when there were none. I remember the relief I felt
when we received permission from the Dylan Thomas Estate to use the
poem on *Intimate Strangers*.

The album was eventually released in 1998. I was well aware of, and
actually comfortable with, the fact that it might well struggle to find an
audience with the same ease that projects like *The Passion* and *Alpha +
Omega* had done. But this was the album I simply needed to make a kind
of emotional anchor. After Sue heard it for the first time, she commented:
"This reminds me of the songs of yours that first made an impression on
me, just after I met you for the first time."

It was the only review that really mattered to me then. Sue's words
somehow breathed a new creative freedom into my heart. The joyful
freedom of a child about to embark upon a new adventure.

23

"I want you to think of me as the dead or disappeared composer!"

The man who was to direct the premiere performance of my latest
work looked surprised and confused. I quickly explained. We were about
to premiere my latest work, which had been years in the making but
effectively lying on the shelf for several years since. This was November
2008 and we were finally ready to reveal *The Cry: A Requiem for the Lost
Child* to the world. And we were doing it in—of all places—St Paul's

Cathedral in London. This production was initiated and spearheaded by my dear friend Ed Newell, then Chancellor and Canon at St Paul's. The Archbishop of Canterbury at the time, Rowan Williams, was also in attendance and would introduce the work. My family and friends were here at the culmination of the long creative process and years of frustration that had followed the completion and recording. This night was to be in aid of Save the Children, an organization I deeply admired for their heart and hard work on behalf of suffering children worldwide. All the pieces were in place for me to enjoy this day to the fullest: the satisfaction of a composer seeing a major work take flight.

And yet . . .

My comment to the director, David Drummond, was calculated. I had largely come to the conclusion that my days as a recording and touring artist were over and this special, and first ever, performance of *The Cry* was to be something akin to a swansong. Very few other people knew that, including the audience. Of course, I was delighted this work was finally being given a proper live premiere. But it was to be with the understanding that I would now be out of the game. This would not be the same old starting point in a music release cycle that saw me embark on a long tour, night after night, only to come home weeks later, sometimes more, and start the entire writing process again. By now, I was resigned to the feeling that this moment in time would be bittersweet.

It had all started out well enough. Soon after *Intimate Strangers* I had felt the urge to continue exploring the voices of the children caught up in situations of conflict and ethnic cleansing. The names that I had listened to as they were being read out loud in the Children's Memorial at Yad Vashem were still ringing in my head. This profoundly reverent, respectful and immensely effective method of remembrance had inspired me to take the idea further. In the simple act of naming each child for a moment, however fleeting, they all lived on. In that place they were no longer just victims, part of a terrible statistic; they were individual people once again, with individual stories. With the writing of *The Cry* I had determined that I would expand this repeated naming of the children to reach into theatres of conflict all over the world. This would be a work to give voice to the voiceless: the "lost children" throughout the world during the twentieth century.

Work on *The Cry* got off to a promising start. I was granted a generous commission from the Bible Society that allowed me to take some months out and away in the late 1990s, enabling complete focus on the creative process. The work presented challenges not only in terms of subject matter but also in scope and scale. I both wanted and needed the process of writing and structuring *The Cry* to be one of collaboration. And I knew immediately who to ask: Murray Watts, a good friend and very gifted playwright who had decades of experience writing theatre plays and who would later venture into film. His plan was for us to spend a week writing and discussing the work in a special place: Freswick, a remote castle in Scotland.

As it happened, Murray had founded a charitable trust that had purchased this old Scottish landmark with the vision to transform it into a place where people from all disciplines of the arts, from anywhere in the world, could rest, be refreshed and renewed and make meaningful connections with other artists. All the activities within Freswick Castle would be underpinned by its Christian world view. Within such a location, who knew what inspiration would come and what works of art might emerge?

The castle lacked ornate decorations, towers or other details that people might normally associate with a castle. There were partial ruins left of what would doubtless have been more in keeping with most people's perception of such a place, but it was still very memorable. This seemingly plain building was located on a breathtakingly beautiful piece of land, its hill a lush meadow surrounded on one side by a calm ring of water and on the other a beach that gave way to the vast expanse of the North Sea. I suppose with these circumstances in mind, the writing for *The Cry* was a little like a full circle moment for me. All those years ago I had retreated to the coastal beauty of Lee Abbey, writing my early works. Now here I was, at another coastal retreat, writing what felt like it could well be my last musical project.

Murray was well aware of my earlier thematic works and the structures I had used, particularly those of the "chapters" in *Alpha + Omega*. So, early in our discussions we decided to place *The Cry* in the framework of a requiem. Countless composers had done so before, including Mozart, Fauré, Verdi, Berlioz. For us, the shape of a requiem would

provide signposts along the way for the story we wanted to tell in the naming of the children. This was a structure that was both liturgical, giving a biblical context for the deceased, and historical, as a form used throughout the centuries. A requiem would typically start with a "Kyrie", a cry for mercy, leading along the way to the "Dies Irae" ("The Day of Wrath"), the proclamation of God's judgement over humankind. The revelation of "Agnus Dei" (the coming of "The Lamb of God") would lead to the response of "Libera Me" ("Deliver Me"), traditionally sung at the absolution of the dead and, ultimately, "In Paradisum" ("Into Paradise"), a prayer sung to guide the deceased to their eternal rest.

These were to be the signposts on our journey as we composed *The Cry* over the following weeks and months. Together we spent many hours exploring the stories of individual children whose own authentic words and poems would be included in the work. And we searched for names of other children who would represent a specific conflict or event that, through the nature of its particular tragedy or horror, would be important to *The Cry*.

Eva Picková had to be there, of course. And alongside her, the most universally known child of the Holocaust, Anne Frank, whose voice lives on to this very day through her diary writings. We also identified and named Maria Coetzee, a victim of the first concentration camp set up by the British during the Boer War in 1901. Then there was Joan Owen, a two-year-old girl who was one of countless victims of indiscriminate bombings during World War II; seven-year-old Hector Pieterson, who was gunned down during the student protests in Soweto, 1976; Gaspard Nsengimana, killed with his mother and brother in Rwanda for belonging to the wrong tribe; Ludwin Omar Valdes, one of the many street children murdered, often by the police, in Guatemala City every year; Maura Monaghan, the eighteen-month-old girl who was one of the victims of the Omagh bombing in Northern Ireland and Dritan Berisha, ten years old, killed by a road mine in the Kosovo war. We would include the emotive words of the poem "On a Night of Rain in Jerusalem" by Uri Zvi Greenberg, the children's writings from "Barracks L318 and L417" in Terezín—"On a Sunny Evening"—and the beautiful, childlike vision of hope for the future written by ten-year-old Roberto from Pula in the former Yugoslavia—"If I Were President".

As far as the liturgy was concerned, in addition to many of the established texts in Latin and English, we also included a setting of the Beatitudes, words spoken by Jesus and recorded in Matthew 5; a Celtic benediction (in "Deep Peace") and an adaptation of Isaiah 11, "A Little Child Shall Lead Them", prophetic words that in so many ways connected *The Cry* to earlier work:

> And a child shall lead them
> To a land of freedom
> Where darkness is forever turned to day
> Where the world was broken
> Wounded, weeping
> Then a child will kiss the tears away.[25]

You cannot easily compose a requiem without the centrality of the choir; the timeless sound of that unique combination of children and adults singing as one voice. To my delight, one of the leading cathedral choirs in the country, Winchester Cathedral Choir, under the direction of the highly respected David Hill, agreed to be our choir for the album recording. And we had already secured the involvement of soloist Natasja Gorlee from Holland, whose beautiful, emotive voice would wonderfully evoke the journey of the "lost child", and Rebecca Engstrom, one of the most expressive, innovative violinists I had ever worked with.

But even after the many months it had taken to bring *The Cry* to completion, I could not agree to its official release until we truly found that access to the broader, mainstream audience I had longed for ever since the beginning. Surely this was a work that went significantly beyond the narrow confines of what so often ended up in music shops under the heading "Christian" or "Gospel" music? I was determined that the finished album would only be released when my manager at the time, Alex Verlek, and I had secured a suitable partner for the promotion, marketing and distribution of the work. Not for the first time, my hopes were greatly raised by the unexpected interest from people who really could make things happen. They included the manager of Damon Albarn (Blur; Gorillaz) and, through him, even the interest of Harvey Goldsmith, promoter of global events including "Live Aid". Yet, in spite of the several

Christmas hampers we received as gifts from the management company, in the end, as so often happens to many of the artists placing their hopes in someone, or in a moment of seeming interest and enthusiasm, it all came to nothing . . .

Ultimately, *The Cry* sat on a shelf, almost literally gathering dust, for three years before I finally reluctantly agreed with Alex that we simply had to release it, regardless of possibilities just around the corner. So, we did just that through our own Serious Music label. In all honesty, it felt like a kind of defeat after a prolonged battle. Self-releasing meant we could barely make any noise around the album. We simply did not have the resources, the marketing and promotional machinery to do that. Once again, at least in my own thinking, a deeply important work of mine, one in which I had invested literally years of preparation, writing and recording, seemed somehow destined to fall far, far short of my hopes and expectations.

This was a culmination of all that my personal journey had unearthed in my music. This told a much larger story. It was not about me. I did not just *want* people to hear this; I felt this *needed* to be heard. Perhaps that is why, in the end, I felt so alone when trying to come to terms with the realization and the disappointment that, after all these years, I had *still* not found the person, the people, who believed in me enough as an artist and in my work as a composer to take it further. Inevitably, all of this fed into my thought processes about my future as an artist. What was God trying to say to me about all of this? Was I destined to be brought to these great highs, time and again, only to have the rug pulled out from under my feet? I was unsure about my identity in more ways than just the artistic, but I increasingly knew this: I could not, was not, going to allow this happen to me again.

So, when five years later I was suddenly presented with the joyful, surprising invitation to perform the world premiere of *The Cry* at St Paul's Cathedral, I felt the need to make it clear to David Drummond that "I want you to think of me as 'the dead or disappeared composer!'" On 16 November 2008 *The Cry* was given a wonderful new lease of musical life at just the time that I felt I had definitively let go of mine.

Above: Richard Frieden dancing in the Song of an Exile live production.
Right: With Rabbi Hugo Gryn at the launch of Song of an Exile.

CINTE POKÁNIE, VERTE EVANJELIU

Above: Curiously captivated audience in Eastern Europe during the "Alpha + Omega" tour.
Right: With David Fitzgerald in the Valley of the Communities, Yad Vashem, Jerusalem.
Below: In Jerusalem, 1985.

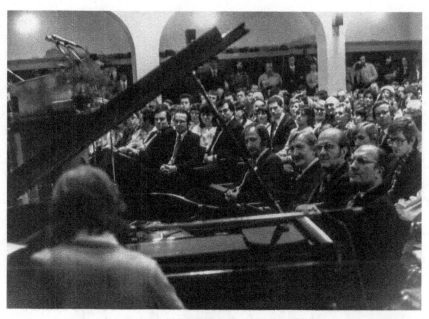

Above: Performing in Prague, circa 1985.
Right: Publicity shoot, 1986.

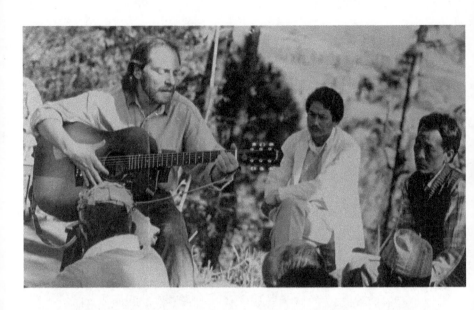

Above: Anandaban Leprosy Hospital, Nepal.
Below: With Padmahari at Anandaban Leprosy Hospital, Nepal.

PART 4

Music Therapy

"Music is a moral law. It gives soul to the universe, wings to the mind, flight to the imagination, and charm and gaiety to life and to everything."

This is a quote widely attributed to Plato, Athenian philosopher in Ancient Greece. He was the founder of the Platonist school of thought and the associated Academy—the first institution of higher learning in the Western world. And, perhaps extraordinarily, he wrote these words in or around 400 BC. This has become one of several quotes about music that adorn a space outside my music therapy room at Three Ways School. I feel it speaks to a deeper truth that is embedded in the miracle of music.

Music functions as a comforting and understanding friend. Everyone has, at some point, heard a song and felt it spoke intimately, even directly, into their own deeply personal circumstances. Such is the power of music that the very same piece can speak completely differently, but with equal power, to tens of thousands of individuals around the world. Music is one of God's many gifts to the world, and it is a rather special one. With his characteristically "fierce love", God provided us with something that not only gave us the means to be inspired and comforted; music allows us to connect, feel, celebrate . . . heal.

I had never needed convincing of the healing power of music, having experienced its extraordinary power, personally, from a very young age. For my entire life music has been like a close friend to me. Within the place of sanctuary that music gives me, so much is happening, continually. At one moment I am grieving, mourning the loss of someone very important to me. At another moment I am exploring every instrument, any sound, that will express the joy about something truly beautiful that has happened in my life. And, of course, using the limitless vocabulary

music offers us, it can enable a wordless exchange, something shared yet unspoken, between two lifelong companions.

I have been privileged to witness the way in which music has given lost children a voice. Seemingly helpless victims of appalling wrongdoing or tragedy, children with profound limitations in the ways they communicate, each of them has somehow been able to share their heart and mind with the world through music and song. I was at a crossroads. It was the healing power of music that set me on another path—that of music therapy.

As mentioned already at the beginning of this book, Beethoven suggests: "Music is a higher revelation than all wisdom and philosophy", which provides food for thought for many conversations on the subject, but music had certainly become a far higher, deeper revelation to the sometimes lost, often bewildered child that I found myself to be. Music has always given "soul to *my* universe", "wings to *my* mind" and "flight to *my* imagination" as in the quote above. Now, it was to give me a whole new purpose. In a sense, my path into music therapy represents a reversal of roles. A world where the word "normal" would be completely redefined. A place to explore, challenge, make possible, meaningful inclusion for all those with special and additional needs. Perhaps another chapter in the story of this lost child finding the path that would lead him home. The first signpost towards this new avenue was to be found in the Netherlands . . .

24

Sue must surely have noticed how intrigued I was by what the Dutch speaker described and, if not, I definitely talked to her about it afterwards.

It was the early nineties, and we were at the Christian Artists Seminar at the De Bron Conference Centre near Zwolle in the Netherlands: a gathering that had become a tradition of sorts. Leen La Rivière of Continental Sound had founded the Christian Artists Seminar as a platform that allowed all kinds of artists to learn from each other and be inspired. Musicians, painters, sculptors, dancers and poets . . . they all spent several days in each other's company, exchanging stories

and experiences while participating in sessions that gave insights into various crafts and topics. It was a place I loved visiting. Here I was surrounded mostly by people who had an appreciation for and, in my view, an understanding of the importance and impact of the arts. These people were more likely to "get" me. It felt like a gathering of friends. Sue accompanied me on this trip as I played my music, and we attended various workshops. The familiar warmth I felt here was most welcome, having just completed my emotional journey through *Alpha + Omega* and *Song of an Exile*. I had not left the themes associated with those projects behind; instead I saw them in a fresh light, as stepping stones into the future. And so, the process of gathering the children's writings and giving them a voice beyond an environment of conflict was still very much on my mind as I skimmed through this year's conference programme. Sue and I ended up attending a seminar led by a Dutch counsellor and therapist, Gefke Koelbloed.

Gefke was an engaging speaker: warm, with a sympathetic smile and friendly face that invited interaction, which must have been helpful in her versatile career. She had studied music and was an expressive painter, but her topic of choice today was her work as a music therapist. I had heard of music therapy before, of course, but never to the extent that I knew what actually took place in practice. Nor did I really grasp its place in the broader field of mental health. Today, Gefke was the first direct window into this world for me. She told us a little about her own background leading up to working as a music therapist. To paint a picture of what she was talking about, she started by describing a therapy session.

Gefke had been working on the psychiatric ward of a prison facility where she helped inmates express themselves and give vent to their pent-up frustrations. For many, if not most on this programme, being able to express themselves in a way that allowed for better understanding, was not easily accomplished. Gefke had brought some unconventional tools with her: giant drums that she positioned across from each other. She first allowed the men to familiarize themselves with them and then let them loose—figuratively speaking. They started what might be described as a drum battle, pounding on the instruments with a rapidly increasing rumble until the room was filled with thunder. Gefke described how the prisoners seemed to lose themselves in their playing, whilst also

connecting on a deeper level. They had found a fresh way to express the angry, violent emotions they may previously have bottled up. As Gefke spoke and described the drum battle, it resonated deeply within me. Somehow, without having been present at this actual session in the prison, I understood the "what" and "why". This went beyond simply understanding a field of knowledge; music therapy was a revelation. I came home from the Christian Artists Seminar refreshed and inspired.

Several years later, with the new millennium looming, I had reached a crossroads in my career. My journey led me to the ever-stronger conviction that the recurring pattern of producing and promoting music for commercial purposes, and the frequent disappointments that this brought about, was taking over the creative and social aspects of my life. I found it unhealthy to the point of asking the question out loud: "What else can I do instead?"

I was talking it over with Sue one day when the memory of Gefke Koelbloed and her seminar all those years ago sprang to mind. The more we talked about it, the more I became convinced I should follow up on it. The mention and memory of music therapy was like a light bulb in my mind, a positive force that pushed back the cloud of disappointment with its promise of opportunity. I tracked down Gefke's contact information and picked up the phone. Amazingly, she still was using the same phone number, and our conversation was as encouraging as I remembered her being in person. She referred me to a colleague at the London Guildhall School of Music to help me get started on the path to a possible new career. Gefke's contact in London pointed me to someone in the field who lived and worked in Bristol, a city only ten miles from our home in Bath. I was surprised to discover that this was a childhood friend of the family, Jane Lings.

Jane invited me to spend a couple of days at her practice as a "fly on the wall". It was a generous proposal that I eagerly accepted. While there, I witnessed her work and the undeniable impact of music therapy. Two very distinct sessions stood out for me: one where she worked with a boy who had almost no means of physical or auditory communication and the other a session with young carers. The latter was a group of youngsters who had had to face the reality of caring for their parents or other family members as the result of illness or accident. They had each been thrust

into a new life as a caregiver, often still lacking the emotional maturity needed to cope with the day-to-day challenges involved. These sessions were a way to help them express what they could not express at home, to find a way forward in the midst of daily troubles. The patients in these two sessions were way apart in terms of the nature of their needs, but I was mesmerized by the obvious power that music as a tool of expression and connection provided for all of them. If I still needed convincing when it came to finding my new calling, this was like a final nudge.

I am hesitant to use the word "calling". More often than not, and especially in the world of Christian music, it can be used as a label to indicate a certain added worthiness to the music. Deep down, Christian artists have to face the inconvenient truth that there is bound to be a commercial aspect to their music-making. We have the same bills to pay, the same financial needs as anyone else. But music can be intoxicating. Whilst we might be serving a bigger purpose, we are also serving an ego. No wonder then the questions around an audience's response to a live concert: do they still like me? Do I still possess what it takes, that indefinable magic that inspires, moves and challenges without words?

Music therapy presented itself to me as a reversal of roles. I no longer thought of my music in terms of what *I personally* could get out of it; in this new context it was about acting as a facilitator so others might get something out of the music. I now felt motivated to apply for music therapy training.

All of this felt like liberation. I had gained a new perspective on my future, but this did not mean that I radically burned my bridges, so to speak. Not yet, at least. Alex Verlek and I were still trying to find a label and platform for *The Cry*. I was absolutely convinced that this work needed to be heard, regardless of what I felt about the new direction my music career was about to take. Of course, if that meant performing the work live, I would welcome the prospect with open arms. But it would be more about my love for the body of work than for the experience of live performance. I was not making a principled decision to entirely let go of my life as a performing artist. What I was leaving behind, though, was the seemingly repetitive process of music-making and touring that frustrated and constrained me. I stopped trying to break through the barriers that I felt were hampering access to my music. I knew it had the

potential to deeply move people, but I was tired of playing by the rules to get to that point. I needed to experience what it was like to make an impact through a craft all over again without any preconceived notions about me as an artist; not having to follow an agenda that was detrimental to the goal of that craft. Starting anew meant I could finally let it all go.

A few years later, when I had completed the course and become a professional music therapist, I experienced a deep sense of relief. Now I was embarking on a new journey. No longer would I need to grapple with my anxiety for the sake of my art or my career. Or so I thought.

25

My colleague and I gathered the pupils together, placing them on the seats as if they were about to go for a ride. We had carefully explained the details of the mission we were about to undertake, and now the time for departure had finally arrived. I could see hints of anticipation on the faces of some of the children and took note. That was a moment to return to later—perhaps ten-year-old Sara would feel able to share her feelings in ways she was resistant to in "the real world". Michael was already fidgeting in his seat, still anxious and unsure about the whole mission. For a moment he stepped back into his place of security when facing the unexpected: he closed his eyes and placed his hands tightly over his ears. Others were looking, listening, full of expectation and excitement tinged with just a little fear of the unknown. As I took account of every child, I exchanged a knowing glance with my colleague.

The multisensory studio we were situated in at Three Ways was now exactly what we had intended it to be: a space rocket about to embark upon its risky mission to the moon and beyond. Together we began the countdown. As we reached 5, 4, 3, a deep, resonant, rumbling sound started, quietly at first, but quickly becoming louder and louder until . . . "BLAST OFF!" On the walls, the projected scenery was clearly moving. With all the appropriate sound effects we managed to simulate a rocket launch. Our adventure had now truly begun. The children were on their way into space.

These themed sessions had proved to be a great success. With another member of staff, I had been developing them to stimulate multisensory learning. We had created sessions around the themes of space, the rainforest, under the ocean, in the jungle or living the life of a pirate. We would use everything at our disposal to engage all the senses. With the forest theme for example, I would create a lush soundscape of birdsong, wind through the trees, crickets, frogs, rain and thunder. We would feel and hear the sound of leaves and sticks crumpling beneath our feet. We might pick up a fir cone and let its unique odour fill our nostrils. Or perhaps allow ourselves the taste of a mushroom. Our special multisensory studio has the ability to project 180 degrees of images and video, making it so much easier to simulate being surrounded by foliage and looking up to the sky between the treetops. We would bring all sorts of materials to scatter around the room, all designed to be picked up, felt, experienced in the context of the imagined theme.

Back to our space journey though, and now our children were actually in space. Now we could safely undo our seat belts, step out of the rocket and explore zero gravity. To achieve this, we would need to imagine walking through water, moving slowly, deliberately around the studio. Maybe we could seamlessly turn this into a zero-gravity dance, with wonderful and weird movements of our bodies immersed in the theme. Michael was now fully engaged: eyes wide open, hands away from ears. Seemingly, it was this moment in our journey that had inspired him to participate. All these moments of contact, connection and self-expression, however slight or obvious, were, and are, always important and meaningful.

If you were a visitor observing a session you would understandably be unlikely to catch that moment of engagement or response that is everything a specialist is actually looking for. It might be something as easily missed as a raised eyebrow, a smile, a rapid series of blinks, something uttered under the breath. In this world, I had learned to search for, and work with, what was actually taking place on a much deeper level. Essentially, for both of us—child and therapist—all these moments become little bridges between us, moments of connection and communication within a safe school environment where we can learn

to experience the world in a new way and importantly have fun in the process.

I sometimes reflect back on that very first group music therapy session I participated in, alongside my friend Jane, with a group of young carers. These days of music-making were more than just an occasion for much-needed respite. They gave each of these precious young people an opportunity to share experiences with others who would immediately understand their particular story and then, importantly, to take all those feelings into collaborative song-writing. There was no pretence, no need to impress or pressure to engage in superficial conversation. As is always the case in a music therapy session, the focus is on authenticity, living in and with the feelings of the here and now. And here as a co-facilitator I also felt a freedom that I had rarely experienced before in using my musical skills.

I realized that this was probably the first time in over thirty years of involvement in the creation of songs where the process was not, in some way, revolving around *me*. As well as the song-writing itself, we would record the finished pieces and transfer them to CDs, allowing each participant to return home with a permanent record of this special, often emotional day of very personal sharing. And my role in this was that of facilitator and encourager. It was a wonderful feeling . . . immensely rewarding. And as I drove away from Bristol Music Space, the location for the day, I became aware of another powerful emotion welling up inside me: joy. Indeed, more joy in a time of music-making than I had experienced for a very long time. As I watched the expressions on the faces of these young people change from sad, burdened and angry to a glow of joy, hope and friendship, I finally, happily, submitted to the ever-louder call towards this new chapter in my musical life. And this would involve embarking upon a much less self-focused story.

Having completed my training and become qualified as a music therapist, I had started to work in three different schools, each of them in close proximity to my house. This made such a difference. The world away from home had been my workplace throughout my life. I would go wherever my music took me. It had taken me to countries near and far away, including places on earth that, prior to an invitation, I would only have experienced through photographs. These had often been

wonderful adventures, certainly, and I would be forever grateful for the privilege of having these opportunities. But now I longed for peace and stability. Working no more than a ten-minute drive away from home provided exactly that. And once the three schools began the process of amalgamating to become Three Ways, things got even better.

I was invited to visit the site of the new school, still under construction but close to completion. I had been granted a wonderful opportunity, namely to explore the building and identify the kind of space within the school that I considered most suitable for music therapy provision. Of course, while there could be no guarantees that my wishes would be granted, nevertheless it felt immensely respectful and affirming that I had been invited to have a genuine input in shaping my future work environment.

Eventually I chose a room on the outer rim of the building, tucked away in a corner, very accessible, with lots of daylight and, most importantly, well away from the noise of classrooms. I was completely free to determine the layout of the room and its contents. This was a little bit like inviting a child to create their own sweet shop. I knew from the start that this needed to be a space where all the senses could be explored. Our experience of the world is at all times multisensory, and it was important to me that, whilst naturally focusing on sound and music, students would be free to engage any of the senses that enabled self-expression or communication.

The next step was easy. I began to transfer musical instruments that had practically filled every available space at home. Over the years, partly because of all my travels, this had become a large and very diverse collection. From the huge gong drum from the Ivory Coast, standing seven-foot tall in its own wooden frame, to a collection of beautiful Chinese *hulusi* wind instruments with a gentle, evocative calling sound; from a set of Indian *tabla* drums, to a large Chinese wind gong. Singing bowls, *kalimbas* (thumb pianos), wind chimes, guitars and shakers adorned all parts of the room, some on the floor, others hanging from the ceiling or on wall shelves. And of course, a piano . . . I could hardly survive without the instrument that had been at the heart of my music-making all my life.

Over the course of several weeks my music therapy room was transformed into the multisensory Aladdin's Cave that I had dreamt of. Wherever you turned you might come across a set of wooden bricks, birds that sang if you squeezed them, an egg-laying chicken, an evocative picture on a wall, a metal tree with violins and bells hanging from the branches; and all of these bathed in exotic lights from a multitude of visual-effect gadgets.

My approach to the provision of music therapy was not particularly conventional. I resisted conforming to the somewhat clichéd image of a practising music therapist: rather separate from the rest of the staff, setting up the relatively few instruments it is possible to bring when working peripatetically; then collecting or receiving the person referred to you, completing the session behind closed doors, writing up your notes and leaving at the end of the day with not much more contact with staff than you had on arrival. In the context of a special needs school, this approach felt too distant for me. I wanted to be as inclusive and collaborative as possible in my way of working. When a child arrived with their support worker or class teacher, I wanted to see that sense of wonder and excitement on both faces as I opened the door. I would quietly rejoice if, after a few moments of glancing all around the room, he or she purposefully made their way over to an instrument or object that was intriguing or familiar and just started exploring. Many of these children would be non-verbal, so I might join in the exploration, wordlessly, myself, or support their activity with an appropriate instrument. With a more verbal child, a conversation might follow or turn into storytelling or the creation of an imaginary scene. By the end of some sessions the floor could well be covered with bricks, soft toys, various musical instruments, the room filled with the aroma of lavender from a diffuser in the corner, and all of us shining a torch towards the laughing monkey hanging from the metal tree!

Of course, an inclusive approach to this work brings its own challenges. And they are often centred around the preconceptions, and sometimes scepticism, of staff and colleagues. For all the many verbal explanations we can give about the work we do, sometimes the only way to really bring about a deeper understanding is to offer a direct experience of what is involved. So, on the first training days for staff at Three Ways, even

before the school officially opened its doors to students, this is exactly what we did.

I was invited to stage a series of music therapy-led multisensory sessions for the staff. Along with a wonderful colleague, herself a highly skilled practitioner in this approach, I hosted a series of group sessions for all members of staff over the course of the next few days. We chose the theme of "Space Travel", and as already described took our colleagues to the moon and beyond, travelling in our imaginary rocket, past stars and planets, inventing the weightless dance, eating dried food, using drums and cymbals to create the sounds of "blast off" and landing and making a big deal of the countdowns! These sessions were immensely successful. "Ok, now I really get it", was a common response as they climbed out of the rocket we had formed inside the studio. These training days were a gift. In some respects, they changed everything. Now I was actively discussing with colleagues new and imaginative ways to enable our children and young people to access the school curriculum.

My line manager even gave me a new title for my evolving role: "Music Therapist and Arts Therapy Consultant for Curriculum Development". Not something that particularly rolls off the tongue but actually a complete fit with what was actually taking place day by day. To my delight, I was now not only helping our students access the outside world and give voice to their inner self, I was also helping class teachers and teaching assistants to explore new avenues in their own work with the children in their care. I was very encouraged. It felt great to be so appreciated. And the significance of the moment was not lost on me. Seemingly embraced by pretty much the whole school, it now felt as if the world was my oyster.

Back to those questions I had always asked myself:

"Will they understand me? Does this person really 'get' me? Is my work valued, appreciated? Will I be invited back?"

The training days at Three Ways had concluded with my colleagues declaring:

"Yes. We get you."

Whereas in my music career I had so often felt as if I was forever climbing uphill, never quite sure of the destination or if I would reach it, here at this school it was as if I had been led to the summit and invited

to embark upon a new journey with new friends. As well as giving me confidence, I had found that place of peace and stability.

And very gradually and quietly, I realized that I had actually rarely felt closer to God. The more I consider the reason, the more I am sure it has much to do with the environment that I work in and, more specifically, the people I have found there. For a start, this world is always about the here and now. The people I work with are largely unconcerned with social niceties. Most would not really know how to conform to social norms. Whilst of course that can lead to a whole range of challenges, equally it is a very disarming, honest place to live. And it is a very forgiving environment . . . perhaps it has to be because so many things happen every day that need the response of patience, kindness, understanding, non-judgement. The work with many of these children and young people can be tough, very raw; troubled backgrounds and fragile emotions frequently, sometimes very suddenly, surface and require a special mixture of clarity and empathy to manage. I am sure that it is here, in this place of constant vulnerability, that God most especially meets us. I cannot spend time with one of our children, particularly those amongst us who are completely dependent on others to enable any sort of self-expression, without considering the character of God; his desire to truly connect with us; that "fierce love" that took him to the place of ultimate sacrifice and then the opening of that gateway.

My work as a music therapist was becoming something of a mirror to my spiritual views and values. It was in many respects a very different experience to that of my music career up until this dramatic change of direction. And it was wonderfully satisfying.

26

I moved as close to Simon as I felt I could in order to catch any sound or expression that I could acknowledge and work with during our music therapy session. The relative silence in the room was largely due to the profound and complex physical and learning disabilities Simon had lived with all his life. Of all those with whom I had worked, his needs were

perhaps the most challenging to meet as his music therapist. Simon was unable to speak, had very limited movements and facial expressions, and I often had difficulty identifying what was an intentional moment of communication rather than an involuntary or unconscious sound or action.

I needed to deconstruct, to rethink my approach to interacting with Simon. Scottish percussionist Dame Evelyn Glennie's profound insights concerning the different ways of hearing and listening were at the forefront of my mind. In this sometimes-uncomfortable struggle to find a place where I could engage with Simon, had I missed something obvious? And as I sat very close to him the answer came, as simple as it was profound: breath! The one consistent sound from Simon that was audible, regular and rhythmic was the sound of his breathing. I moved even closer until my mouth was positioned next to his ear as if I was about to whisper. Slowly, deliberately, I started breathing with him at an audible volume. I made sure I was matching his sound and rhythm as closely as I could. In so doing, I hoped that Simon would gradually come to an awareness that this was a moment of real connection. That in this simple act of breathing in union, we were together. That this was at least a place to start, to bridge the communication gap between us.

On another day, in a different session, Lucy looked at my guitar with eyes that seemed vaguely bemused. After several weeks of working together she knew what was coming next. The guitar was tuned to an open chord, so I ran my fingers down the strings, producing a pleasant, tuneful sound. Her eyes lit up some more. Then I sang and played the song we always started and finished our sessions with. I ended the song with an exaggerated final chord, making the guitar vibrate for a while as the sounds reverberated around the instrument's body. Initially, Lucy had no interest in playing the strings herself. Rather, she placed her ear against the wooden body and felt the vibrations made by the sound. Her face held an expression of pure delight. Now, ever so slowly, she placed her hand over the strings and felt the slightly tingly sensation on her palm. I have a world of musical instruments and sound sources at my fingertips in the music therapy room. But Lucy's primary access to sound and music is through "resonance"—the vibrations caused by sound waves, with all

the contrasts dependent on the shape, textures, volume and the actual space in which we are working.

William was brought to me by his key worker. He arrived clearly agitated. William was severely autistic and, although he would make all sorts of sounds with his voice in trying to communicate, he was largely non-verbal. He was frantically waving his arms as if this was the only place left in his body his anxiety could go. As soon as he entered the room, William started pacing back and forth. I spoke briefly with the staff member who then closed the door to wait outside. I gently beckoned, inviting him to join me in front of the gong drum—a very large, deep, resonant, double-sided drum. Then William spoke, softly but decidedly, as he approached the instrument.

"Heartbeat."

He repeated the word with an intonation that revealed how important it was to him, now, in this moment.

"Heartbeat."

From our previous work together, I understood where we needed to go in our music-making. I chose a large, soft drum beater and started to pound the gong drum in the manner of a fast beating heart. The sound and resonance filled the room. You could feel the air vibrate, and other instruments and items in the room sounded as they shook. You could feel the pulsating sound in the pit of your stomach. William began to match his pacing around the room to the rhythm of the drum. No more need for words; just this immersive sound, generated by his therapist, and the freedom to allow his body to respond accordingly. Gradually, the sense of anxiety and agitation lessened, and William's movements became more fluent and controlled. This was the signal for me to slow down and soften the sound of the drum. We watched each other intensely. Given William's reticence to offer any direct eye contact, that in itself was significant. And now, the drum sound, its pace and volume, matched his. Within another minute all that was left was a gentle brushing sound on the buffalo skin of the drum, reminiscent of waves rolling into the shore and William finally still, seated on the floor, at peace again.

Twelve-year-old Mark had suffered severe trauma early in his childhood. I was fully aware of the family circumstances that lay at the root of the resulting emotional damage. He had witnessed several

incidents of serious violence committed by his father upon his mother. Several months after his father had served a custodial sentence and then been released with a restriction order forbidding him to be within a five-mile radius of the family home, he had taken to stalking Mark and his mother. On several occasions he entered the home and destroyed furniture, at one time throwing a chest of drawers down the stairs.

Unsurprisingly, Mark lived in perpetual fear. He developed moderate learning difficulties, very likely associated with the trauma he was living with daily, and trying to process. At a certain level Mark was able to communicate relatively coherently. If I were to put a question to him relating to something practical, straightforward and non-threatening, he would respond, somewhat vaguely, but at least with an answer relevant to the question. But any questions relating to his past, incidents that troubled him or brought him anxiety, would be met with immediate and complete diversion.

There was nothing remotely subtle about this diversionary subject matter. Mark might well answer a question about his sleep patterns: "Do you find it easy to fall asleep? Do you wake up during the night? Do you remember your dreams?" with something like: "I went swimming yesterday", "I've been playing a new game on my PlayStation" or, just as often, by asking me a question: "Where do you live?" "Do you have a car?" "Is our session nearly finished?" and so on. Mark's level of evasion was almost pathological.

It was abundantly clear that Mark could not, would not, open a window to his emotional world through regular conversation. At a certain point, I asked him if he would like to write a song with me, perhaps a song about his life, the things that were important or memorable to him. He was immediately enthusiastic about the idea: "Would it be just my song?" "Could I say anything I wanted to?" "Could I play it to other people?"

The moment he received a completely positive response to each of these questions, everything changed. We began to explore the kind of words and sentences that might tell his story truthfully. With great enthusiasm, my pen and paper at hand and ready to transcribe Mark's stream of memories, thoughts and fears—including extraordinarily detailed descriptions of actual and imagined events—a song lyric was formed. There was no holding back, no filtering of memories or lived

experiences. Also, no need for structure, rhyme or rhythm. Just a stream of the unconscious becoming conscious in the context of songwriting.

"I was there, looked out of my window, saw my Dad, ran downstairs, he broke in, went upstairs, threw furniture down the stairs, I hid, then the police came, they took him away, but he might come back . . . "

As soon as Mark was satisfied that his lyric was truthful and complete, we decided on the sound and music accompaniment. He was clear from the start: "Piano here, guitar there, you sing here, I shout there, we end like this . . . "

It was clear as day. This was his story. His trauma. It came seemingly out of nowhere. What apparently could not be expressed in conversation, could be expressed through song. Somehow, this musical format was the only non-threatening way of him expressing the words that had been silently eating away at him. We had found a way to engage the trauma in order to start the healing. We had a breakthrough.

Once again, music as a path to healing was powerfully experienced by both child and therapist. A reminder that when the analytical, speech-and-language, more rational parts of the brain give way to the instinctive, creative, imaginative—even primal—responses within our minds, emotionally forbidden territory can suddenly be explored almost without limitation.

Simon, Lucy, William and Mark have very contrasting levels of disability or additional needs. Naturally, the way I employ the instruments in my room varies accordingly. But all of these examples share a general principle. Instead of focusing on the limitations of the person or situation, I focus on what *is* possible, what these unique individuals *can* do. Simon can breathe and indicate awareness that we are breathing in harmony; Lucy can enjoy the resonant qualities of my instruments, embracing the physical manifestation of sound and allowing herself to open up to other forms of self-expression; William is able to submit himself to a process of self-regulation, allowing another person to tune into his anxiety and distress and, all within a world of drum beats, move from heightened tension to restful calmness; Mark can address some of the root causes of his childhood trauma by turning the inherent threat posed by the spoken word into song.

In all of this, a delightful consequence for me personally was the freedom to explore and learn to play a huge variety of new instruments. Until my qualification as a music therapist, my music-making had been centred on piano and guitar. But, as any visitor to my room at Three Ways would discover as soon as they stepped inside, now the only limitations were dictated by size, cost and availability.

In January 2010 I came across a YouTube video in which the CEO of Apple, Steve Jobs, introduced the world to the iPad. Even considering my ignorance about and relative resistance to new technology, I quickly grasped the huge potential of this tablet in my world of music-making. What I could never have imagined at that point was the extent to which this single piece of modern technology would transform my life within just a few years. As a tool for composition, recording and performance, it had already captured my imagination and greatly renewed my motivation to write and record again. But what I had not anticipated was the extent to which the iPad would become the single most powerful tool for creative self-expression and communication ever invented for those with special needs and physical disabilities.

When Steve Jobs had first demonstrated the functionality of the device, I had felt genuine excitement. As soon as it was released it became clear that we were all moving permanently beyond the constraints of desktop computers. As a musician, I had always until now been linked to a stationary device in order to work on my music. Whilst I could experiment to my heart's content, it would always be within the limitations of a defined, physical space. Throughout my music career I had gratefully relied on producers and musicians with programming and sequencing skills, but now, with the arrival of the iPad, significant aspects of the sonic world were literally at my fingertips. It felt immensely liberating.

The constant self-doubt, endlessly repeated through that inner voice: Is this good enough? Will it meet expectations? How will it be received? Should I just discard it and start again? . . . All this was now replaced by a far more positive narrative: Which app will most enhance, inspire and inform the piece I am already working on or want to compose? And within my music therapy work, being able to offer so many of my clients a completely new, greatly enlarged world of sound and music-making,

involving genuine and meaningful collaboration, was a delightful experience.

Such was my enthusiasm that I went on to recreate a place at home that was like my music room at school. Having always longed for somewhere to retreat to, where I could meditate, listen to and make new sounds and music, I ordered a yurt (a traditional, round tent). This was installed in our back garden. Here I was to acquire fresh inspiration with a myriad of instruments. The pieces of the puzzle were all coming together. But, as yet, I could not see the picture they made.

27

For just a moment, Cindy's smile lit up the living room of her home in Korçë, Albania. A look of delight broke through the struggle of the past few minutes as she and I made music together in an attempt to connect and allow her to overcome the barriers in her path. Cindy has cerebral palsy, a permanent movement disorder that often means a lack of coordination, stiff or weak muscles and body tremors. This disorder has a cascading effect on many bodily functions like swallowing, speech, hearing and other sensations. During our personal session here in her home town, this child had her mother support her head and her physiotherapist hold a harmonica between her lips, whilst I played the guitar and wind chimes. We had been making music together: a mishmash of rhythms, dancing around one another without any discernible coordination. But suddenly, Cindy was able to control the movement of her head and her breathing enough to produce a clean sound on the harmonica. Music had once again proved its power. If only for a brief moment, she had broken through the isolation that cerebral palsy had put her in and gained a little bit of control over her body, breaking through . . .

Isolation as a concept is not lost on many Albanians. For decades under the rule of Enver Hoxha the country had shut itself off from the rest of the world. Hoxha had implemented a strict communist system in Albania when he took office in 1944. He would remain in power as head of state until 1985, becoming increasingly hostile to Western culture,

economic policy and religion. In fact, Albania declared itself the first "atheist state" on earth, leaving no doubt about its stance towards any beliefs outside a total loyalty to the state ideology. Hoxha's rule became typical of so many authoritarian people in power. His grip over Albania saw the country turn inwards in a culture of fear. On Hoxha's side, it was the fear of losing power, as several purges among his political adversaries proved. But it was also fear of the greater world. The ruler had become obsessed with his perception that Albania was under a direct threat from outside, from Western countries in particular. In 1973, he had declared that Western popular culture (including music) and its influence was to be rejected and banned from society. Western culture was not only seen as decadent; it was also seen as a ploy to turn the Albanians into slavish consumers, addicted to the idea of accumulating wealth and possessions. Hoxha's paranoia had grown over the years and become increasingly visible in daily life. The economic situation had seen the country descend into poverty. It had become the poorest nation on the European continent. Ironically, it was rich in fine edifices that, seen at face value, would lead one to believe this was a country of exquisite wealth. But there were other buildings that gave a different impression. These served a sinister purpose. Scattered throughout the country, countless bunkers and fortifications had been built. They were meant to repel an invasion that Hoxha regularly assured the people would be coming, since the outside world would be so envious of what he called "the country's glory" they would not allow it to stand. Although not in use now, these bunkers are a stark reminder of Albania's former isolation, the fear that had gripped the country for so long. When I arrived here for the first time and made my way to the town of Korçë, they were visible everywhere. They were no longer mere monuments referring to a past reality; they were tangible reminders that I would meet people with a much deeper understanding of fear and isolation than I had met before.

At the time of this first visit, Korçë was the sixth largest city in Albania, located in the south-east of the country. I travelled past the many landmarks that showed that this place had been at the frontier of different cultural influences: part Greek, part Ottoman. Korçë is derived from the Slavic word "*gorica*" meaning "hill". True to its meaning, the city faced onto lush green hills and was a far cry from the stark, level, concrete

jungles that larger cities developed under communism often were. The apartments, homes and other buildings of Korçë city centre seemed to peek out from underneath a layer of bright green foliage. Towering over it in plain sight were two buildings that were a clear sign that the country had turned a page. No longer was religion banned from public life. There was the Mirahori Mosque and the Resurrection Cathedral, the city's main church. The intricate Eastern architecture was impressive. Korçë looked like a beautiful place to visit, but I was not here as a tourist. I had been invited to come to Albania by a friend of mine from our Bath community, Paul Alkazraji. He had married an Albanian woman, appropriately named Albana, and had moved to the town of Korçë. One day, as he and I were chatting, he made an observation:

"Adrian, you write songs, you perform them, you are a music therapist . . . it is clear that you passionately believe in the power of music to be able to break through barriers. Barriers of culture, of language . . . Would you be willing to come over to Albania and share those skills with the many children, and adults, for whom words are not the primary means of communication? But also, with those amongst us who long to learn how to communicate without words?"

As we talked about this, it became clear that such a visit would include working with street children and orphans, children and older people with learning and physical disabilities . . . These were the lost children of Albania. To work with them and discover what I might be able to bring from my newfound perspective as a music therapist was a more than intriguing prospect. I eagerly agreed to come to Korçë.

That first trip took place during the summer of 2004. Soon after my arrival I was taken to a centre where street children came every day. Each child was welcomed, fed, washed, taught—simply loved and accepted as they were, just as unconditional love demands. After lunch the staff gathered the children, wrote each of their names on a sticky label, placed it on a shirt or jumper and brought the rather uncertain but excited group to the room we had prepared for the session. As soon as everyone was there, guitar in hand, I started to sing a simple welcome song, acknowledging each child by name.

It was not hard to sense that most of these children had a deeply rooted distrust of adults. From a very young age they had had to learn

to look out for themselves. Home was likely to be deeply dysfunctional. Even if one or both parents were there, the child was often forbidden from coming home until a certain amount of money, begged for on the street, had been raised. For these children, life was effectively just about survival. They had made, and learned to live in, their own world. None of these children had any experience of an alternative world, inviting them in with a welcome and an invitation to participate.

With that level of distrust, it was very clear that we needed music, song, instruments and our imaginations to build bridges between us. Just the act of moving from child to child, making eye contact, resting my *kalimba* on a hand, shoulder or very gently on the head and quietly singing their name, was for these children one of the most powerful and unexpected moments of affirmation they had ever experienced. The response was very disarming. Giggling or silently observing at first, the children started to pay attention, respond and gradually express genuine enjoyment and a willingness to participate in the various music-led activities. These children, through circumstances, accidents of birth, largely lost to themselves, were often for the very first time in their lives learning to enjoy their peers, sense genuine appreciation and, most importantly, feel loved . . . unconditionally. Yet again, the power of music could be seen to break down barriers.

The centre for Korçë's street children was a part of the Kenedi Foundation; an organization that had blossomed into many areas of society in Korçë and its surrounding villages. It was named after its founder, Phineas Kennedy, who had first come to Korçë from America at the start of the twentieth century. One of his first concerns was to establish a school for girls in a significant town where there was none. It was a direct need that quickly blossomed as Kennedy returned in the years that followed. Bit by bit, he established institutions of social care that embraced all those considered vulnerable and in danger of neglect. The Kenedi Foundation (the Albanian spelling of the Kennedy name) had begun to make a major impact on Korçë society.

History had, of course, made it difficult to keep developing this work. But when Albania came out of its long period of oppressive rule, the Kenedi Foundation was given new life. The vision of its founder was resurrected in a string of projects, all linked to the vision of the Korçë

Protestant Evangelical Church. In this community, the thinking, the understanding, was that church, beyond meeting weekly for worship, teaching and fellowship, should be synonymous with social care and involvement. Being church was equally about looking after the sick, the widow, the orphan and the street child.

Over the decades since its simple beginnings, under the equally visionary leadership of Ian and Caralee Loring, the Kenedi Foundation had grown into something very significant, moving and meaningful. The more I experienced the depth and reach of this foundation, the more convinced I became that this was essentially a model of what church should be, but clearly had sadly failed to be in many places around the world. Flashes of that little boy, all alone, banging his fists on the door of the barracks in the Traiskirchen refugee camp, came to mind. Here in Korçë, this church had taken up the challenge of providing refuge, home, even if just for a few hours each day, for these lost children.

Over the years that I have travelled to Korçë I have been greatly challenged and moved as I have learned about the many areas of daily, difficult life where the Kenedi Foundation has made a significant impact. In many respects the isolation of these children was in its nature and outcome similar to the isolation of the autistic children I was working with daily in my hometown. Here in Korçë I would have the joy and privilege of helping the staff at the different centres develop ways of implementing a multisensory approach to communicating, learning, self-expression—demonstrating the power of music therapy at work in the lives of these children on the fringes of society.

One place in particular stood out amongst all of these impressions. This was a building situated on a hill, as if to set it apart from the rest of the city. Intentional or not, it was symbolic. This was known as the "Asil", the asylum. It was a residential home for people of all ages who had nowhere else to go. Effectively, it was a government-run institution for people with learning and physical disabilities. Some were orphans, but most had been placed there by families who simply could not, or were not prepared to, accept the challenge of caring for their son or daughter with special and additional needs.

This Asil is called "Lulet E Vogla" ("Little Flowers"), but I started referring to it as the House on the Hill, a disheartening place. It was

clear that the staff working there had the barest minimum of resources to adequately care for the residents. The rooms were crowded, allowing for no privacy whatsoever. Whilst there were the occasional pictures on a bedroom wall, nothing was personal, nothing to emphasize the individual. You would rarely see any personal belongings—even if they existed, each resident had no more than a couple of drawers and a small section of a cupboard to keep them in. The Asil was filled with people who could not communicate their thoughts, desires and frustrations. Even those who were left there without having any significant learning difficulty or mental health problem, would ultimately come to exhibit similar traits to those who had.

In working with the residents I drew on all the techniques I was using back home, including a key ingredient: laughter. This was so important. Finding that delicate balance between light and serious, the comic and the poignant. One minute I would be interacting with six-year-old Cassandra using a combination of wind chimes and *kalimba*, privileged to witness her gradually emerging from her protective shell. And then I would be playing the guitar for Koli as he soloed wildly and joyfully on the melodica, a mini keyboard with a mouthpiece, one hand holding the instrument, the fingers on the other hand playing the notes. Koli had never seen a melodica before, but immediately and instinctively understood how to make a delightful sound on it!

For a full week, I experienced many mixed emotions as I visited the extraordinary range of projects started by the Kenedi Foundation. By the end of my time in Korçë two things were crystal clear:

First, that once again music was the bridge between us all, the pathway to hearts and minds. This was the shared language that went beyond words and provided the means for these folks to express themselves in ways they had not been able to before. Here was an opportunity to genuinely socialize—to experience the pleasure to be found when coming out of isolation and joining with others to make something beautiful and meaningful for everyone to share.

And secondly, that I needed to make a long-term commitment to this community if all this work towards building relationships was to have any lasting impact. From this year on, Korçë would become my home for one week or two during the summer. This would be very different from the

fleeting visits to towns and cities in different countries when performing a concert tour. Different from the experience of visiting a place, a specific project, at the invitation of an organization, as with my visit to India and Nepal as a guest of the Leprosy Mission. There, while I had forged beautiful relationships with Padmahari and other patients in Anandaban, I was unlikely to return and develop those relationships further.

The people of Korçë had shown me that using the well-established principles behind music therapy practice, coupled with a real ongoing commitment to returning each year, the possibilities for positive change and personal development were limitless. In the end, the need for validation, for love and unconditional acceptance, is universal. And music simply ignores the boundaries and obstacles around country, culture and language.

During the years that followed I have been able to keep my promise to my growing number of friends in Korçë, returning faithfully year by year. Here the church has found its true calling, and the power of music is changing lives. Increasingly, it has become clear that my input and the training of local staff is much valued, allowing some of the creative, new ways of interacting with people with special needs to continue, develop and thrive long after I have returned home. After all, music is able to break the chains of fear and isolation, just as it had for me.

28

Looking out into the trees of the Kakamega Forest, I signalled to my travel companions to be quiet. I reached into my pocket and pulled out my minidisc recorder, switched it on and listened intently as the beautiful, intricate sound of a bird filled the air. This was no ordinary birdsong. The Kakamega Forest in Kenya is home to over four hundred species of birds, so we knew we would probably see and hear some unfamiliar sounds. But this particular one caught my ear and stopped me in my tracks. The bird was singing what sounded like a developed melody, repeating it again and again. The sequence was beautiful. Straightaway, I decided to connect with this small creature and record its singing for possible future use.

It was an unlikely partnership: a rare species of bird in one of the most biologically diverse areas of Africa, performing for—and unwittingly recorded by—a British musician who had embraced a fundamental skill: listening.

While I was still a performing artist so much had been about getting a message across: transmitting outward. But I could not have become a therapist without being able to actively listen; to be silent and not feel immediately ready with an answer; to be in the moment, giving all the time needed to understand what is being communicated. I had taken the inspiration gained from Dame Evelyn Glennie to heart; that remarkable woman who had been declared deaf at the age of twelve and later stated to her audience that "you hearing people do not know what you are missing". It was a profound statement that had me reach for deeper levels of communication in my work as a music therapist. But it had also challenged me to embrace more fully all the other sensory experiences we are constantly bombarded by. That can be overwhelming at times, as it had been during my visit to India and Nepal. I stood there, listening to this exquisite birdsong, reflecting on the wonderfully intricate beauty of God's creation and the connection we all share in it.

This trip to Kenya in 2001 was something of a pilgrimage for my mother. She and Dad had lived and worked in Kenya for a number of years, travelling extensively around the country, and had found their lives transformed by the people they met. Inspired by their stories, my sister Julia had followed in their footsteps and spent two of her most formative years here after her schooling. She had come here with her best friend, Beth, and they returned with the same stories of a life-changing experience. The events leading to our return were bittersweet. Dad had died years before, and Mum had ultimately remarried. She had often expressed a desire to return one day, a desire that became even stronger when my sister Julia passed away after a long and difficult battle with cancer.

We travelled to Kenya to reconnect with key people from my sister's and father's time there, and this special "holiday with a purpose" quickly became memorable and emotional as my mother came face to face with people she had known decades earlier and never expected to still be there. The journey made such a big impression on me and Sue, and my

minidisc recorder became indispensable as a means of capturing these new and exotic sounds. This little machine, easily fitting in a pocket or the palm of my hand, must have made me look to my travel companions rather like a sound designer in the film industry, always listening out for sounds we might take for granted, but which could well become an integral part of the soundtrack one day. As well as nature's soundscapes—birdsong, thunder and rain, the thundering of a herd of wildebeest—I also recorded the children's choir in a home for orphans. These were the kind of inspiring moments captured on disk without a predetermined destination but with the certainty that they would find a place in a future musical project.

Much of the move away from my recording and performing career had been rooted in frustration. In contrast, my discovery of music therapy has not in any way diminished my instincts for creative exploration as an artist. It has slowly but surely reinvigorated it and is immensely affirming and rewarding. Indeed, back home I am increasingly finding myself wanting to stay on in my music therapy room after the end of the school day.

The room has become my personal sanctuary for reflection, seeking new inspiration and allowing time for my own self-expression. Ever more frequently I find myself recalling melodies that might have emerged during a session: rhythms, textures and soundscapes ripe for exploration. These times have become much more than personal downtime after work. They have become fresh inspiration for new songs. New music. The composer in me has never truly left. Perhaps he has simply gone into hibernation, only to find that the sleep was very light and short-lived. My creativity now feels renewed with the added confidence I have gained in this place. Importantly, all this is spilling over into life at home, leading to a very special collaboration . . .

My daughter, Carla, has become a wonderful singer and songwriter. I am immensely proud of her development, her beautiful voice and the quality of her original, slightly jazz-influenced pop songs. At some point, she had heard me play the piano accompaniment to songs I was currently working on and made an exciting suggestion: a musical collaboration between us, where she would provide lyrics and melodies to these rudimentary pieces of mine. I agreed, in no small part because

of my belief in her skills and creativity. Maybe I would have had to field such a request rather carefully some years before, but several key things had changed. I was more confident in my work and my own ways of expressing myself. I no longer felt the same strong need for validation from outsiders, the root of so much of my earlier anxiety.

The decision to move away from the active recording and performing life had largely freed me from these shackles: the pressure you can feel once you start making music for an audience. The pressure to conform to expectations, to find your perfect niche, that place where your audience feels safe when they come across your name or prepare to listen to something new. I had allowed myself to carry that particular burden too heavily and very much wanted my daughter to be as free from that struggle as possible as she was developing her own voice. When Carla suggested we work on music together, the timing felt just right. And I knew she would bring a new energy and direction to some of my songs that would be exciting to me and my audience.

The first results of our collaboration brought a very special quality that I felt was missing in much of my previous work: joy. The kind of joy that speaks to the child in all of us. The ability to enjoy life, friendship, all that is given to us. "Thank You" and "You Make Me Feel Worthwhile" emerged as the first pieces to be written with my daughter. Expressions of a joy and love that we would go on to record with a tangible sense of gratitude.

By this time, it was obvious that a new album was on the way. I was under no illusions that to produce new music with the intention of reconnecting with my audience, and searching for new listeners, would inevitably involve returning to the concert stage. Until now that door had been firmly closed, but the new inspiration, now gathering on this album, was undeniable. To his credit, my manager, Alex Verlek, had persistently encouraged me to continue writing and never to completely rule out the possibility of another recording. He was always convinced that I had new music in me that deserved to be heard. Several of my friends expressed similar thoughts.

So, when I finally convinced myself and we set out to make a new album, things moved quickly. I decided to work with Jon Birch again and asked him to produce what would eventually be entitled: *Every Place is under the Stars.* Our previous collaborations had made me feel completely

at ease. I knew he was always wanting to push the boundaries as far as sounds, textures and use of available technology were concerned, and I trusted his ability to find my voice in all of these eclectic ingredients that were now becoming songs. I used one instrument in particular that became a key element of the opening track, "You Are There": the *kalimba*. This small, simple, hand-held instrument had its origins in Africa and was like a little portable piano, having thin metal keys akin to a xylophone on a small wooden board, but played with thumbs rather than beaters. When I had first discovered it during my visit to Kenya, I quickly fell in love with its sound and practicality. It had already become an instrument I used daily in my music therapy sessions. I would typically play it around a child, as close to the head as was comfortable, creating a moving, immersive sound and resonance. On one of the occasions when I was by myself in my therapy room I started exploring all sorts of new tunings for the keys and finally found one where every note, and combination of notes, felt exactly right. I started playing, and a familiar melody came to mind. I started to sing a kind of chant:

> The Lord is my light and my salvation every day
> He is the stronghold of my life in every way
> If an army were around me, even then I would not fear
> For You Lord are with me, wherever I go, You are there.[26]

These words from Psalm 27 had travelled with me over many years, first expressed in song on the album *Feed the Hungry Heart*. They had comforted my own children as words I used to sing them just before sleep, and I had proclaimed them to people under the threat of actual armies during our 1991 tour of the Baltic States. Now, they would open *Every Place is under the Stars* to remind me and the listener of that sure and certain love that watches over us. It made a positive connection between Adrian, recording artist in 1984, and now Adrian, music therapist in 2006.

I invited my good friend, Luca Genta, from Italy to play an integral part in the album arrangements. This was because of the wonderful scope of his musical abilities. As well as being a gifted cellist, he was also a superb player of the bass guitar and whistle. Luca brought such a warmth

to the instrumental piece "Hymn to the Sea". As the basis for this, I used a recording I had made of the sea rolling in to the shore at Lee Bay, next to Lee Abbey in North Devon. I love the sea as a metaphor. This ever-flowing body of water that is always in motion, both dividing and connecting continents and us, their inhabitants. This was yet another of the many deeply meaningful and influential experiences gained at Lee Abbey. Standing on that shore, looking out over the sea and being overwhelmed by the feeling of smallness and vulnerability in the face of such vastness, I also knew that I was intimately known and loved by the creator, who had formed the ever-changing, yet changeless patterns of the tides.

Another song on the new album, "Flowers on the Carriageway", had a rather different source of inspiration. As part of my work-related travel, every fortnight I drove along a stretch of dual carriageway within half an hour of my home. The first time I drove along it I saw fresh flowers placed on the central reservation, but did not think much more about it. Over the course of the next few months I noticed a pattern. Every time I took this route the flowers would be renewed and fresh. Clearly, someone was tending this tiny floral display with great care and attention to detail. They looked beautiful but somewhat out of place where they had been left. Eventually, my curiosity got the better of me and so I decided to stop the car. I parked by the side of the road and got out, making my way to the central area, which was easier said than done. I had to wait some considerable time before it was safe to cross and make my way to the flowers. Up close, I could see they had been placed on what looked like a little shrine. Attached to a post was a brass plaque upon which was an inscription. As I read it, my eyes filled with tears . . . This was the exact spot where a boy had been struck by a car and died. The plaque and flowers had been put here by his father. The inscription was beautiful—a now permanent expression of grief and loss and of this father's love and longing for his child. I considered that this father had been crossing the carriageway time after time, week after week, to replace the flowers and polish the brass. He too had to wait for a gap in the speeding traffic to get there safely. It was an image that stayed with me and one that I thought about every time I passed by this spot, from then on. Ultimately, it became a poem, and then a song.

"You Are Loved" was another expression of unconditional love . . . this time the love of our Father, Mother, God, for the children, women and men I had come to know so well in the Asil in Korçë.

> You are loved
> Nothing, no-one, can take this away from you
> You are lost to yourself
> I am looking, searching for you
> I will never rest till I find you
> You are mine, I am yours
> I am standing, holding on to you
> I will carry, carry you to safety.[27]

And then there was my recording of the bird in Kakamega Forest. This was one of those beautiful moments for a composer when, effectively, a song writes itself. I just let the recording play continually, without interruption, until I felt that this was the moment to sit at the piano and simply turn a solo into a duet . . . I think "Kakamega", as it became titled, was to become the single piece of music that most represented this new place in which I found myself: the music therapist rediscovering his skills as a composer but now from a place of far deeper listening, not just to the sounds that fill our lives at every moment, but to the heart. And there, if we truly have "ears to hear", we cannot help but engage with people at a deeper level, where words are not needed, but where somehow sound and music become the primary methods of meaningful communication.

"Lost Without You" was written for Sue. She was far away, actually in Tanzania, for several weeks. I was missing her enormously. And one evening as I stood outside our home and looked at the moon and the stars in a wonderful clear night sky, it suddenly occurred to me that, at this very moment, she and I were staring at the same moon, the same stars, just from different places. Suddenly I felt both connected, and intensely alone . . . two small people looking up at the night sky, seeing the same things, yet thousands of miles apart . . . unable to hold onto each other or slip into the comfort of an embrace . . .

On holiday with Sue in Tuscany, Italy, we had come across a beautiful, isolated chapel at the end of a narrow path and overlooking the typical

Tuscan village countryside: hills, fields, vineyards and the outlines of ancient towns and dwellings, often largely unchanged since they were first built centuries ago. We stepped inside the chapel and, having noted the cleanliness, the tidiness, the sense of fresh attention and care, we found ourselves looking at a kind of prayer mural painted fully around the church interior. Sue still had a basic understanding of Italian from her university days, so was able to give me a rough translation there and then:

> O Lord
> Protect, console, comfort
> Bind the wounds
> Of the souls and bodies
> Of your devoted children near and far.[28]

Right there, working with the unique acoustics of the chapel, I found a melody to support the words and sang—into my minidisc. "O Signore" was to become the first and only song of mine to be sung and recorded in Italian.

When the time came to finish the artwork for *Every Place is under the Stars*, I knew I wanted to ask Jon Birch. He was among the most gifted musicians I had met and an equally talented illustrator, as already proven with the illustrations for *Beautiful or What?!* Also, he had a random sense of humour that might surprise me . . . He did not disappoint; what he created was very powerful. Jon had drawn a tree growing out of what looked like the Earth, with the branches housing all sorts of images that somehow connected to the lyrics of the album: a bird, a set of flowers and a tear-filled eye, seashells and ocean fauna, coffee mugs. It truly was "every place under the stars". I had read the expression in a work from John Burroughs, the American naturalist and poet. Here, it was a wonderful visual representation of the character this new music had. Jon was particularly skilful when employing a cartoon technique to his drawings. I had asked him to design the album cover and to look after all the other visual elements to the packaging. To my delight, hidden in the artwork was a final expression of Jon's wonderful, random sense of humour. He had drawn a set of stairs and placed under it a small shoal of fish, led by a clearly more dominant plaice. Thus, a little reference to

"every plaice is under the stairs" became one of those understated, but important, moments of light-heartedness that was not often to be found in my previous work.

I still reckon that *Every Place is under the Stars* is probably the most joyful album I have recorded. In so many respects I find it life-affirming. It was the result of the first musical steps that connected my past to music therapy in wonderfully creative ways. It would not be the last.

"A FATHER
IS SOMEONE
WHO LIFTS YOU UP
AND HOLDS YOU THERE,
forever."

Top left: *"Hold you there forever" card.*
Top right: *Publicity shoot,* Kiss The Tears *era.*

Diana's CD collection reveals her love of Christian pop star

Above: The Sunday Times *article on Princess Diana's music collection (21 June 1998).*
Right: *Touring* Beautiful Or What?

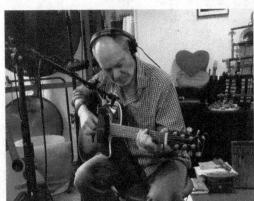

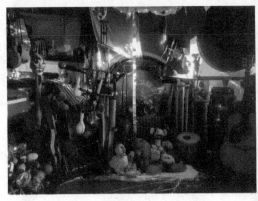

Above: Communicating
with the kalimba.
Below: The tenori-on in
use at Three Ways.

Top: Recording in the Music
Therapy room at Three Ways.
Above: The Music Therapy room at Three Ways.
Below: Using the kalimba in a
music therapy session.

Above: *Performing Alpha + Omega for the 30th anniversary in the Netherlands.*
Right: *Fierce Love original artwork by Adrian.*

Left: *Performing with Carla,* Every Place Is Under The Stars *era.*
Below: *The musicians and singers for the re-recording of* Alpha + Omega *in the Netherlands, 2016.*

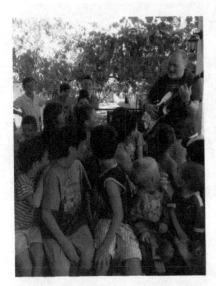

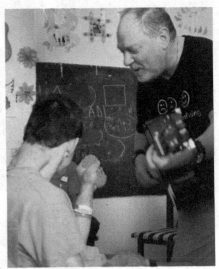

Top left: *Adrian makes music with village children in Albania.*
Top right: *Connecting . . . in Albania.*
Left: *With Carla in Korçë, Albania.*
Below: *Publicity shoot, 2017.*

PART 5

Forgiveness

If I were to single out one thing about the Christian faith that I could not live without and that influences the way I live my life every day, it would be forgiveness.

Understandably, from a faith point of view, the first association with the word is the redemptive nature of Jesus' death and resurrection; the building of this wonderful bridge between a fallen humanity and an infallible God. But when I use the word forgiveness it carries with it more than that. To me it conveys the idea, or rather, the fact, that nothing in my life is wasted. The idea that God somehow uses all the things that make us who we are—all our mistakes, however grave; all our failures, however serious. He uses them to transform us into the sort of people he wants us to become. That is more than a kindness; it is acceptance in its purest form. As I understand it, the reality, the offer of forgiveness is the ultimate basis for all hope.

Life can become so dark to the point where it seems devoid of meaning. This was one of the things I struggled with so profoundly as I faced the Holocaust head on, seeking to step into the lives of those, especially children, who were the witnesses. And then, out of that bewildering journey, making my musical response through *Alpha + Omega*, *Song of an Exile* and *City of Peace*. Where was the meaning in all of this? If there were no forgiveness, what would be God's response to the evil in this world and, closer to home, in our hearts?

As I began to understand and accept more fully, it all began with his desire to make a total connection with humanity. He chose to create humankind for meaningful, developing relationships rather than the far less risky option of creating puppets or complicated pets. Simply put, we are "living works of art" made in God's own image. When God named

Adam and Eve, he gave them more than just a designation; he gave them identities. From the moment God became Father, Mother, to us, he made sure we would never be lost to the point of having no identity or home. When Adam and Eve chose to cross the boundaries that God had set, just for their own good, the first consequence was their immediate awareness, embarrassment, anxiety over their nakedness. Suddenly they were experiencing shame and guilt for the first time . . . and so they felt the need to hide. And God's response was as telling as their behaviour. He called out to them, using the names he had given them. God, their creator, just wanted them to step out of the shadows; wanted to find them, and then to re-connect.

I am sure that this longing for connection is in all of us. Ultimately, I think to be human carries the absolute need to connect, interact and communicate with others. This is how we experience acknowledgement, where we feel accepted and understood. And more important than anything—where we know with absolute certainty that we are loved, completely, unconditionally. And where we feel that love in the depths of our being.

As a child I had heard and been taught so much about God's love. I always tried to understand or experience it with the same kind of warmth, comfort and safety as the love my parents had for me.

As an artist I would sing about God's love so many times in such contrasting places and situations. But I was almost always singing outward, to others. It was to be through the eyes and hearts of other children—like Eva Picková, or our leading girl in *Beautiful or What?!*, or the children at Three Ways and those on the streets and in the institutions in Albania—that I would finally learn to accept and to direct that message inward, as well.

29

The counsellor, sitting across from me, had just made a remark that stopped me in my tracks, and now I was trying to make sense of it. I would like to think that, normally, I was capable of thinking on my feet

but, on this occasion, I was really rather taken by surprise. It was like a door being opened to reveal a signposted path along which I could start to explore an entirely new way of looking at myself as I continued on my journey of self-discovery.

Over the years, I had decided to seek out a select few people to offer me some form of counselling. These became sessions and conversations I engaged in somewhat unenthusiastically in order to try and understand why I was the person I had been as a child . . . and the person I had grown into. It was obvious that I needed to get to the heart of my behaviour, anxieties and lifestyle choices. Understanding all of this might make it better; this was my rationale at least. I had now booked a handful of sessions with a woman who had been recommended to me. They were quite expensive so, instead of the usual deliberations before counselling sessions, I was actually struggling with the question of how many of them I would need to book. When I sat down with her for our first long consultation, I started to relax a little. She is an easy person to be around; with quite a sense of humour, in fact. And apart from her helpful personality, she relayed to me something of her own background, which I had read up on a little, prior to our meeting.

As I sat in her room, I was still in some ways the anxious little child and the timid teenager full of angst, shaped by his own journey of faith, yet still so afraid of how it would be perceived and maybe even misconstrued. Her background and story made me see her as someone who would know that about me, understand it and yet try to break through it in order to get to the core of the issues I struggled with.

Our first meeting came and went, and she listened to my methodical presentation of the issues I struggled with, both growing up and still now as an adult. I tried to give her all the background and describe in detail all the thought processes I deemed important so as not to be misunderstood. I spoke of my childhood, of those fearful times as a budding artist and also about how my possibly unrealistic expectation of ever experiencing secure and lasting affirmation was so stressful. Halfway through our second meeting, she stopped me and spoke up.

"Adrian, I'm going to say something which I'll need to explain. It might surprise you, but let me just put it out there."

I looked at her, puzzled. She continued:

"You are a very autistic thinker."

I was really quite taken aback, and therefore a spontaneous response was out of the question. Of all the things she could have said just then I had least expected this. After all, I was the one working *with* autistic people. I struggled to find the right follow-up question and all I could timidly muster was:

"Well, how much?"

"Well, if you asked me to put a percentage on it, I would say 80 percent," she said.

I was baffled and certainly needed further explanation, so she began to talk me through my life almost like a retelling of our previous conversations. One main issue with how I saw the world was obvious to her: my need for things to be absolutely black or white. I was capable of multi-coloured thinking, but how my brain told me to respond and how I implemented those responses were two different things. To illustrate this, she said:

"I'm going to give you a box of coloured paper clips."

As she talked, she handed me a little plastic box that was indeed filled with paper clips of varying colours.

"I want you to put this in your pocket," she continued, "and over the next week, before you come here again, every time you experience one of your moments of anxiety and stress, I want you to put your hand in your pocket, shake this tin and say to yourself: 'There are so many colours and shades to this issue. There is not a single right or wrong way to respond.'"

There will be those that would see this observation as completely obvious! And in a way it is obvious to me too. But when you tend to think and experience life from a somewhat autistic perspective and have been brought up in a home environment underpinned by Christian faith and values, it becomes all too easy to live life in absolutes. In that environment, personal failures or mistakes, falling short of your own expectations of yourself, quickly lead to guilt and shame. And sustained guilt and shame *always* lead to despair. To live in this cycle is profoundly unhealthy and destructive. And this is why I have come to believe that forgiveness is everything.

Over the next two or three meetings she proceeded to describe to me what she would expect from someone who shared similar traits to me.

What she shared was so accurate that we decided to invite Sue to join us for a session and ask any questions she might have. After all, Sue was the person who had lived with this reality for over thirty years. She had the unenviable challenge of coping with my behaviour and the strain it put on our mutual understanding. Her ability to understand where I was coming from had often been key. Now my therapist had presented me with another way of looking at how I approached life, and I was intrigued enough to follow it through. Sue did indeed join us and, in the process, we came to a shared realization: maybe what often appeared to be self-centred or self-obsessed behaviour was rooted in my need to control the environment around me; a need to enforce some kind of manageable structure in order to avoid the stress and anxiety that someone with this kind of disposition struggles with.

Something definitely flipped a switch in my mind as we began to explore further the implications of all of this. I took myself back to my earliest childhood memories. That little boy coming home from school, slamming the door and sighing; that little boy really not understanding how people could be the way they were out there; my not understanding how you could be a Christian and not go out into the streets and heal people. Now I began to realize where that all came from. It was not about right or wrong; it was about who I was as a person. I had struggled so much, feeling frustrated as I wondered why everybody did not necessarily think the same way I did. How could they not see what I saw? How could an audience not respond the way they should? How could someone in the band joke around when we were dealing with such profound, such intense themes? How could this album not be the success it should be? It dawned on me now that the problem had actually been the reverse. Many people see the world in a multi-coloured way, but I was the one who had the problem with it because of the way my mind was shaped. Looking at myself with new eyes now, I recognized the traits: my mind could so easily lead me down a path of obsessive and compulsive behaviour; I had a hard time letting something go; if I embarked on something, I became totally immersed in it.

I began to think about my visit to Bergen-Belsen. I had always been utterly convinced that the history of that place had forced its way into my heart so powerfully that it had made me change direction and go down a

long and winding path with my music. I imagined myself as a passenger who had allowed himself to be taken on a journey. But now, with a greater understanding of myself, I saw another aspect to this period of my life. If anybody had asked me, during my years working on albums like *Alpha + Omega*, *Song of an Exile*, *City of Peace* or *The Cry*, if my focus on the Holocaust and especially the children had become something of an obsession, I would have responded like a wounded animal, with the indignant edge of someone defending his convictions. For me, it had been all about identity: "This is who I am. This is what I do. How could you even imagine I could put that to one side for a bit and move on to something else? How could you say that?"

Having an obsessive side as an artist can actually be an advantage because it means you can attach yourself to something and work on it until you get it right. But now I was starting to see that a lot of the decisions I made as an artist and many of the roads I decided to follow were utterly all-embracing because of this compulsive nature. It was all or nothing, all the time. When there was feedback from Christians on my work, I often found myself locked in a struggle to cope with it. Like a criticism I once received that claimed I was "in danger of letting music become my god". I had found the process of musical discovery to be freeing, so for someone else to claim that it was actually confining me was confusing. Then there was the time I received a letter after *Fireflake* was released, and someone questioned my theology in the lyric of "Gethsemane". I would anxiously ask myself: "Am I wrong? And if so, what do I do?"

But music, above all, had helped me get through all the angst-filled years. It had, in a very real sense, saved me. This was now clearer to me than ever before. Now I had been made aware of my tendency to think autistically, I could recognize in myself some aspects of the children I work with at school. How they try to find release, for instance. The coping mechanisms they use to keep their footing in the world are not unlike the sheer bliss I experience when on my own, improvising, playing my music for hours on end. Music was my joyful obsession and my release. The excitement of finding chords and melodies that work together, revisiting them again and again. The feeling was glorious. And I felt safe in those moments. I would completely embrace my music, not unlike an autistic child finding ways to deal with a threatening world. Of course, I did not

have the same levels of anxiety as the children I work with, but working with them and knowing what I know now, I have come to understand why I feel more than just a professional sense of fulfilment. With these struggling young people, whose struggle is rooted in their person, I feel at home.

Those therapy sessions felt like a real landmark in my life. Not one of factual change, but one of perspective. As we talked, there were three revelations in particular that changed my thinking the most:

The first was the realization that I was not going to change. For most of us, being confronted with an issue or problem is the trigger to seeking an answer, a solution somewhere. As if searching for a spiritual or emotional hospital: check in, receive the treatment and return home sorted! What my therapist helped me see was that this was never going to be the case for me. This was who I was, and everything I was dealing with was about managing that reality.

The second thing I came to understand was that my black-and-white thinking had informed my faith as well. Was I searching at times for answers to the huge questions surrounding *Alpha + Omega* where there were none? "How, why, did God allow all this to happen?" "If he is all-seeing and all-knowing why did he not intervene to spare his children from such unspeakable suffering?" "How will God judge humankind for all the evil that they do?" A Jewish proverb comes to mind: there are no strange questions, only strange answers. My immersion in the Jewish roots of my faith had given me a hopeful perspective, an understanding of the journey God took with his children. But so often I had felt like a lost child in both my daily life and in my relationship with God. It was an ever-present, lingering sense.

The third realization to come from my sessions involved colours. I learned to accept that the world out there is full of greys. And not just for me, as someone who wanted either black or white or tried to stick to one particular colour, but also for the people looking at me from the outside, making judgements. As an artist, carrying a lot of anxiety, I had so often allowed that to overwhelm me and inform my response. But there was something oddly liberating in allowing myself to reach into my pocket, feel the tin of coloured paperclips and say to myself: "We are complex creatures." Letting go of a black-or-white perspective when viewing the

world gave me a renewed appreciation of other people's struggles. It freed me enough to remind myself of a simple truth: it is just not that simple.

My therapy sessions had revealed one truth that was to pull back the curtain to reveal another truth: God's forgiveness goes before everything and outlasts all things. As a little child I would come through the back door, lean against it and breathe a sigh of relief because I had made it safely home. As a grown man I could now lean into the arms of God and breathe a sigh of peace. I was already home, safe and sound.

30

I looked around the room at my children as the preliminary result of our efforts was playing from the mixing desk. Jamie was seated at the controls; Carla was on the bench across from me. We had not yet completed what would become my new album, but I already knew I was experiencing deeply meaningful moments in time. Not only was I once again recording music; this new album was shaping up to be the work at the centre of that intricate web of threads that together defined much of my life. The journeys I had been on had all led me to this point where I was once again letting music lead the way. In so many ways these new songs were a testimony to my life coming full circle. My emotional, historical and spiritual journey were all felt here. Even more than my previous album, this one was born from my work as a music therapist. The children at school, as well as those in Korçë, had inspired me to recognize the story threads that were coalescing here, and I was working them into new songs. And without a doubt, one of the most meaningful experiences to me was the fact that I was creating this album with the capable help of my own children. This was to be the first album to bring together Adrian Snell the artist, the father and family man, the lost child grappling with world events and, ultimately, the music therapist. This was 'Fierce Love'.

It had been almost seven years since the recording of *Every Place is under the Stars*. With the passage of time and my now complete immersion in the world of music therapy, I had considered that project a one-off: a moment of significance definitely but, nonetheless, not a return

to an active life as a recording artist. But the inspiration for new music had been constant. I was surrounded by exotic instruments, moving and immensely challenging life stories and fascinating insights into the human psyche and the way we measure its worth. So how could I not be encouraged to explore sounds, write lyrics and even dabble in the first stages of a song arrangement?

The collection of instruments in my room at school had increased steadily to the point of resembling a treasure trove of music-making and sonic delights. As already described, these included organic instruments from around the world and, at the other end of the spectrum, the iPad and the extraordinary, electronic, Japanese *tenori-on*. The latter had found its way to my room after a friend and colleague drew my attention to video footage of comedian and musician Bill Bailey using it live during a concert at London's Royal Albert Hall. The *tenori-on* was a square shaped touchpad that, when activated, could play a sequence of sounds akin to the soundtrack of a futuristic movie. Depending on where and how you interacted with the surface, the sounds, pitch and even lights and effects would change accordingly. The results were mesmerizing, and it had already proved to be a tool that encouraged children to step out and explore its many musical and social possibilities. Like so many of the sound-generating artefacts in my room, it was so much more than the glorified handheld computer game that it might have appeared to be at a cursory glance.

I had gained a renewed appreciation for the power of music through these new tools and instruments which, not so many years ago, I would have hardly considered in my own processes of composition and performance. One particular instrument I am certain I would never have discovered was the *sound wave bed*. At first glance, it resembles a rather over-designed snow sled with slatted wooden panels cut into one side, steel strings covering the other side and a slightly curved wooden surface shaped for a body to lie on with the head slightly raised. A pupil can lie down on this surface, quickly discovering that this is not at all a bed in the traditional sense, but rather a powerful musical instrument designed and built completely for therapeutic purposes. The wooden panels are in fact four tongue drums, each tuned to a different note. And the steel strings are tuned to different octaves of the same note, creating

a long-sustained drone when played with fingers and hands or with a beater. In effect, the whole object is a highly resonant musical instrument. On gently beating the wooden panels or playing the strings, the *sound wave bed* is cleverly designed to pass the maximum vibrations through the body of the person lying on it. The effect is remarkable, powerful, physical and deeply calming at the same time. This has been another example of my journey across new frontiers as a musician. Electronic and acoustic technology were now well and truly in the mix, with all the subsequent exciting possibilities this would afford.

Equally encouraging to me personally was finding that writing lyrics and poetry was flowing as never before. For some reason, this process, which in the past could be so laborious—stressful even—and often left me dissatisfied, was now becoming very natural. I even came to view these new lyrics as amongst my strongest ever. This was a far cry from the Adrian of the 1970s and 80s, so lacking in confidence once away from my comfort zone of musical expression. All in all, I should not have been surprised by the question I was asked at a board meeting of The Coverdale Trust, which is engaged in supporting aspects of my work. But I was.

"You clearly have new inspiration, Adrian. Why don't you record a new album?"

Typically, I would have politely answered by saying that, no, my time as a recording and performing musician had passed. I would have reminded the trustees that I was now firmly and fully committed to my life as a music therapist; that I found enough satisfaction within my work with the special needs community; that I was still enjoying the freedom from all the expectations and pressures that surround an active performing and recording artist. Except this time, I found myself momentarily silent, pensive and challenged in a way that left me unable to answer with certainty.

The question sparked a very familiar flame inside me. It flickered ever stronger until a kind of clarity came. I often found music therapy sessions to be creatively and musically inspiring. Given that spontaneous improvisation lies at the very heart of a music therapy session, original music would arise and develop every day. On occasions, in my own time, I would find myself naturally developing chord progressions, melodies and rhythms into something new and more structured. Was I now in a

place where I could integrate both worlds much more effectively and authentically? Was this now the time for Adrian "composer and recording artist" to resurface but with the canvas greatly expanded; expanded to include all the new sounds, instruments and changes in my whole approach to music-making that had arisen from my recent training and practice?

This thinking began to excite me greatly. Within days of the Coverdale Trust meeting, the new album *Fierce Love* was definitively in the works. It was as if floodgates had been opened. Now that I was confident this was the right time to write and record again, I quickly gained clarity about the shape and content of this new album. For the first time in many years I felt a kind of freedom that comes when the pressure to write and record to sustain a career is not there. At last the burden of expectations from friends, colleagues and audiences was lifted and no longer dictated the next steps. This truly began to feel like a fresh start. Music therapy had brought me the gift of genuine artistic freedom and I intended to use it.

This sense of a fresh start was amplified by another decision I quickly made. In addition to inviting Carla as guest vocalist on the album, I had concluded that Jamie was well able to take on the role of producer. I had been so impressed when listening to some of his recent productions, realizing just how much his musical skills had developed and matured. It was with genuine excitement that I approached him as my producer of choice, beyond the close father and son relationship we enjoyed. It is hard to put into words the joy I felt in knowing that *Fierce Love* would now represent not just my world of music-making as artist, composer and music therapist but also something of the love and creativity shared with two of the most important people in my life. With Ryan too, ultimately to be included in the album's premiere and later performances as percussionist, it now became obvious that the ideal location for the recording was my music therapy room at Three Ways. The school generously agreed to let us record there during the next school holiday between the hours of 8am and 6pm, Monday to Friday. Jamie was fully equipped to install a mobile recording unit, all the instruments we would need were already in place and, with no staff or children in the building, the room was well soundproofed. We would record the piano and vocals at home where I had my beautiful and beloved Blüthner grand piano.

The narrative behind the album was also clear to me by now. In part, this would be a vehicle for some of the Three Ways children's stories to be told. But alongside that, I would include songs written about, and for, people close to me, people whose lives and stories had helped to shape my own. There would be instrumental tracks and material that sought to personalize places of current conflict and suffering. And central to the album, the title track "Fierce Love" would be an overarching expression of God's fierce love for all whose vulnerabilities made them dependent on others, often living in varying degrees of isolation. The kind of love that, as expressed in the songs themselves, "celebrates difference in the dullness of the same", "dignifies us" and "sees in *all* a work of art" whatever our background, need or disability; the kind of love that will always be there, without hesitation or condition, for a loved one; the kind of love that achingly longs for a better world, holding out hope to our fellow human beings that things will surely be better eventually.

The opening song of the album, "Hold you there forever" (written for Carla) was inspired by the picture and message in the Father's Day card she had given me earlier in the year, just weeks before she was to leave the family home and make a new start in London. The photograph on the front of the card was of a father holding out one arm and supporting his tiny daughter, depicted as standing in the palm of his outstretched hand. Both were smiling broadly, trusting completely. The text below the photograph read: "A Father will lift you up . . . and hold you there . . . forever".

Both "The Firefly and the Dazzling Moon" and "Sometimes the Broken Hearted" had their roots in moments when I had wanted to comfort a friend in particular need. On one occasion, a tiny firefly had come to symbolize how we should never underestimate our own significance in spite of how small, inconsequential or insecure we might sometimes feel compared to other, apparently brighter lights. In the second song, inspired by a separate, unrelated situation, the lyric acknowledged someone's emotional pain and longing to be loved again. I wanted it to ultimately feel like the kind of embrace that says more than words.

The instrumental piece, "Safe back home on the shores of Loch Goil", was inspired by the story of BBC journalist Alan Johnston. At the end of his posting in Gaza, this correspondent had been captured by militants

and held hostage for 114 days. I had followed the case with interest and was deeply moved by the words he spoke immediately after his release when he arrived back in the family home on that Scottish loch. He had just been reunited with his elderly parents, who had publicly appealed for his freedom every single day and, through the TV cameras, constantly expressed their love, support and belief in this positive outcome.

"In my captivity, I learnt again that oldest of lessons. That in life, all that really, really matters, are the people you love. And here I am . . . safe, back at home, on the shores of Loch Goil."

Journalist Megan Stack had given a detailed and uncomfortable account of her life as a war correspondent in her book *Every Man in This Village Is a Liar: An Education in War*. She recounted her experiences in places like Afghanistan, Iraq, Yemen and Libya, describing the impact of war on the local population with clarity and empathy. I was not so much moved by the book for its revelation that theatres of war were rarely black and white—that much I already knew. What Stack so powerfully succeeded in doing was to paint an honest picture of the brokenness of the innocent victims of war and violence, especially the impact that could be felt long after a conflict had ended and the attention of the world had moved elsewhere. Stack's descriptions showed the sombre consequences of war for the violated: the endless cycle of hatred, revenge and further violence that could last for generations. This challenge to us all led me to write the lyric "Broken", which I prefaced musically with the instrumental piece "The Desert and the Eagle". This included the authentic audio recording of a speech given in the House of Commons on 6 December 2012.[29]

Colonel Bob Stewart was recounting his exchange with the victim of a bombing in Northern Ireland where he was stationed. It was a young girl who was badly hurt. Her legs were gone, her body utterly broken. As the colonel approached her, she quietly asked him:

"Am I hurt?"

"Quite a bit," he answered.

"Am I badly hurt?"

"Yes, you are," he replied honestly.

"Am I going to die?"

With all the care and tenderness of that father holding his child in the palm of his hand he said, softly:

"Yes."

After a brief pause, the girl spoke again. She now understood this was the end. And the question she asked spoke volumes.

"Will you hold me?"

Another kind of freedom I had experienced during my years in the arts therapies was that of exploring other forms of artistic expression—in particular photography and drawing. So many of our self-imposed limitations are surely rooted in our concerns about the opinions of others: "What if they don't like it, don't think it's good enough, professional enough or up to a certain standard?" What if the implied suggestion is "Why would a musician think he or she is qualified to express themselves in another art form?" In this I am frequently mindful of, and indeed often repeat, the famous Picasso quote: "All children are artists . . . the problem is how to remain an artist once he grows up."

I decided to embrace that way of thinking with the visual elements to *Fierce Love*, namely the CD cover art and the contents of the booklet alongside the lyrics. One of these was the drawing I had made to accompany the song "Breath". Above my interpretation of the word I had the letters "YHWH"—the Hebrew name for God made pronounceable for non-Jewish readers and writers by including the vowels "A" and "E", thus allowing for the spoken form "YAHWEH". But, in a sense, this addition missed the whole point, the meaning behind this extraordinary combination of Hebrew letters given to the Jewish nation by God himself. That is, these letters were intended to be unpronounceable, as many Jewish rabbis and writers have pointed out. When one attempts to voice them together the sound that emerges is the sound of a breath. I find such depth and beauty in this . . . that, essentially, the king of the universe, the creator of all life, has suggested as a name to represent who he, she truly is, four letters that, when pronounced together, sound like a quiet whisper . . .

On 11 March 2013, my dear mother Margaret passed away. Just five years previously my brother Christopher had lost his battle with pancreatic cancer. Having lost my sister, Julia, to cancer in 1995 and earlier my father Stuart in 1988, I had to face something I had never

remotely expected: that I would now be the only surviving member of my birth family. There is a dimension to the grief of losing all of your closest family that I never knew existed. When my mother's condition worsened, I spent a lot of time by her bedside. She often asked to listen to my music and was especially eager to hear the new material I was working on . . . probably my most faithful supporter till the very end. In her final hours as I sat by her bed and tried to support her while she struggled with her breathing, frequently requesting oxygen from the tank positioned next to her bed, she momentarily lifted the mask and whispered:

"Could you sing me that new song, Adrian? The one from the poem?"

I had set a beautiful poem by e e cummings to music. The title was "Grateful". That single word so encapsulated Mum's approach to life; the poem could easily have been written specifically for her. And so, I began to sing, accompanying myself on a guitar I had brought from home.

> For my life, I thank you
> Leaping greenly spirits fly
> In everything I thank you
> In this moment
> All things new
> All creation
> Here for you
> And a blue true dream of sky
> Endlessly, I thank you
> Natural, eternal, now
> God of wonder, thank you
> For this most amazing day
> For my life, I thank you.[30]

Nothing else needed to be said in this moment. This poem-turned-song, "Grateful", sung over my mother in the final hours before her "leaping greenly spirit flew . . ." was the gift I could bless her with at a time of great need. My mother had known the secret of true, perpetual gratitude. She had lived her life in both dependence on and thankfulness towards God. I would grieve her passing, of course, but would forever be grateful to have the memory of this beautiful, intimate moment of shared music with the

person who, alongside my father, had loved, nurtured, encouraged and supported me in everything since the day of my birth.

"Grateful" was to become the final song on the *Fierce Love* album. If you happen to own a copy, next to the printed words of the poem in the album booklet there is an original drawing made on an iPad. The little flower at the bottom of the picture was drawn by my mother. In spite of her failing eyesight, because I was able to enlarge the picture on the screen, I had invited her to contribute something to the drawing. This is what she had chosen to do, a first in terms of artistic collaboration between my mother and her son.

Life and death are irrevocably linked. Shortly after my brother and mother passed away, Sue and I became grandparents. The birth of Maya and, later on, Frankie, River, and then Sonny, filled us with a sense of excitement, wonder and gratitude for the times to come. The promise of new life, a new generation, held great significance to me. I had wrestled with the darkness of countless lives lost in the Holocaust through the eyes of children.

More recently, on the thirtieth anniversary of the year in which it had first been performed in Jerusalem, I had made a completely new recording of *Alpha + Omega* after encouragement from many to do so. There was no doubting that the message was still as relevant as it had been in 1986. The face of history, though different in the details, was still easily recognizable. The prophetic words of *Alpha + Omega* keep on ringing true. Along with Dave Bainbridge, David Fitzgerald and several fine Dutch musicians and friends, we recorded performances of the work in the Netherlands and used this template to build the newly issued "thirtieth anniversary recording" of the work. I had always felt the original album showed its age sonically. Now this message for current and future generations would benefit from the special kind of energy that comes from a live recording and all the music-making technology available in 2016 that artists could only have dreamt of in 1986.

My perspective on past, present and future has changed too. I can now look back on my music career with more gratitude. Of course, I still wonder what might have happened had my self-confidence and creative freedom been somehow more complete in my teens and early twenties; what I might have achieved had I felt less afraid of stepping beyond the

comfort zone with its inevitable limitations that are the consequence of a performing and recording career largely within the Christian music world. But, far more importantly, music has saved me in key moments of my life. It has been an extension of my personality, my faith, my hopes and dreams. And in the discovery of music therapy it has become more than that. It has become like a loyal friend and partner, exploring the ways to connect with so many lost children.

I have gained new insights into my own inner struggles. With this, I can now navigate the seas of doubt and anxiety with new tools. This personality trait is not going to change. There is nothing to cure; this is no disease. I need to learn to manage some of the resulting behaviours better and I still have the familiar voices whisper their messages of self-doubt and absolutisms to me. But it is largely children that have led the way to this point. Children like young Eva Picková, whose words survived the Holocaust where she had not, reaching and inspiring me to new meaning. Children like the little girl at the heart of the story in *Beautiful or What?!* who sowed the seed for my work among children with special needs. Children like Padmahari's companion at Anandaban Hospital in Kathmandu. Those in Korçë, Albania. And, of course, the children at Three Ways who helped me open not only their hearts but also my own through the amazingly inspiring work of music therapy.

"The only meaningful prayer is for forgiveness, because those who have been forgiven have everything."[31]

This quote by American clinical psychologist Helen Schucman adorns the inside of the door to my music room at Three Ways. Over time, its significance has increasingly been revealed to me. I believe it holds true over my own life and I believe, as a result, has a deep and healing influence upon the children I work with. I was a lost child, but I found a path forward as the recipient of fierce love and forgiveness. And as I write, this path is already leading me into perhaps the most exciting chapters in my composing and recording life . . .

ADRIAN SNELL
— AT THE —
ROYAL ALBERT HALL

World Premiere of Adrian Snell's new recording
SONG OF AN EXILE
and the final major performance of
ALPHA AND OMEGA

SATURDAY 4th FEBRUARY 1989 7.30 p.m.

SUPPORTED BY
KING'S PARK

ADRIAN SNELL
PROJECT OVER JERUZALEM

'Blessed are the peacemakers,
for they will be called children of God'

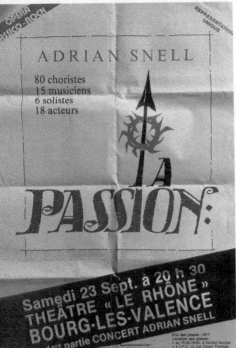

OPÉRA ROCK

REPRESENTATION UNIQUE

ADRIAN SNELL

80 choristes
15 musiciens
6 solistes
18 acteurs

LA PASSION

Samedi 23 Sept. a 20 h 30
THÉÂTRE « LE RHÔNE »
BOURG-LES-VALENCE
en 1ere partie CONCERT ADRIAN SNELL

D R S
Schweizer Radio DRS

ADRIAN SNELL
BEAUTIFUL
... OR WHAT?!

Ein Musik-Theater
Comédie musicale
über die Welt
sur la vie
eines geistig
d'une jeune
-behinderten
handicapée
Mädchens
mentale

PROFILE

Do 22. Sept. 94 20h00
Spirgarten
Zürich-Altstetten

Erlös zugunsten Kinderheim Bühl

Preise: Fr. 48.–/40.–/32.–/26.–
Alle Plätze sind numeriert.

Vorverkauf ab 22. August

Info-Tel: 01/784 84 79

WORLD PREMIERE OF
CITY OF PEACE

BY

ADRIAN SNELL

JERUSALEM
JUNE 27~28. 1995

BEAUTIFUL OR WHAT?!

P R O G R A M M A

Seven Words
for the
21st Century

Music: Adrian Snell
Words: Rowan Williams
Edmund Newell
Giles Fraser
Peter Doll
Tarjei Park
Sabina Alkire
Hugh White
Helen Cunliffe

Edited by
Edmund Newell

With an introduction by
Richard Harries

Adrian Snell

I dream of Peace

Ich träume vom Frieden ·
Texte von Kindern über die Sehnsucht nach Frieden
vertont von ADRIAN SNELL (Gesang, Klavier, Gitarre)
mit NATASJA GORLEE (Gesang)

Lindenkirche (Gemeindesaal)
Johannisgerger Straße 15a (M 9)
Sonnabend, 31. Mai 2003, 13 Uhr

unter Mitwirkung des Coverdale Trust
Ökumenischer Kirchentag Berlin 2003

Adrian Snell

Préado
Vocal
Band
&
Cast

Cité de Paix
Yerushalayim

YAD VASHEM
The Holocaust Martyrs' and
Heroes' Remembrance Authority

A unique concert composed and performe
by British musician **Adrian Snell**

SONG
of a
EXILE

UNIQUE MUSIC ACCOMPANYING JEWISH TEXT

The performance will take place on Wednesday 24 August, 1994, 20.00 in the Valley of the Communit

Performers
Adrian Snell
Richard Ayal Frieden - mime and dance
Caroline Bonnett - vocals and percussion
David Fitzgerald - saxophone and flutes
Narrator - **Benny Bondel**

With the support of the
International Christian
Embassy, Jerusalem

With the support of
The Culture department of
the Jerusalem municipality

With the support
of The British
Council Israel

For further details please contact the Public Relations Department, tel: 02 751658

The Cry
A REQUIEM FOR THE
LOST CHILD

by Adrian Snell

6.00 pm
16 November 2008
St Paul's Cathedral

Mark Stone
Niamh Perry
Jeanine Thorpe
London Oriana Choir
The London Oratory School Schola
Mill Hill School Choir
Alpha Preparatory School Choir
Musical Director: David Drummond

We Save the Children Will you

St Paul's Cathedral

Conclusion

It took a break away from an active life as a performing, recording musician to rediscover my purpose. I cannot look back on this without a deep sense of gratitude. The children at Three Ways did much more than open my ears and eyes to a different way of looking at the world. They challenged me to step outside my own comfort zone. To connect. To learn how to acknowledge them in a way that not only respected them as individuals but also opened the door to new possibilities. I have seen children, lost to themselves, find new bearings through the power of music. A gong, the strumming of a guitar, the seemingly simple act of writing a song. Their stories are, deep down, constant reminders of my own story: someone struggling to make sense of the outside world and communicating with others. It took the gift of music to help me cope.

Looking back, I also cannot help reflect on the position of the Church in all this. That colourful community of Christ-followers that was a beacon in my youth and turned into what I felt needed to be challenged when *Alpha + Omega* set me on the path towards rediscovering the Jewish roots of my Christian faith. Over the years during which I had written, recorded and performed *Beautiful or What?!*, *Every Place is under the Stars* and *Fierce Love*, I found myself increasingly imagining what church might look like if it truly embraced the community of those with special and additional needs.

To clarify a little: for me the word "embrace" signifies much more than extending a welcome on a Sunday morning. More than a ten-minute section during a regular service where the needs of this community are prioritized and the language of church is temporarily adjusted to take account of those for whom words can be a major obstacle. No. By using the term "embrace" I mean seeking out those with particular needs in order to do what churches do best: building a community, becoming an extended family, creating an environment that feels like home. I often ask

myself what would need to happen, to change, in our way of thinking and at the heart of church culture, for us to be positioned at the forefront of a multisensory, inclusive and totally accessible way of worshipping and learning.

As it happens, and I reflect on this now, whether as a child or teenager through to adulthood and the present day, it is when all my senses are engaged that I remember and understand at a deeper level. A captivating soundscape, the smell of incense, a piece of drama, the taste of unleavened bread—these are the moments that stay with me, that I can easily recall sometimes many years after. I think that has to be true for most of us.

But for those amongst us for whom words—whether spoken or read—are relatively meaningless, it is *only* through multisensory communication that there will be full engagement and the experience of inclusion. I happen to believe that this is what I am, we are, called to be: members of a community of believers who look out for one another, break bread together, value one another through the knowledge that we are all, each in our own unique way "fearfully and wonderfully made".

I have always been particularly drawn to, and challenged by, the occasions when Jesus specifically included, prioritized even, children in his ministry and teaching. Time and again his disciples were reminded that God insists on the unconditional acceptance and integration of children in our midst as a body of believers.

"The kingdom of heaven belongs to such as these . . . "

And I firmly believe that these words equally apply to the children, young people and adults with special needs who live and grow amongst us. Not on the sidelines but fully participating. Seen and heard with loving pride by our creator.

Fierce the love that binds us
Guides the hand and shapes the heart
Love that dignifies us, sees in you a work of art . . .

Discography

Fireflake (1975)
Goodbye October (1976)
Listen to the Peace (1978)
Something New Under the Sun (1979)
The Passion (1980)
Cut (1981)
The Virgin (1981)
Adrian Snell Classics (1982)
Midnight Awake (1983)
Feed the Hungry Heart (1984)
The Collection 1975–1981 (1986)
Alpha + Omega (1986)
Cream of the Collection 1975–1981 (1989)
Song of an Exile (1989)
Father (1990)
Kiss the Tears (1992)
We Want to Live (1992)
Beautiful or What?! (1993)
Solo (1994)
City of Peace—Moriah (1996)
City of Peace—My Every Breath (1996)
My Heart Shall Journey—The Best of Adrian Snell (1996)
Light of the World (1997)
Intimate Strangers (1998)
The Early Years 1975–1981 (1999 3 CD)
Poems Without Words / Seven Hills (2000)
I Dream of Peace (2001)
The Cry: A Requiem for the Lost Child (2003)
Every Place is under the Stars (2006)

Fierce Love (2013)
Alpha + Omega 30th Anniversary Recording (2017)

Photo Credits

Cover photo: Dominika Nachowiak

Photo at the end of the Preface: Marleen Van De Voorde

Adrian's children watching from the side of the stage: Joanne Hogg

"Let the outfit do the talking . . . ": Maranatha! Music

Artwork for *Something New Under the Sun*: Eugene Press/ Peter Wagstaff,
 Kingsway Music

Artwork for *Listen to the Peace*: Eugene Press/Dovetail Records/Kingsway
 Music

Artwork for *The Passion*: Eugene Press/Peter Wagstaff, Kingsway Music

Artwork for *Goodbye October*: Eugene Press/Phil Thomson, Dovetail Records/
 Kingsway Music

Artwork for *Feed the Hungry Heart*: Eugene Press/Myrrh /Word (UK) Ltd.

Meeting Princess Diana: Leonard Smith

TV-recording of *The Passion*: NCRV, The Netherlands

Ticket for the concert in the Royal Albert Hall: Adrian Snell

Drawing of the child with a crutch: Jeanette Obbink

Adrian and Rabbi Hugo Gryn: Word (UK) Ltd.

Adrian with children in Nepal: Leonard Smith

Promotional black and white photo (next to "A father is someone who . . . "):
 Theresa Wassif

Recent concert photo and Adrian playing the guitar: Eelco Noortman

Painting for *Fierce Love* CD artwork: Adrian Snell

Adrian and daughter Carla at the piano: Alex Verlek Van Tienhoven

Band posing (below the Red/Yellow painting): Peter Mulder

Adrian playing the guitar (recent promotional photo): Dominika Nachowiak

Notes

1 Alexander Wheelock Thayer, *Thayer's Life of Beethoven*, Volume 1 (Princeton, NJ: Princeton University Press, 1967), p. 494.

2 "I Was A Stranger", written by A. Snell (*Fireflake*, Dovetail, 1975).

3 "Song for John", written by A. Snell, Lowde (*Fireflake*, Dovetail, 1975).

4 Jack Clemo, "Lunar Pentecost", *The Map of Clay* (London: Methuen, 1961), p. 75.

5 *Buzz* magazine (Musical Gospel Outreach, 1975).

6 Eva Picková, "Fear", in Hana Volavkova (ed.), *I never saw another butterfly . . . Children's Drawings and Poems from Terezin Concentration Camp 1942–1944* (New York: McGraw-Hill, 1971), p. 55.

7 "Alpha and Omega", written by A. Snell (*Feed the Hungry Heart*, Word (UK) Ltd., 1984).

8 Hanuš Hachenburg, "Terezín" in Volavkova, *I never saw another butterfly . . .*, p. 22.

9 Elie Wiesel, *Night*, tr. Marion Wiesel (London: Penguin Books, 1981).

10 Eva Picková, "Fear", in Volavkova, *I never saw another butterfly . . .*, p. 55.

11 "Only Jesus", written by A. Snell, P. Crompton (*Feed the Hungry Heart*, Word (UK) Ltd., 1984).

12 Elie Wiesel, International Scholars' Conference on the Holocaust, July 1988.

13 "Feed the Hungry Heart", written by A. Snell, P. Thomson (*Feed the Hungry Heart*, Word (UK) Ltd., 1984).

14 "No More Tears", written by A. Snell, P. Thomson (*Father*, Word (UK) Ltd., 1990).

15 "Psalm 27 (Wherever I Go You Are There)", written by A. Snell (*Feed the Hungry Heart*, Word (UK) Ltd., 1984).

16 "Favourite Song", written by A. Snell, P. Thomson (*Kiss the Tears*, Word (UK) Ltd., 1992).

17 "Homocystinuria Aria", written by A. Snell, P. Thomson (*Beautiful Or What?!*, Word (UK) Ltd., 1993).

[18] "Alpha and Omega", written by Snell (*Alpha + Omega*, Word (UK) Ltd., 1986).

[19] "Like a Child that is Quieted is My Soul", written by A. Snell (*City of Peace: My Every Breath*, Alliance Music, 1995).

[20] Aaron Zeitlin, *A Treasury of Yiddish Poetry* (edited by Irving Howe & Eliezer Greenberg), Schocken Books.

[21] "Sure and Certain Love", lyric by P. Thomson (*Intimate Strangers*, Serious Music, 1998).

[22] "Fire and Ice", lyric by P. Thomson (*Intimate Strangers*, Serious Music, 1998).

[23] "Intimate Strangers", written by A. Snell (*Intimate Strangers*, Serious Music, 1998).

[24] Dylan Thomas, © David Higham Associates Ltd.

[25] "A Little Child Shall Lead Them", written by A. Snell (*The Cry*, Serious Music, 2003).

[26] "You Are There", written by A. Snell (*Every Place is under the Stars*, Serious Music, 2006).

[27] "You Are Loved", written by A. Snell, C. Snell (*Every Place is under The Stars*, Serious Music, 2006).

[28] Words adapted from *Concediamo L'indulgenza di 200 giorni a chi recitera devotamente questa preghiera* (Lucca, 4 maggio 1959, Antonio Arcivescovo).

[29] Quoted from speech given in the Chamber of the House of Commons on 6 December 2012 by Colonel Bob Stewart.

[30] "Grateful", music by A. Snell, in homage to the poem by e. e. cummings (*Fierce Love*, Serious Music, 2013).

[31] Helen Schucman, PhD, *A Course In Miracles*, p. 42 (New York: Ixia Press, 2019), p. 42.

Printed in November 2021
by Rotomail Italia S.p.A., Vignate (MI) - Italy